# VISION & VOICE

## REFINING YOUR VISION IN
## ADOBE PHOTOSHOP LIGHTROOM

David duChemin

**Vision & Voice: Refining Your Vision in Adobe Photoshop Lightroom**
David duChemin

New Riders
1249 Eighth Street
Berkeley, CA 94710
510/524-2178
510/524-2221 (fax)
Find us on the Web at www.newriders.com
To report errors, please send a note to errata@peachpit.com
New Riders is an imprint of Peachpit, a division of Pearson Education

Editor: Ted Waitt
Production Editor: Hilal Sala
Cover and Interior Design: Charlene Charles-Will
Layout and Composition: Kim Scott, Bumpy Design
Color Production Consultant: Marco Ugolini
Additional Image Conversion:  Mimi Vitetta
Indexer: James Minkin
Cover Image: David duChemin

ISBN-13 978-0-321-67009-0
ISBN-10      0-321-67009-4

9 8 7 6 5 4 3 2 1
Printed and bound in the United States of America

*For the amateurs—the lovers—those who do this
for the love of the image and the journey of getting there.
This is for everyone who loves this craft, whether you
draw a paycheck from your efforts or not.
For everyone who has ever created an image
just to say, "Look at this!"*

# Acknowledgments

This whole book-publishing thing is terribly unfair. The author gets all the glory, and it's my name on the spine, but it's a large team that actually takes my words, shapes them, puts them on pages, and gets them out there looking far, far better than I ever imagined. Beyond that, it takes friends and family to see the author through the process with his mind in one piece, and it takes people like you for these books to find an audience. I am, it seems, the smallest piece of the puzzle. But I am deeply grateful, and I never take all this for granted. To the following, I am deeply indebted and grateful.

Ted Waitt, my editor and friend, is the man behind some of the best books about photography being produced today. That he continues to not only turn my words into readable books is amazing, but that he does it for other authors, as well, and with such excellence and grace, amazes me.

My publisher, Nancy Aldrich-Ruenzel, who continues to take chances on me. In publishing the books she has, Nancy's contribution to the photography community have been immense, and we're all richer for her. I've joked recently that if a publisher ever asks you to release three books in just over a year, you should poke that person in the eye and run like hell, but Nancy's willingness to take this adventure with me, on this crazy timeline, has been one of the great blessings of the last few years.

Charlene Charles-Will, the artist who lays these books out so beautifully, and Hilal Sala, my production editor, who keeps this train on the rails.

Scott Cowlin and Sara Jane Todd, who take the books to market and humor me when I call to check in. These folks at Peachpit/New Riders all feel like family to me, and I can't imagine a team I'd enjoy working with more.

Corwin Hiebert, my friend and manager and the guy who holds my life together when I travel. As my career grows and becomes more complicated than I can handle, Corwin manages it all like the lovechild of some crazed superhero/geek and an uber-organized hipster. He's also my go-to guy when I need a beer and a conversation, and has been known to take calls from me in Africa in the middle of the night to change a flight, without so much as a complaint.

My colleagues and peers in the photography world. Joe McNally. Scott Kelby. Vincent Versace. Zack Arias. Chase Jarvis. Chris Orwig. RC. Gary S. Chapman. The folks at B&H Photo.

My sponsors, who believe in me and my work and support it with exceptional gear and support. Gitzo. Adobe. Think Thank Photo. Blackrapid. Wacom. OnOne Software. Artistic Photo Canvas. DROBO. PocketWizards.

To the readers of my books and blog, who have created a community around my words and lunatic rants. Thank you. What you have given back to me is generously disproportionate to the words I crank out.

To every client I've ever had that has allowed me to do what I love and serve them in the process, thank you. To Lyric especially, my first and favorite client, who took a chance on me because, while unproven, we shared the same vision and passion. And then she sent me to a war-zone.

My friends, long-suffering and faithful. Troy Cunningham. Erick Pay. Matt Brandon. Gavin Gough. Jeffrey Chapman. Erin Wilson. Daniela Kreykenbohm. Mike Todd. Reid Barton. Dane J. MacKendrick. Eileen Rothe. Kevin Clark. Dave Delnea. The Legendary H. KF. Daniel and Barbara Brown. Alan Smith.

My mother, Heather, one of my best friends and heroes. My stepfather, Paul, a man who has been unfailingly supportive of me despite the fact that I never got a "real job" or worked the steel mills in Hamilton. Paul fed me a steady diet of *M\*A\*S\*H\**, *Monty Python*, and *Black Adder* as a kid, and he is to blame for my sense of humor.

Finally God, from Whom comes both my calling and the gifts to chase it. Be Thou my Vision, oh Lord of my heart.

# About the Author

David duChemin is an international assignment photographer specializing in humanitarian projects and world photography. His work has taken him around the globe with his cameras. From Mongolia in the middle of winter to shooting killer bees in Africa, catching malaria in Ethiopia and typhoid in Peru, being thrown off a camel in Tunisia, and being abducted by street kids in India and forced to play cricket, David's adventures have only deepened his love for this world and the people who inhabit it.

A passionate contributor to the international photography community, duChemin's first book, the bestselling *Within the Frame*, received worldwide acclaim for its vision, passion, and depth.

David's work and blog can be found online at PixelatedImage.com and his eBooks can be found at CraftAndVision.com.

Photo: Yves Perreault

# Contents

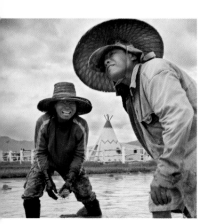

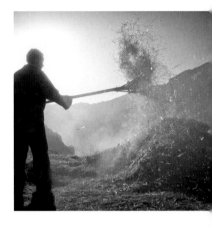

**CHAPTER SEVEN**

# 20 Visions, 20 Voices . . . . . . . . . . . . . . . .96

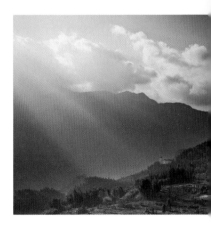

# Introduction

A COUPLE YEARS AGO my friend Matt Brandon and I lectured at the Himalaya Club in New Delhi, India. I remember it more clearly than similar lectures I've given, for two reasons. The first is that Delhi was rocked by a series of bomb blasts before the lecture began, but things went ahead as planned, with only a delay of a few minutes to accommodate people stuck in the resulting traffic chaos. Business as usual. Mildly unsettling, to say the least. The second reason I remember it so clearly is the Q&A period afterwards that threatened, if briefly, to go dangerously off the tracks. The rogue question was twofold. One: "Do you do any post-processing to your images?" to which I answered, "Yes." Two: "So how do I know it really looked like that?" It went downhill from

▶ Canon 1Ds Mark III, 58mm, 1/160 @ f/8, ISO 800

Goree, Dakar, Senegal, 2010.

there and finally got lost in a quagmire of ethical assertions with no authority to which anyone could appeal and settle things once and for all.

The seeds of this book were conceived that evening.

> "We've grown up being fed the lie that the camera never lies."

"So how do I know it really looked like that?" For what it's worth, I think this touches the heart of the matter, though I'd rephrase it slightly. Without changing a word of it, the answer, of course, is, "You don't." Simultaneously, the answer is, "Trust me." And in some ways, the answer is always, "It didn't."

We've grown up being fed the lie that the camera never lies. So if "the camera never lies," is our starting point for objectivity that any manipulation of the negative can only introduce corruption into the process? But that's the problem, isn't it? The camera tells any lie we ask of it. Or any truth, for that matter. It's a tool, no more objective, really, than a microphone. Wielded by Martin Luther King, Jr., it's a tool of truth and justice; wielded by a corrupt politician, it's a tool of spin and propaganda. A tool. No more. No less.

We are beginning with a fallible, corrupted product. The moment you consciously choose one focal point over another, you change how the picture is taken, and how it is perceived. When you change the medium, you change the message. Always.

Every setting we choose has an effect on the aesthetics of the image. If I choose an aperture of f/1.2 to take advantage of a softer depth of field, am I not changing the so-called objective reality of the scene? Surely it didn't "look that way." Or did it? I'm near-sighted, I wear glasses. If I take my glasses off I see my foreground sharp and my background blurred. I see perpetually in f/2.8. So when I set my aperture to f/22 and create an image with limitless focus, is that the way the scene "really looked"? Not to me.

The same is true of shutter speeds and their ability to imply time's passage in a frame. I've never seen a waterfall with sharply frozen water, as though time has stood still, have you? What about cropping? Do you look at the world through a cardboard box, limiting your field of view? I don't. The moment we include certain things, we exclude others.

By its very nature, photography is subjective. A tool. How do you know it looked like that? You don't. The best you can do is trust me to show you what it looked

like to me. In fact, I'll go you one better. The very best you can hope for is that as a photographer I get over my need to be completely objective and instead take the time to create a photograph that makes you see, and feel, the scene the way I saw it. Did it look like that? It did to me. And if part of my process to bring the image closer to my vision is to use a postcapture tool rather than my camera, I think that's okay. It's hair-splitting to say that a magenta filter on a lens is okay while the same applied in post is not.

Have painters ever dealt with this? Monet paints in permanent blur-o-vision and no one ever asks where he was painting that the lilies looked so blurry. Painters are free of the burden of this objectivity. Perhaps these are the birth pangs of our craft, a phase we need to go through to get to the good stuff—the expression of our vision through the voice of digital capture and refinement in the digital darkroom.

I'm aware that photography is also a tool of reportage, and the needs and ethics of the journalist are different than those of the artist. But if I can venture an opinion, I think even then it's just a different line drawn on a different patch of sand. The best we have is a corrupt product, and that's why a photojournalist's integrity is as important—more important—than his other skills and assets. The camera will still lie. The moment that journalist decides to take sides or spin the story, his camera will fall in line. But this book isn't about that.

So why start off on this foot, with all this philosophical navel-gazing? Because the question is important. Did it look like that? That's just another way of asking, "How did it look? How did it feel? What are you trying to show me?" This book is about using your voice to express your vision so you can answer those questions.

Did it look like that? Did it feel like that?

It did to me.

The deeper my forays into digital photography, the more I am sure that there are three images that make a final photograph: the one you envision, the one you shoot, and the one you develop. The better you are at the last two, the closer you can come to the first. This book is about that third image that goes into the final photograph—the one that is refined in the digital darkroom. In this case, it's

"Every setting we choose has an effect on the aesthetics of the image."

the specific digital darkroom of Adobe Photoshop Lightroom. But I like to think that any photographer, using any program, like Photoshop or Apple's Aperture, could apply these principles to their workflow with equal success. The sliders are different, but the way we refine and polish an image to bring it back into alignment with our vision remains the same. It's a poor singer who can only sing through a microphone of a particular brand.

Lastly, this book is not a book about the entire workflow process from import and organization to printing, web presentation, and redundant backup.

It's not about digital asset management.

It's not really even about Lightroom, though it's Lightroom I use here. How we do this is less important than why. Use Aperture or Camera Raw. Use Photoshop Elements. The best creatives use the tools they have and don't spend time convincing themselves or others that their tools are better than someone else's. The process and the print matter; the tool doesn't.

It is not a book of tips and tricks, not a book of tutorials. Though there are both in here. It's really, really not a book of recipes to make images look "better."

It is a book about bringing your vision to the digital darkroom. In this case, the digital darkroom is Adobe Photoshop Lightroom 3 because that's the tool I, and most of the photographers I know, use on a daily basis, in a way that supports the vision you had when you created the digital negative. This book really has one goal in the same way that most of my images have one intent, one mood, or one emotion to convey. My vision for this book is that readers learn to approach digital development as a craft in service of their vision. Sure, you'll learn some cool tips and techniques, and ways in which your voice can be refined, but it's more than that.

Let's go back to the metaphor of voice. In this book, it means the tools with which you give your digital image—the song—its fullest and best expression, and all the voice training in the world without a powerful song to sing is just unsung noise. I hope this book brings you another step closer to identifying and expressing your intent—or vision—for your photography, and that it also makes your work stronger when you have the camera in hand.

"My vision for this book is that readers learn to approach digital development as a craft in service of their vision."

## Image Downloads

The final chapter of this book is a collection of tutorials based on some of my own images. I'm making my original RAW files (in DNG format) available for you to download and follow along with. I've never had much luck reading along with technical writing—much less being able to absorb or recall the information—without also doing the steps described.

To download the images, register your book at peachpit.com/visionandvoice by signing in (it's free) and entering the ISBN. After you register the book, a link to the images will be listed on your Account page, under Registered Products.

As with all copyrighted material, please resist the urge to call these your own and sell them for millions. If you're not strong enough to resist that urge, please at least resist the urge to not cut me in for part of the profits. Use of these images is limited to the context of working through the tutorials in this book and under no circumstances are to be fobbed off as your own…or given to Joe McNally.

# Vision in Focus

IT WOULD BE EASY FOR ME to overuse the word *vision*. In fact, it'd be hard not to. For one, it's part of the title, so it's a good sign that I'm not even going to fake at being restrained. For another, this is a book about image development that is immediately derived from your vision. Third, I did this in my previous two books, *Within the Frame* and *VisionMongers*. After two books, it's not just a quirk; it's an M.O.

You might say I'm obsessed. It took me 20 years to find my vision, so I place a great deal of value in it.

▶ Canon 5D Mark II, 24mm, 1/40 @ f/14, ISO 400

Ko Samet, Thailand, 2009. I shot this with a two-stop graduated neutral density filter.

Vision is the way you see the world. In big strokes, but also in the small strokes, one frame at a time.

Vision is the unique angle from which you alone see things, and the unique way in which your eyes—and perhaps more importantly, your mind and heart—filter this world. It's everything to the photographer: the stories you want to tell, and the way you want to tell them. Vision is that original spark that was ignited within you and made you pick up a camera to capture whatever it is you saw, that made you turn to shout "Did you see that!" only to find no one there—so you created an image to do the telling.

Too artsy for you?

Vision is like a visual opinion.

> "The rational and the serious are empty playgrounds for the muse."

It's my slant on things. It is, quite literally, the way I see it. It's not always simple, it's not always easy to express, and usually it's made out to be something more mythical than it probably is. It must be, because so many photographers I know wrestle with this concept. In fact, it seems to get harder as we grow into our craft and become so serious about it. A five-year-old with a box of crayons doesn't need to be conscious of his vision to draw from that place. But as we grow and get all cloudy and befuddled with techniques and theories and inverse square laws and…well, it just gets so much less intuitive.

I believe this happens for a couple reasons. The first pertains specifically to the vocational photographer, the one who's decided to make her living from the craft. She starts to believe the stakes are too high to just muck about with this, that playing, experimenting, and making mistakes are the lesser work, whereas exact composition, light ratios, and sharpening algorithms are the realm of the professional. When we lose the innocence and play of this, it all becomes so… rational. The rest of us, the nonvocational photographers, get bogged down by less professional concerns, but the anesthetic effect remains, and we get numbed by our need to follow the rules, listen to the pundits (of which I am one, so take this with a grain of salt), and compare ourselves with others. It all just gets so serious. The rational and the serious are empty playgrounds for the muse. What poet ever sat down and wrote passionately from that place? What painter or sculptor ever spoke to our hearts with work that did not come from their own?

Is the struggle between the heart and the mind irreconcilable? Will the poet and the geek never find common ground? I think they can. They must. But they need to both have their say and know their place.

This is a book about bringing your image into closer alignment with your vision. That's an artsy, right-brained kind of activity. But it's also a book about doing so through the skilled, intentional use of technique and machinery. That's a left-brained activity. Fortunately for us, once the left brain gets its stuff figured out, it can operate in the background. It doesn't need the glory; it doesn't care. That's how happy it is to just play with sliders and tone curves. Your right brain, however, wants to feel, to express, and it very much does want its time on the stage unhindered. So they're great partners. Your left brain/geek serves your right brain/artist, and both serve your vision. Together.

The more you work on your technique in a way that is subject to your vision, the more intuitive that technique becomes—and the more quickly it gets out of the way. That's why the five-year-old has no issues with this. He hasn't read the books or heard the theories. He isn't weighed down with the rules of perspective or scale. He just draws, ham-fisted crayons serving his vision unhindered by anything but a lack of technique. He learns technique, but that brings him only a little closer. It's when he gets to the other side of technique that his vision is finally unhindered.

That's what this is all about. Getting to the other side of technique. Back to the intuitive. To that place where our vision ignites and our voice is equal to the task of expressing it.

> "Your left brain/ geek serves your right brain/ artist, and both serve your vision. Together."

CHAPTER **TWO**

# Vision & Process

NONE OF THIS IS EASY. The goal of all this is that we get closer to working intuitively, to wielding our tools so comfortably that they get out of the way and simply help us create images that express what we're longing to express. That, in fact, might be the easy part. What's hard is being conscious of what is essentially an unconscious (or subconscious) thought or emotion.

But if that thought or emotion is not conscious, then what good is it in driving our process?

Good question. In reply, I'd like to talk about writers; sometimes it's easier to illustrate a point using something else entirely. Call it a parable or a metaphor.

---

▶ Canon 5D Mark II, 70mm, 1/2000 @ f/3.2, ISO 800

Chiang Rai, Thailand, 2009. I was shooting in a temple, walked out, and shot this. As often happens, I forgot to change my ISO until several minutes later. Chalk it up to artistic distraction.

# The Process of Vision

Writers are a hard-working bunch. They don't sit around and navel-gaze about their vision for their novella about 17th-century Russia. They sit down and start writing. They write every day. Sometimes they write nothing but crap. But they write all the same. And one day, after lots and lots of false starts and pages and pages of crap, they unearth the plot, the true nature of their characters, and the arc of the story. Writing is not separate from the process of discovering their vision. It is the process of discovering their vision. To put it another way, they don't write when they *have* inspiration; they write to *find* inspiration. Writers know that inspiration comes with work.

"Inspiration comes with work."

So it is with photographers. It's hard. I seldom see the image in my mind, grab a camera, and create the photograph that perfectly expresses what I saw in my mind's eye. Some do; I don't. For me, it's more like a feeling. I see a scene or a moment, and it makes me feel something; I grab the camera, then I sweat blood while trying to find a framing, a focal length, and an aperture that captures or re-creates that thing I saw in the way I saw it. It takes lots of false starts, bad frames, and poor exposures. Some days I don't get it at all. On the best days I flounder for a while—like chipping away at the marble to expose the statue underneath. I mutter to myself a lot. And on those days when I really nail it, it doesn't end with the capture. I've created a great negative, but the darkroom work is still ahead of me.

And it's no different in the digital darkroom with my mouse or tablet pen in my hand. I mutter, I hit the Undo shortcut a lot, I reset the image and start again, all in an effort to regain that guiding thought or emotion I had when I shot the frame, and to bring it out with the clearest visual language possible. All this fussing about is not an obstacle to my process. It *is* my process. Discovering what my image doesn't want to look like is part of discovering what it does want to look like. Remember playing hide-and-seek as a child? Each place you looked that did not contain a hiding friend was one step closer to finding the place that did. Seeking was not an obstacle to the game; it was part of the game. In fact, it was the game. The moment you found your friend the game was over.

So while at times I discuss a vision-driven workflow (VDW; see Chapter 4 for more) in ways that make it sound simple—as though your vision were as easy to find as the nose on your face—it's only because I know you've read this and

understand that it's not. It's not easy. And often the process is part of unearthing and clarifying your vision. At times you will wrestle with an image, unable to put a feeling or thought into words, unable to clearly articulate the heart of this visual story you want to tell or the mood in which you want it told. And the wrestling will wear you down to near defeat. And in that moment before you give up, you'll make one last-ditch attempt and nudge the wrong slider—only to find your vision jump out at you and yell, "Surprise!" If you're like me, you won't know whether to smile or punch it in the nose.

I'm a big fan of serendipity. Serendipitous moments make up the best of my photographs. Serendipitous mistakes are responsible for others, both in the capture and the development stage of image creation. And the more open you are to them, the more readily you'll recognize in them a collaborative force in the creative process. Your job is to be ready for them. I can't usually make the moment happen—if I could, it wouldn't be serendipity—but I can be sure my technique is as practiced and as sharp as possible so that I'm ready when it strikes. Luck, as they say, favors the prepared.

"Discovering what my image doesn't want to look like is part of discovering what it does want to look like."

## Vision in Process

The way you see things (vision) and the way in which you express them (voice) are evolutionary. Your vision and your voice are so heavily tied to you as a unique person that it's impossible to separate them from who you are. So they evolve and change, making them a moving target and, at times, infuriatingly unpredictable. Finding this elusive vision is not a destination; it's a journey. I know, it's a cliché. But if you expect to find it once and spend the rest of your life trying to express it, you'll be needlessly frustrated. There's a great deal of freedom in knowing, and accepting, that your vision grows and changes. Remember the game of hide-and-seek? It's worse than that. It's a game of hide-and-seek where the kids keep switching places. You look under the table today and the kid's not there. Look tomorrow and he might be. That's just the way it is.

So how, in a game of moving targets, do you even start? The good news is that you already know; you just don't know that you know. This is no secret locked away in the metaphysical world and unlocked with a secret handshake. It's who we are. Who *you* are. It's your passion, your likes, your dislikes—the whole thing. The easiest way to get a read on this is to follow the stream. Look

> "Follow the stream. Look at the images in your collection, especially the ones you really love. Chances are some patterns will emerge. The more time passes, the more those patterns become recognizable."

at the images in your collection, especially the ones you really love. Chances are some patterns will emerge. The more time passes, the more those patterns become recognizable. You'll see common subjects, themes, framing—perhaps even commonalities in color and design. I did this with my own work. After 15 years I looked at my collection and noticed my work fell easily into recognizable streams. Children. Emotion. Culture. Travel. Simple compositions. Graphic elements. Bright, luminous colors. Moody duotones.

Let me digress with a story. I spent nearly 20 years as a passionate hobbyist photographer, shooting everything I saw and working on my visual storytelling skills with no idea what stories I really wanted to tell. I shot everything that moved and many things that didn't. And then I was asked to go to the island of Hispaniola and shoot for a small NGO (nongovernmental organization) that works for children in rural Haiti. From the moment I arrived and took my first images, I found the spark of recognition. This was what I wanted to do; I found the stories I wanted to tell. And then I looked back on my past work. Images from Peru: the keepers all had kids in them. Images from Russia: same thing. Everything I'd ever shot that I still loved was about kids, culture, travel, and emotion.

Knowing this is helpful in describing my vision, but it does not define it. Fact is, I could shoot a wedding and still do it in a way I love—focusing on the ritual, the emotion, the kids, the portraiture. My compositions will be simple (not simplistic) and more than likely my eye will gravitate to emotion, strong moments, graphics, and colors. I just know what I like, and I know in which direction my creative stream flows.

I followed the stream and discovered where my vision tends to go. This helps. But again, it doesn't define.

That's vision on a macro scale. It's the big-picture stuff. But we also speak of vision in micro terms—on an image-by-image basis—and the smaller stuff is no easier to nail down than the bigger stuff. Sometimes it's harder. I've heard many photographers tell me they understand their larger worldview-level vision to some degree, but when it comes to one particular scene or one particular image within a scene, it's even harder.

Many of us become paralyzed by options. You see something that moves you and you think, "Hey, look at that!" You grab the camera and suddenly what was

so easily perceived with the mind is captured by the camera with such difficulty. What shutter speed? Which aperture? Long lens? Wide lens? What's my POV (point of view)? And if that weren't torturous enough, we're faced with exponentially more options when we import the images into Lightroom. Never mind the pain of having to choose between two similar frames in the Library module; when the image is staring you in the face in the Develop module, begging you to refine it, to bring the image back to the one you saw in your mind's eye—your heart's eye—then the real paralysis begins.

Or it doesn't. For some of us, a hint of paralysis would do us some good. It would slow us down and force us to consider the "why" before diving, without reck or regard, headlong into a spastic choreography of sliders and tone curves, hoping to God we find something that makes our image "better." Some of us approach our development with no sense whatsoever of what the final image ought to look like or feel like. We don't consult the moment of capture and the way we were thinking at the time. We don't think forward to the moment it will appear as a print. We live like some insane lobster that's consumed too much absinthe and read too many poems by Gerard Manley Hopkins. No, I don't know what that means either, but I suspect what I'm trying to say is onions and oyster farming! See, just picking words out of thin air works no better for verbal communication than random choices work for visual communication, and to know which words are most suitable it's important to know what I am trying to communicate and how that might best happen.

But I'm digressing. Back to the point that, as I recall, was this: our vision can be difficult to pin down. Whether it's the larger vision at play in our work or the piece-by-piece vision that's derivative of the larger, it's tough. And all the options make it harder. That's what I was trying to say. Slow down. Take a breath. Unless you're working for a client, the clock isn't ticking, there's no rush to birth this image. Take a moment. What was it you saw when you were moved to pick up the camera? I'm going to pretend I didn't hear you mutter something about thinking "it looked cool." Dig deeper. Was it a thought, a feeling, a simple moment when your eyes did a double-take at the intersection of two lines? Was it a lick of light, two blocks of color? This isn't navel-gazing. I'm not after a deep answer. If your answer really is "It just looked cool," then I'm going to encourage you to dig deeper—what about it "looked cool"?

> "For some of us, a hint of paralysis would do us some good."

> "The word 'better' means nothing without something against which to measure it. That something should be your vision."

Let me try a different tack and ask this: what is this photograph about? "Well, it's about two kids at the playground," you say. "Anyone can see that." But it's not. Not really. It's a photograph of those children. The children are the characters in the plot, and the playground is the setting. But what's it a photograph *about*? So I press harder. You get a little irritated and consider taking a photograph about being annoyed. Fair enough. But I'm not being pedantic. What's it about? You could have shot any image, but you created this one. Could have chosen any moment. But you chose this one. Why? You shrug, look around to see how close the exit is. "I don't know," you mutter. "I liked the way they were playing. I liked the laughter." Yes! That's it! Play. Laughter. That's the core. That's what the image is about.

Forget the notion that a picture is worth a thousand words. For a moment, humor me. What if you were allowed only one word? One thought. One emotion. One theme. What if a photograph, as a piece of visual communication, could only communicate one thing, if it contained only enough information and impact to powerfully express one thing alone? Go with it for a moment. I know, we all like to think our images are full of subtle details and nuance, visual surprises, the odd visual joke. Maybe. But most of our images, if they are stories at all, are not novels; they're not even short films. They're one-liners. One verb. A couple nouns. A few select adjectives or adverbs. And the word "the" or "and." That's it. What if that were the case?

We'd have to make it the best one-liner we could. And to do that you'd have to be pretty sure of that one nugget—the core of the image—that one thought, one word, one emotion that describes what the image is about. And if you did that— and it might take a little time—you'd have the core from which to work your visual magic in the digital darkroom. Far from spastically throwing around the sliders and hoping to make the image "look better," you'd have a start on what it means for the image to look better. The word "better" means nothing without something against which to measure it. That something should be your vision.

The how-to books will tell you to give the image more contrast. Maybe. Pretend it's the rough cut of a movie. The director asks you how you would improve it. You've always liked *Die Hard* movies, so a car chase seems an obvious addition. Car chases make any movie better, don't they? Sure. Unless it's a period piece set in the Middle Ages. Add a fight scene! It's a love story. Add a sex

scene! It's not that kind of movie. Add aliens! See the problem? We're looking for directions without first knowing our destination.

Back to our image. Want to make it better? Add contrast! Boost saturation! Just push some sliders, any sliders! Don't just sit there, for the love of all that's good; stop with the Zen stuff and give me a graduated filter!

Whoa.

Slow down.

It's time to take that breath again.

When we discover the core thought or emotion that drives our image, we discover the beginnings of the route we might take to most compellingly express that thought or emotion. An image about play might well benefit from saturated colors. An image about peace and serenity might benefit from the exact opposite—from a color treatment that's less saturated, from less contrast. There is no universal "make it look better" formula.

# Vision & Style

SPEND MUCH TIME in the world of Photoshop, Lightroom, or any other digital darkroom, and inevitably you'll bang your head into the issue of style. One moment you're happily looking for and refining your vision, and the next you're racked with self-doubt. Why? Because someone will ask you what your style is. Or they'll speak in hushed tones about so-and-so's style, usually calling it the insert-name-here effect. Worse, they'll be furiously trying to copy it, stalking the creator on discussion forums, hoping he'll let his guard down and his secret slip. Heated discussions take place. Demands for tutorials and workshops. Wars have been fought for less.

---

▶ Canon 5D, 70mm, 1/1600 @ f/2.8, ISO 800

Pashupatinath, Kathmandu, Nepal, 2009. I spent a while with this man while shooting for *Within the Frame*. He lost his right foot to leprosy.

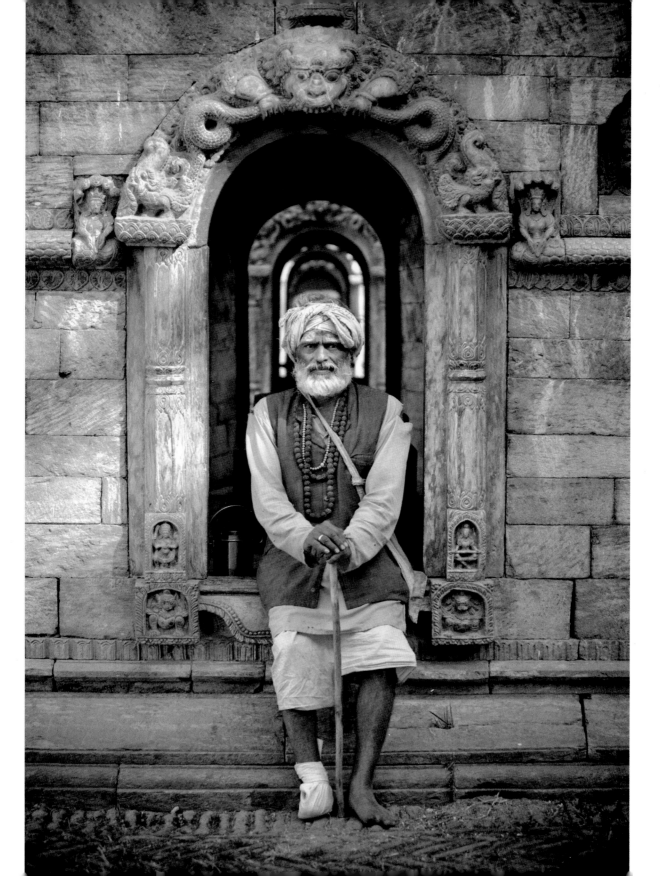

> "Your vision wants its own voice, not someone else's."

And while all this is happening, two other events have slipped quietly by unnoticed. First, the originator of this magical effect has moved on, conscious that in a field of imitators that particular voice no longer uniquely expresses his vision, and by the time the masses get it figured out it's passé. Done. So last year. The other thing that's happened is our vision is sitting in a corner weeping, and dying inside just a little. Your vision wants its own voice, not someone else's.

## Adapt vs. Adopt

Each time someone comes up with a killer new technique, the masses rush to copy it. They adopt it wholesale and use it as an un-suck filter for images that just don't quite work—but wave the magic-wand-of-the-day over it and *poof*! It looks awesome. Or does it? Maybe it just looks novel. New. Man, we love the novel and new. The problem is, new gets old fast. And expressing *your* vision with an idiom someone else worked hard to create in order to express *their* vision is usually rife with problems. Ansel Adams said there was nothing worse than a sharp image of a fuzzy concept, but that hasn't stopped us from trying.

However, you'd be right in saying every technique out there is derivative. No question about it. One influences another, which in turn gives birth to another. While I am a harsh opponent of adopting another person's idiom to rescue your own lack of vision or mastery of technique, I am a huge fan of adapting new techniques and styles to more fully express your own. Artists through the generations have reacted to one another, derived techniques from one another, and a visible evolution is often clear. The true geniuses appear to have a vision so unique it requires techniques that seem to develop without that evolution of technique, but I suspect they just make bigger jumps. Picasso is a long way from Monet, but he still used paints and brushes.

It all comes back to the intentional pursuit of your vision and the best means to express it, your voice. The next time a new trend flies past you, remember you can't rescue a poorly conceived image with a new, shiny, flavor-o'-the-day technique. Adopting someone else's style is a good way to ensure your work is just more noise in a sea of imitations. But adapting that style, combining it—or parts of it—with your own to take your skills that much closer to being able to truly express your own unique vision—that's the way artists have done it for years. By all means learn the technique, play with it, see if there is something in

it that can be adapted to your visual toolbox. It's a great way to learn, but applying the voice of another to your vision is a fast route to creative stagnation, if not outright regression. Imitation is a form of flattery, not artistic growth. Maturing as an artist means you no longer adopt—you adapt.

# Horses and Carts

We value style, forms of expression so unique to shooters that you can identify their work immediately. Show me a Jill Greenberg photograph or an Annie Leibovitz cover, and their name comes to mind without a conscious thought, much less looking for the photo credit. So valued is the notion of style that it won't be long before someone writes a *Dummies* book about it and cashes in on our hunger for it. But like anything we value, we value it for its scarcity or the difficulty in attaining it. If it's so easily achieved that it could be found between the covers of a book, it's not nearly as valuable as we thought.

Style is a by-product. It is the end and not the means, and there are no shortcuts. Truly authentic style is not something you can conjure or fabricate. It's a result of shooting thousands of images that express your unique thoughts, feelings, and opinions with increasing faithfulness. It's something that comes as you refine the means by which you express your vision.

There's nothing wrong with seeking to do things in a unique form, but seeking to be different for the sake of being different won't give you images that are personal; you'll just have photographs that are merely different. You yourself are unique—you have ways of seeing your world that are unlike those of anyone else—so find ways to more faithfully express that, and your style will emerge.

Of course, there's room to be intentional about refining the expression of your vision. The more you study and understand the visual language tools available to the photographic storyteller, the more consciously you can choose one set of tools over another. The danger lies in thinking that one set of tools, chosen for stylistic reasons, will always be the best choice of tools for every image. Selecting tools based only on stylistic criteria can result in highly stylized images that say precisely nothing about you or the world you are photographing. Work on refining your vision and your voice, and the style will take care of itself.

"Style is a by-product. It is the end and not the means, and there are no shortcuts."

# A Vision-Driven Workflow

THERE'S A SCENE in the movie *Planes, Trains & Automobiles* where John Candy and Steve Martin accidentally drive down the highway heading the wrong way, against traffic. Oncoming traffic swerves out of the way. Other drivers yell at them, "You're going the wrong way! You're going the wrong way!" Candy's character shrugs it off. "How do they know where we're going?"

Indeed.

▶ Canon 5D, 17mm, 1/60 @ f/22, ISO 200
Giza, Egypt, 2009.

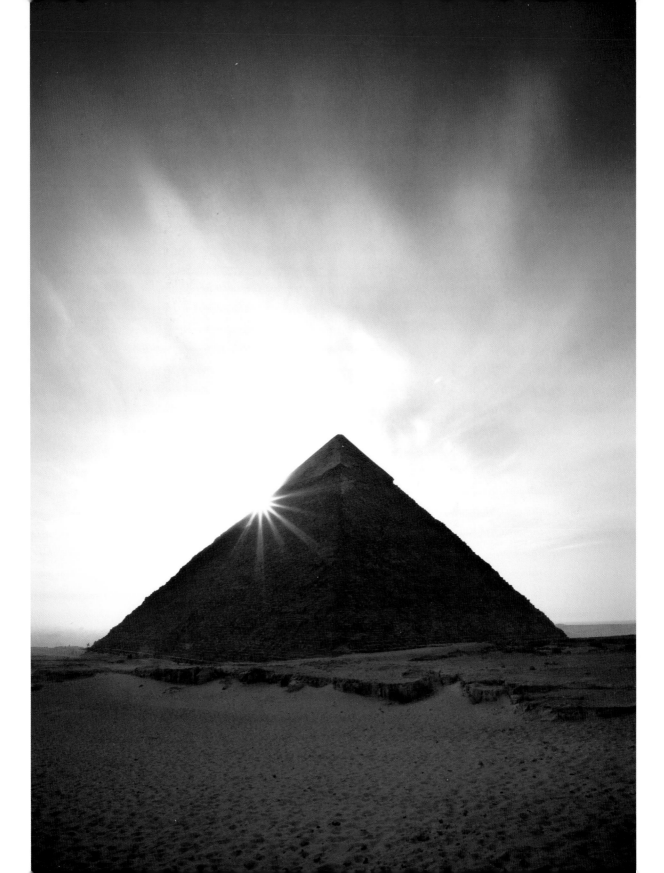

> "Calling this whole thing a vision-driven workflow (VDW) makes it sound like a system or a program. It isn't."

Many of the books out there that teach digital processing allow you to learn some skills you can use to address the question "How do I make my image look better?" But this is essentially an act of putting the proverbial cart before the horse. Until you define what it means for the image to "look better," you have only learned how to read a map without having learned how to choose a destination. You're driving toward, well, who knows? And if you don't know where you're driving, how do you know whether turning left or right is the correct decision? I don't at all mean to imply that those other books aren't needed—they are. In fact, the more technique you pull from those books, the more you can pull from this one. This is a contribution to a larger discussion, but I think an important one—or one that's been conspicuously absent.

Enter a workflow that is determined by your destination, driven by your vision.

## What Is a Vision-Driven Workflow?

First, a caveat. Calling this whole thing a vision-driven workflow (VDW) makes it sound like a system or a program. It isn't. It's just the handle I've put onto what is essentially a holistic approach to image creation. Second, it encompasses the whole process, from conception to capture to development to output, but this book covers only development. When I speak of workflow here, I'm referring only to the steps of refining an image in Lightroom's Develop module, not the broader sense of the word that includes importing images, backing them up, rating them, and so on.

I used to spend hours in the darkroom. Mr. Harris, my high school photography teacher, knew full well that I was taking his class only for the free darkroom access it gave me. I would spend hours in that room, playing, waiting for images to appear in the red light. Smelling the chemicals, listening to the tick and buzz of the timer, completely unconscious of the hours slipping away. Ruining hundreds of pieces of otherwise perfectly good Ilford paper as I learned my craft. And craft it was. I miss those days. Spend hours now in front of a Wacom tablet and a cinema display and you're more likely to be accused of geekery, not craftsmanship. I don't mind telling you that really chafes me. But there could be a reason for this. Could it be we've developed a reputation for doing things because we can—because the technology allows us to—rather than because our vision demands it?

It's time our geekery became craft, and we do that by assigning it its rightful place—in service of our vision. So let's get to it. Let's consider the foundation laid. I'll stop bellowing into the microphone, take down the revivalist tent, and stop looking for converts. But just to make sure we're more or less on the same page as our starting point, I'll say the following.

A vision-driven workflow is a process of creating images, specifically in the digital darkroom, that begins at the point of conception and ends upon output of the image. VDW is guided by the intent of the photographer, and it is the means by which we bring the image conceived, the image captured, and the image developed into one photograph. More simply, VDW is a series of decisions about the aesthetics of an image that are made based on 1) your vision, or intention, for that image, and 2) your voice, the tools at your disposal.

Of course we know that the realms of craft and art are messy, full of ambiguities, failed experiments, and works in progress. Sometimes the camera imperfectly captures what the eye sees; that may be a failure or limitation of the technology, or it may be a failure or limitation of the one who wields it. As you grow in your craft, if you need to occasionally use more paint to cover a flaw in the canvas, then do so. You'll learn more about your own process, and your ability to capture better images will grow as you become tired of repeatedly fixing problems you might have avoided in the first place with a more intentional capture.

I'm pretty sure that digital photography hasn't been around long enough for the so-called purists to be speaking with much authority yet. So go ahead, play and experiment. What's the worst that can happen? You mess up a digital file; it's a canvas that's easily wiped cleaned and you can start over again.

# What Are the Principles of a Vision-Driven Workflow?

VDW is the continuation of the creation of an image that began when you thought, "Aha!" and captured a moment. It is the acknowledgment that your vision for this photograph informs the tools you use to refine it in the digital darkroom. Your vision determines your voice. But how well you use your voice determines how well you can express that vision. VDW is a process that begins not with the question "How do I make my image look better?" but with the following groups of questions as guides.

> "Every aesthetic change within the image will change the way the image is read and experienced."

## Intention

What do I want my image to communicate? What is this image about? What mood, thought, or emotion do I want my image to carry? Intention is where you begin with the image, and it's the place from which you decide where you are going with the image (aesthetics) and how you are getting there (process). Intention is your vision for this image made conscious.

## Aesthetics

What does that mood or emotion look like? What does my image need to look like in order to communicate that mood, thought, or emotion? What do I want my viewers to look at, to see? What am I pointing at with this image? I don't mean this pedantically or in broad strokes; I mean it very specifically. Really, what do you want them to look at? Write it down if you have to. Draw circles and arrows on the image if that works for you. Moving from your intention to its expression through the aesthetics of the photograph is an act of interpretation and is by no means a simple process. Between the act of seeing and the act of expressing that vision is a world of your own unique preferences and the growing expertise required to communicate that vision to others in an understandable way. It's a topic for a book of its own, but here's what's important. Every aesthetic change within the image will change the way the image is read and experienced in much the same way as changing words and sentences in a novel will change the sense of it. Be conscious that you are playing with elements of visual language and communication. This is no trivial thing if you're hoping to create images that resonate with others. But it must first resonate with you.

## Process

What digital darkroom tools are at my disposal? Which processes (sliders, curves, global and local adjustments) can best make my image look the way I want it to?

VDW is an intentional and somewhat introspective process. It is not a magic wand. You must keep in mind that the digital darkroom is not a set of tools for fixing a photograph that was poorly imagined or created in the first place. It is, in a perfect world, a smooth transition from seeing, to capturing, and finally to refining. From eye, heart, and mind to the camera and through the digital darkroom to the print.

Remember, this is not a canonical process. This craft, digital photography, is too young to have things set in anything but wet cement. What matters is that you pursue a process that works best for you. Here's how I approach it.

## Identify Intention

I begin with a conscious understanding of what drew my eye and my attention at the moment of capture. You should know what your image is about, how you feel about it—and, therefore, how you want others to feel about it—and where you want to direct the eyes of the reader. You should know this before you touch a single slider, and I mean "you should" in the sense that this is something you should on some level already have understood at the moment you pressed the shutter. How, without knowing this already, will you have made decisions about your optics, your point of view, your aperture, your shutter? When you get to the darkroom you're already well into the process; the tracks have been laid and your work is one of refinement. Now is not the time to question your intention; it's the time to recognize the intention you've already burned into the RAW file, and to make decisions about how to best reveal that intention, how to interpret it and present it to your audience. It's not easy, and sometimes we create images so instinctively and subconsciously that uncovering our own intention is difficult, but it's something we need to be in touch with on some level before we can hope to communicate it.

As we discuss this process, it might be helpful to walk and talk at the same time, so to speak. I shot the image we'll use for this example (on the following pages) in Kathmandu in January 2009; it appeared in *Within the Frame* and is still one of my favorite photographs. Several things drew my eye and moved me in this image, and it's those things I want to draw out as I develop this shot. The first was the gesture of the image: the gaze of the girl toward the butter lamp. The second was the color depth of this image: the warm yellows leaping out of the surrounding darkness, and the bluish background.

It's important to remember that I'm presenting a simple example here. It's not meant to walk you through how I do things but to familiarize you with my process—and that's more about thinking, not how many tools you use to get the job done. Less is usually better. The zeroed image is at the top left on page 25.

> "In my own mind it seems that the global adjustments made to an image affect the mood of the image, whereas the local adjustments, which I deal with last, are about where the eye is drawn and in what order."

## Minimize Distractions

I look for and fix any weaknesses present in the image: dust spots, misaligned horizons, and other issues that distract. I fix them from the beginning so I'm not distracted from the look and feel of the image as I develop it. Of course, the great benefit of doing all this work in Adobe Photoshop Lightroom is that the nondestructive nature of the fixes means I can undo them or tweak them later. If a change or refinement in the crop is obviously needed at the beginning, I do it here as well, knowing I can undo or redo it later. My goal at this point is not refinement but the removal of elements that will distract me from the process— a dust spot in the sky will continue to pull my eye and frustrate me if I don't deal with it first. Few of us do our best creative work when we're distracted or frustrated.

The flaws in this image, aside from a little noise that has never bothered me, are few. What I want to do is crop the image to bring the girl to the right of center and make the diagonal gaze of her eye to the candle more prominent. So I've cropped this as my first adjustment in order to bring balance to the frame (opposite page, top right).

## Maximize Mood

Once I've gotten in touch with the intention of the image and fixed the obvious weaknesses, I turn my attention to the biggest possible adjustments. In my own mind it seems that the global adjustments made to an image affect the mood of the image, whereas the local adjustments, which I deal with last, are about where the eye is drawn and in what order. So I refine the mood or feel of the image first. Color temperature (how warm or cool the image is), exposure (how dark or light it is), and whether the image is presented in bright saturated colors or in cool-toned black and white—these are all decisions made at this point.

In the case of "Prayers at Boudhanath," the first thing I did was make the blacks black by pushing the Blacks slider to 10. That darkened the background, which I further pulled in with a vignette (Amount: 100, Midpoint: 50). Finally, I pushed the Brightness slider to +40 to bring back the glow and warmth of the candles, and set the Clarity value to +30 to pop the details a little (opposite page, bottom left).

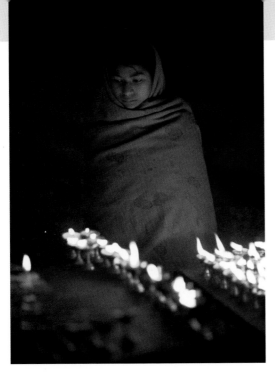

Zeroed image.

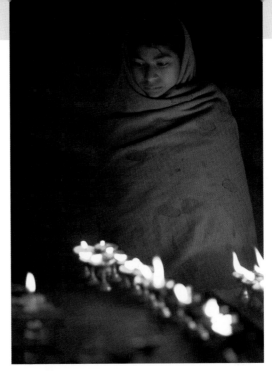

Minimize distractions.

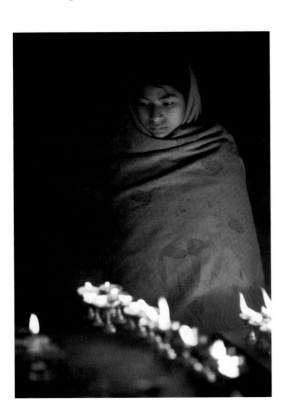

Maximize mood.

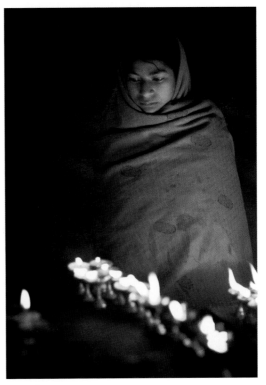

Draw the eye.

## Draw the Eye

Finally, I turn my attention from the macro to the micro. By this point I have an image that feels the way I want it to feel. Moving from global to local gives me a process that my brain can work with—a continued refining that gets closer and closer to the intention I identified at the beginning. Here is where I make the small tweaks that draw the eye to one area with greater pull in order to say, "Look at this," or to draw the eye away from certain areas by downplaying them in order to give other areas greater pull. If it's a portrait, I will often dodge (lighten) the eyes a little, or burn (darken) peripheral areas with the Adjustment Brush and a little negative Exposure and Brightness. If it's a landscape where I want the eye to follow a particular path through the image, I might do the same. I'll delve more into this topic in the next chapter, but for now just know that brightness pulls the eye and darkness pushes it. Saturation pulls, desaturation pushes away. Sharpness pulls, less sharpness pushes. Being familiar with these principles and using them allows the photographer to manage the attention of the viewer.

Returning to our image, I did two final things. I pulled a Graduated Filter with a –1 Exposure setting up from the bottom (to pull back the exposure on the table and lamps themselves) and in from the left side (to darken the shadows where a vignette couldn't really reach). Then I used the Adjustment Brush with a little bump in the Exposure and the Brightness to add some spark to the girl's face (previous page, bottom right).

## Prepare for Output

I then size and sharpen my image. I leave this process for last and it's done specifically for the image's final output. A large print on one medium requires different sharpening than a small image being uploaded to a website. Output-specific sharpening is a subject well covered in other books and videos. For now, just understand the sharpening process is dependent on your output and is a task best left to last. I sharpen my prints in Photoshop because it allows me to sharpen the image on a duplicated layer so that, using a layer mask, I can paint away areas of sharpness. Sharpness draws the eye and since I don't want the eye drawn with the same strength of pull to all areas, I prefer to do it a) in Photoshop; b) selectively; c) last; and d) based on my output. For those reasons, we won't be talking about sharpness much.

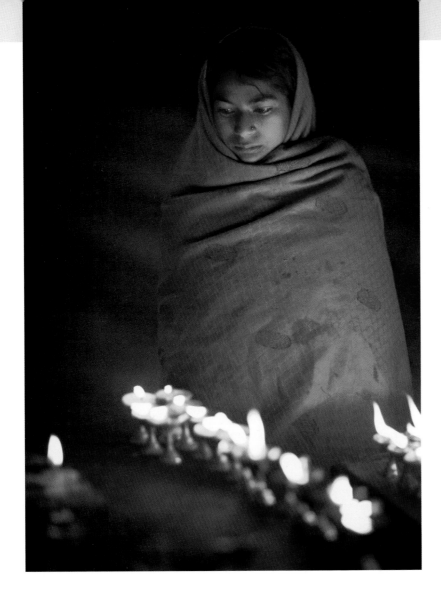

◀ Canon 5D, 85mm,
1/125 @ f/1.2, ISO 400

Boudhanath, Kathmandu,
Nepal, 2009.

What's important to remember about this process—particularly the way I
describe it here—is that a) I knew what I wanted the image to feel like and what
I wanted the viewer to look at before I started, and b) it's not always that simple.
This is an organic process—for some of us much more than others. What I've
described here makes it sound like I know the numbers going into it, but I don't.
I push the sliders I think will give me the aesthetic I want, I see what it looks like,
then I pull them back, undo them, try something else. Intention, as far as the end
result, is important, but so is remaining open to surprises and doing this work
with a light touch and an open mind.

# Voice Training

WHY "VOICE"? I use the word *voice* because it's a word that describes communication and expression, but implicit in that is also a sense of uniqueness. Writers use the word to describe their own unique style of writing, and it fits equally well here. After all, writing isn't vocal expression any more than photography is. Photography is graphic—using symbols and conventions of language instead of verbal words—but the word voice still works. So I use the word metaphorically to describe the means by which we translate our vision—which is an invisible, internal thing—into the outer, visible thing: the print. Voice is that bridge. It's more than our tools; it's how and why we choose to wield those tools.

▶ Canon 5D, 40mm, 1/80 @ f/4, ISO 400

Cairo, Egypt. 2009. I found this image deep in the alleys of Old Cairo. I have a thing for doors and windows; this one seemed too good to be true.

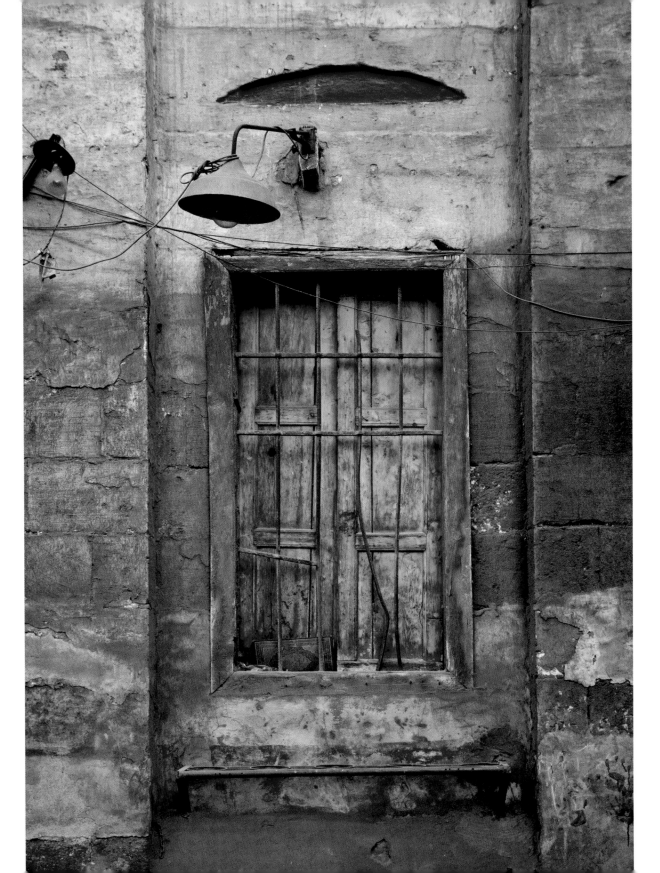

# The Craft of Voice

There is no substitute for learning your craft and paying your dues. You can play and experiment; there is great value in doing that. It's important, even necessary. But all the playing in the world won't necessarily make you good at what you do; it only makes you really well practiced. I don't mean to be iconoclastic here, but practice doesn't make perfect; it merely makes permanent. Practice is repetition, and if you repeat the same mistakes over and over you'll simply be very good at making mistakes. Along the way you might learn a thing or two. The rare person will have an epiphany and be hailed as a genius. But for most of us, practice just makes us good at doing something poorly. If perfection is your goal—and I'm not sure it should be—then it's practicing perfection that makes perfect.

So what role does this notion have in the arts, which are an essentially subjective thing? Who am I to tell you what's right or wrong? Indeed. Perhaps we need to abandon the notion that there's a right way and a wrong way. For many of us, that kind of talk just makes us go rogue. Tell me not to run with scissors and I'll start lacing up my runners and rummaging through the cutlery drawer. So look at it this way instead: craft matters. It's in the accumulated wisdom of others that we find our starting points. It's allowing the mistakes of other craftsmen, the masters who have gone before us, to allow us a starting point just beyond the mistakes they've made. It's in learning the so-called rules so we, who fancy ourselves above them, know which ones to break. It's standing on shoulders to see further.

So before we continue, here's yet another of the caveats I'm so fond of: these are only suggestions and bits of wisdom; there isn't a "rule" in this book that can't be broken. Break them all, see what happens, play, find your voice outside the norms and conventions. But don't ignore them. Learn from them, allow them to inform which rules you break and why. Artists have long been renegades, but few of them are total anarchists to their art.

> "There is no substitute for learning your craft and paying your dues."

# Make Your Blacks Black

When I started learning my way around a darkroom, my teacher offered me this piece of wisdom, and it's been a guide ever since: make your blacks black, and make your whites white. Simple, right? But that advice opened my eyes. Prints I'd been happily cranking out by the dozen suddenly looked different to me.

Murky. Flat. Lifeless. It was a huge step forward for me; it gave me a handle to understand why my voice and my vision weren't working in unison. My vision generally isn't a murky, muddy, low-contrast one; my voice couldn't be either. My prints improved. And then that improvement started showing weaknesses in my exposure that I hadn't seen before, and that changed, too. I studied Ansel Adams's Zone System and learned to use my meter—not just follow it blindly. It wasn't a minor tweak to what I did; it was a total overhaul. Those days are behind me, but the lessons I learned stuck with me. As a starting point, blacks should be black. Whites should be white. Craft matters.

I'm going to start this whole thing where I myself was started, by making the blacks black and the whites white. We'll do this in the lessons that form the bulk of this book, but in broad strokes following this advice means paying attention to your histogram both as you shoot and as you develop. It affects your contrast, it affects white balance, and therefore it affects the feeling or mood your image exudes. Want your image to feel murky? I can help you with that. Want your image to feel bright and vibrant? I can help with that, too.

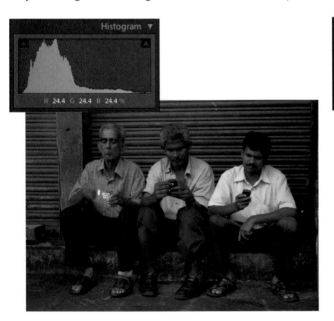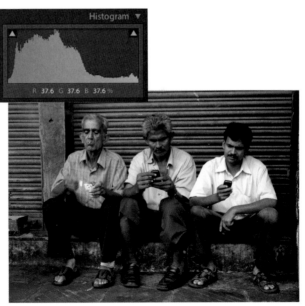

▲ Canon 5D Mark II, 28mm, 1/125 @ f/4, ISO 160

Old Delhi, India, 2009. In this case, retrieving my blacks and whites meant using a couple of techniques. Notably, I pushed my Blacks slider (to retrieve the blacks) and my Exposure slider (to retrieve the whites) and then used the Tone Curve to steepen the values even more. I will do other things to further refine this image, but this is where I begin.

# Histograms

For some people the histogram is extremely helpful, but for others it is so confusing that it becomes completely useless to them. Before you write the histogram off completely, let me take a crack at convincing you that you should not ignore it and that it can, in fact, be your best friend. It's just misunderstood, and it's nowhere near as complicated as it looks.

The histogram, both on your camera and in Lightroom, is just a graph. It's a visual representation of the tones present in the scene you've turned into a digital file. On the left side are the darkest bits, and on the right, the lightest. Can't remember that? Try thinking "black and white": black is first, on the left, and white is second, on the right. Looking at the histogram shown here, you'll see peaks and valleys. Don't worry about them for now. You can't do a thing about them at capture. Is one of the peaks spiking right through the graph? No problem. Let it go—you need to relax. All the histogram (in this case, a grayscale histogram) can do is say, "In black and white tones, here is what your scene looks like." There's a huge spike in middle gray—so what? That's your scene, and in this case, you obviously have significant elements in the scene that are middle gray. Unless you're in a studio, there's not much you can do to change the scene. A peak at one tonal value, or group of tonal values, simply means you've got lots of that tone in the scene; a valley means fewer. What does matter is where, from left to right, all these various peaks and valleys sit on the graph; this you can control, and must. Here's why.

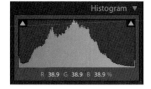

Assuming you want to take your image into the digital darkroom, the best digital negative is the one with the most digital information—and the only way you can know this is to look at it. And the only way to look at the digital information is the histogram. Looking at a histogram, most of us would assume that the digital information—the raw data—is evenly spread across the graph, that on the left half of the graph sits a possible 50 percent of the data and on the right half a corresponding possible 50 percent. Makes sense, right? Wrong. There's some kind of funky math going on here that I don't understand, but the right side of the histogram is capable of storing exponentially more data than the left side. If your sensor can record around 4,000 levels of data, 3,500 of those are represented by the right half of the grid and the remaining 500 are on the left. That's a huge difference.

"The right side of the histogram is capable of storing exponentially more data than the left side."

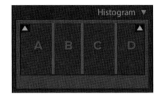 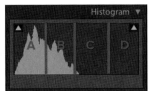 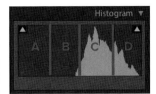

I've divided the same histogram into four quadrants and pulled out the data for now (above, left). All we have is an empty bucket, so to speak. But the bucket's a little wonky. Working backward, quadrant **D** can hold about 80 percent of the total data in an image, quadrant **C** can hold about 10 percent, quadrant **B** can hold about 7 percent, and quadrant **A** can hold about 3 percent. Again, this is a simplification, but I'm trying to establish this: if you capture your scene and it looks like the histogram in the middle image above, you'll have robbed yourself of nearly 90 percent of the possible data, and your digital negative will be much thinner and less capable of withstanding manipulation than one that looks like the histogram next to it on the right. Why? Because there is more data in the quadrants where the second scene sits.

That one stop of underexposure is half the amount of light getting into the camera—that's a lot of missing information that is no longer available to contribute to the aesthetics of your image. This isn't just stuff to amuse the geeks and the math nerds. I care about it because it has a huge impact on how much I can play with my digital negative before it falls apart. The more elasticity my digital negative has, the greater the chance that I can make a gorgeous print that expresses my vision. Noise and posterization don't generally play a starring role in my vision, so it falls to me to ensure I get the most information to work with.

How does this translate to actual shooting and development? I'll discuss the histogram in the Develop module in the next chapter, but it plays a key role in evaluating your exposures when you shoot. First, understand that the histogram on the LCD of your camera is taken from a JPEG representation of your image, so it's not 100 percent accurate. If it looks like you've accidentally blown your highlights a little, you probably haven't. Same with the shadows. But don't get

"The more elasticity my digital negative has, the greater the chance that I can make a gorgeous print that expresses my vision."

sloppy. In general, the rule (to which there are always exceptions) is this: expose to the right. I don't use the preview image on my LCD to evaluate my exposure; I use the histogram for that. And because I want my image to have the most amount of digital data, and since the most amount of data is stored on the right, I push my exposure until it creeps up toward the far-right side of the graph. This means that the exposure I make in-camera is frequently quite a bit brighter on the back-of-camera LCD than the final image will be after I've developed it in Lightroom. At this stage, I'm after a digital negative with the highest amount of data, not one that looks just right. I'll tweak that later.

There are two common exceptions. If I'm shooting a scene with the sun in it—or other bright specular highlights—then the histogram will spike heavily on the right, and I'll rely on the LCD's "blinkies" to show me *which* highlights are out of range. If it's the sun and the specular highlights but nothing where I want actual details, then I'm good. The second is if the image I'm shooting is of such a broad dynamic range—in other words, the highlights are so bright and the shadows so dark that my sensor can't capture it all in one exposure—then I have to make a choice about which end of the data I'm going to clip. Do I clip the highlights or plunge the shadows? In that case, it's all a matter of priority. I tend to place the bulk of the midtones more heavily to the right than to the left; it's those midtones that most likely constitute the important part of the image—and I still want as much wiggle room as possible. Keep an eye on the blinkies; when you lose a little too much, back off. That's when you should start to consider multiple exposures or bringing some light into the scene with strobes.

Don't let the histogram scare you off. It's pretty simple stuff. Try this. Take the previous information and pick up your camera. Shoot an average, flat-lit scene at what appears to be a proper exposure. See how the bulk of that scene just kind of sits in the middle of the histogram? Now overexpose the image by two stops. See how the whole scene has now shifted to the right on the graph? Now go the other way and underexpose it by two stops, and you'll see the whole thing shift again, past the center and toward the left. Now, in this average scene, what's the best exposure for the RAW file? The exposure that gives you a file with the most information. And to do that, you have to push that scene closer to the right because that's where the most information is. But if you push it too far—off the right side of the graph—you're losing data again.

# Give and Take

One of the fundamental laws of physics is that for every action there is an equal and opposite reaction. For every push there's a pull. And that's about as much physics knowledge as I can impart to you. But it applies, so bear with me. Lightroom processing is nondestructive. Every change you make to your image is simply another instruction to the computer that says, "Show it to me this way." Unlike Photoshop, Lightroom will not allow destructive editing. But that doesn't mean you can't create some horrible-looking images. Eventually these instructions are applied to the image when you export it, and those pixels have only so much room to move around before you bust them up. There is only so much information in even the deepest, largest digital file, and you can push them around only so much.

Because this isn't a technical book, I'm going to address this concept in the broadest of strokes. What it means for most of us is this: When we blow out our highlights, we've got very little room to pull details out of the brightest spots. They've simply been burned off the negative. The same is true of the shadows. If you dramatically underexpose your image, you have exponentially less information in the resulting negative than would be there if you'd exposed the image well. Any efforts to bring those details back will go only so far before introducing another problem—digital noise. Push your Saturation slider too far and you'll find the limits of your information as the blue sky begins to posterize. For every push there is a pull, and that pull will eventually result in aesthetic changes to your image. For all the magic under the hood in a program like Lightroom, and for all the incredible flexibility of the RAW file, we still have limited pixel depth and limited dynamic ranges to deal with.

The goal of all craft is to work within the constraints of the medium while still allowing our vision to find its best expression. That means knowing where those constraints are and working within them. It means knowing how far, and at what point, you should be sharpening your images. It means knowing a little about chromatic aberrations and lens vignetting and all kinds of other constraints our technology forces upon us. And to some degree, that's where you'll reach the limits of this book's purpose. You can find some excellent books out there by educators like Martin Evening, Katrin Eismann, Sean Duggan, and Scott Kelby, who write about the technical side of things with great clarity and authority. They are the people to whom I go for help wading through these waters. What

> "The goal of all craft is to work within the constraints of the medium while still allowing our vision to find its best expression."

is relevant to this book is that you know that your tools have limits. These limits force you to be intentional about creating the best digital negative possible, and to consider the push and pull that will be required at the development stage while you are still at the capture stage.

# Shooting RAW

You should be shooting RAW. It's conceivable that people have plenty of reasons not to do so, but if you are assuming a degree of postcapture development, and I assume you are or you'd be reading *Twenty Ways to Rescue Crappy JPEG Files* instead of this book, then you should be shooting RAW. If you have no intention of postprocessing your files much, or are happy to let the camera make these decisions for you, then by all means shoot in JPEG.

RAW is an unprocessed digital negative. Unlike JPEG files, a RAW file is uninterpreted and uncompressed. It is a bigger file because it's a deeper file. It contains more information. RAW files allow us a greater degree of push and pull in the digital darkroom before the image falls apart into unrecoverable noise, posterization, and ugliness. RAW allows you greater elasticity in your work, and it takes the interpretation of the image out of the hands of the camera and into yours. In the real world it looks like this: If you shoot JPEG and you overexpose an image, you have a maximum of half a stop of recovery before those highlights are irretrievably lost. Gone. When shooting RAW, you'll have closer to one-and-a-half or two stops of recoverable data. The same is true on the other end of the histogram. In a JPEG file, you've got very little information left in the darkest shadows, and any effort to pull detail out of them will give you ugly digital noise. Shooting RAW allows you much greater room to pull detail out of those shadows because there's more information in them and, therefore, less noise. It's not unlimited flexibility, but next to JPEG, RAW formats are the superheroes of file formats.

Like development, a certain amount of give and take is associated with shooting RAW. The gains are huge, but it costs something. For one, RAW files are big. Really big. You'll fill your memory cards and your hard drives much faster, and the processing power your computer needs will be greater. RAW steps up your game, for sure, but it makes some demands.

The other disadvantage is that, unlike JPEG, there is no single RAW format. Canon RAW files differ from model to model as CR2 or CRW files, and Nikon

RAW files are different still. Leica, Pentax, Olympus—all different RAW files. So you need to be up-to-date with the latest version of Lightroom in order to have the latest RAW engines that will interpret these files. It's not uncommon for a new camera to be released several months before Adobe can issue an update and Lightroom can do anything with those RAW files. And what happens in 20 years when you've switched from one brand to another, and the manufacturer no longer supports those ancient RAW formats from the year 2010?

Enter DNG. DNG stands for Digital Negative and is an open source Adobe format created in an effort to standardize RAW files and give them a nonproprietary longevity. The assumption is that this format will last much longer and, because it's open source, it's less reliant on the stability or decisions of the company that created it.

The advantages of DNG stretch beyond the hope of it being more future-proof than its Canon or Nikon equivalent. When changes are made to a RAW file, those changes are written into a separate XMP file—what they call a *sidecar* file. One file is the RAW file (CRW, NEF, etc.) and the other is the set of instructions that tells the software how to interpret that file. When you push the Exposure to +2 in Lightroom, that change takes place in the instructions file (XMP), not the RAW file itself. This is good, but it means two files instead of one. DNG consolidates them. The example often given is a file folder. DNG is a folder that holds both the RAW file and the instructions that allow Lightroom to process it. The other advantage of DNG is that, generally speaking, it is a smaller RAW file. There's no data loss, but assuming you don't choose to keep the original proprietary RAW file when you convert to DNG, it takes up less space on your drives.

Lightroom allows you to convert to DNG on import, and although this slows the import process, it's the way I choose to do it. In the Import dialog box, you are given the option to convert to DNG on import ("Copy photos as Digital Negative (DNG) and add to catalog"), and unless time is important to me, I generally choose this option. On shoots when I'm pressed for time, I import the RAW files; later, when the important work is done and I can just let Lightroom grind away overnight, I select all the images and choose Library > Convert Photos to DNG. When I'm on assignment, this is generally the last thing I do before going to bed.

Whether or not you opt to convert your images to DNG, you should seriously consider shooting RAW—and this book assumes you're doing so.

"RAW allows you greater elasticity in your work, and it takes the interpretation of the image out of the hands of the camera and into yours."

# Visual Literacy

Photography, even at its artsy-fartsiest, is an art of communication. Of course, the *really* artsy photographers will call it expression—and will probably do so while wearing a beret with a straight face—but it's six of one and half a dozen of the other, really. How clearly or articulately you express yourself or communicate through your images depends on how well you understand how your audience will read the image. Assume for a moment we're talking about verbal communication. If I give a speech without knowing who my audience is, how old they are, what their cultural references are, and what language they speak, then I'm undoubtedly speaking but I might not be communicating. The difference between speaking and communicating lies in how well we translate *what* we want to say through *how* we choose to say it. In the case of spoken words, that means, at the simplest level, knowing the language of our audience. Same with photography. All the way through the process of creating an image, we must be aware of how our audience will read an image.

The topic of visual literacy could fill a book. But not this one. Still, it's important we grasp the basics of how we generally read an image. In the West, we read a page from left to right, top to bottom. Bucking this convention isn't generally seen as creative or innovative. It's confusing. So, assuming you are looking to create images that express something to other people, let's explore a few of the basics related to how an eye reads an image.

"How clearly or articulately you express yourself or communicate through your images depends on how well you understand how your audience will read the image."

# Visual Mass, or Pull

The eye is drawn to some things—probably for some very good reasons that have developed over millennia—before it is drawn to others. This is the basis for the decisions we make within the frame. If an element is within the frame and is important, you need to draw attention to it. To do that, you need to know how. Inversely, unimportant elements within the frame are deemphasized using the same knowledge. At its most basic, this might be a matter of focus. If you create an image with an out-of-focus foreground and background, and with a mid-ground that is sharp, my eye will be drawn to the focused element and away from the elements that are not sharp. Focus can be used to draw my eye to one element, which in turn draws my attention away from others. You're telling a visual story, and in doing this you are saying to me, the viewer, "Look here." You're saying, "This is where the story is." By managing the attention of your

viewers, you guide them to the heart of the story and free them from the difficult task of wading through an ambiguous image and its distractions.

So what is the eye drawn to? Generally we are pulled to look at:

- Sharp elements before out-of-focus elements

- Human elements before nonhuman elements

- Faces before other elements—and on a face, the eye before anything else

- Warm colors over cool colors

- Bright colors over dark colors

- Areas of high contrast over areas of low contrast

- Recognizable elements before unrecognizable elements

- Oblique or diagonal lines before straight lines

- Large/dominant elements before smaller elements

- Isolated elements before cluttered elements

Few, if any, photographs contain only one of these sets, and then it's a question of which element the eye will be drawn to first. Will it be the large but cool element, or the warm but small element? What if it's two faces, and one of them has a smile that's brighter and more prominent than the other's eye? Usually it's the eye with the greatest pull, but is that the case here? It now becomes a question of visual and emotional mass, and this is considerably more complicated than our simple list of paired opposites. It's more like a dance, or a piece of music—there are areas of greater pull, and which one is which depends on the context.

The good news is that this is not secret knowledge; it's all visual. You can see the image and assess it based on your own reaction to it. Look at the image. Where does your eye gravitate? If one element has greater visual mass, it will pull your eye to it. Mass is not about size. It's about pull. A large item might have greater mass, but it might not. All things being equal, we are more powerfully drawn to things that matter to us, and for most of us a human face matters more than a big rock—so we look there first. Of course, at a certain point the rock will become so big, or the human face so out of focus, that the visual mass changes and something else draws us.

Take a look at a handful of your favorite photographs and become aware of the path your eye takes. Generally it will begin at one point and follow the same path around the image before returning to the starting point. That is the hierarchy of visual mass in your image. Look at the image of my friend Lori and her dog Parker. Most of us will first look at the eyes of the dog, then quickly move to Lori's face, then scan the image clockwise for more details in the red sweater, the jewelry, and then back to Parker again. Notice how your eye doesn't do much more than give passing notice to the background. It does this because it takes only a glimpse to perceive that the background holds nothing of interest. Had I shot this with greater depth of field, the visual mass of the background would increase significantly, competing with the foreground and pulling the eye differently. In fact, had Lori been looking at the camera instead of at Parker, it's most likely we'd be drawn to her eyes first instead of to Parker's.

Your eye will tell you naturally how the areas of pull, or mass, are distributed in your image. Now the point to all this: is this the way you *want* people to look at your image? If my eye goes to a bright triangle of light in the lower-right corner and kind of gets stuck there, is that where you want my eye to go? No? Then you need to do one of three things—exclude that white corner with a crop, diminish the pull of that white corner with a vignette, or provide me with an area of greater visual mass to pull my eye from that spot and put it where the story is. Make something else more interesting. Make a face brighter, warmer, or sharper. The best tool for creating the desired visual mass in an image is the camera, but that's not always possible.

In the photograph of the woman on the train to Delhi, India (page 42), several elements are vying for attention. The windows, the bars, the Hindi writing, the word *window*, and, of course, the woman herself. This is a heavy-handed example, but in the second treatment I've pulled in a vignette to darken the corners, and I used dark graduated filters with Clarity set to −100 from both top and bottom. I've also dodged in the woman's figure with the Adjustment Brush, and I added some warmth with the same Adjustment Brush by adding a little yellow. As I said, it's heavy-handed for the sake of illustration, but these few changes allow this image to draw the eye differently by assigning greater visual mass, or pull, to the woman, and less to the competing elements. They are still an important part of the image, but they're discovered secondarily. If I were developing the image for my own purposes, I would make these changes with greater subtlety.

▲ Canon 5D, 135mm, 1/2000 @ f/2, ISO 100

**North Vancouver, Canada, 2007.**

This, more than anything else in this book, is worth understanding before diving headlong into developing your images and manically pushing sliders around. This is the *why* of this book: understanding how to gently lead the eye through an image, to say to your viewer, "Look here," and to do them the courtesy of creating images that don't tire them out from the effort to discern important elements from unimportant ones.

## Mood

Naturally, there's more to it than that. Color psychology, for one thing. It's important to know how colors make people feel. Color establishes mood faster than any other element you can place into an image. We respond to it passively. You don't have to know how to read an image or do anything with your eyes to see red and instantly get a feeling from it. You can completely defocus your eyes, look at an image, and get a sense for the mood of it. The more consciously you work with this, the more powerfully, or subtly, you can communicate through your images. Of course, in a black-and-white image the impact of color is taken away; the power play falls to lines and tones. It's one of the reasons photographers choose to render their vision in black and white; it allows the eye to first fall on other elements. It changes the dynamics.

In the middle are the duotone images and other variations of split tones and tri-tones—essentially black-and-white images with a deliberately chosen mood created through color.

Mood is created in other ways, and with time you'll feel those intuitively. Visual mass, too, is more complex than what I've conveyed here. Among other things, it affects the balance of an image—and that's crucial in creating a great composition—but even balance relates to how we feel about a photograph. What's important is that we recognize the necessity of pulling the eye and creating a mood because these are two of the most powerful ways in which we hone the visual story we are telling.

This stuff isn't egghead theory. These things are basic elements of the visual language and form the beginnings of visual literacy. The more conscious you are of the way in which people react to images, the more intentionally you will be able to wield your tools—at both capture and in the digital darkroom—to express yourself.

"Color establishes mood faster than any other element you can place into an image."

◀ Canon 5D, 60mm, 1/15 @ f/2.8, ISO 800
Agra, India, 2007.

A simple color interpretation of a scene in Old Havana. The color is nice and it provides a little more information, but it also dilutes the mood of this image and pulls the eye in directions I consider less important, like the green clogs.

This is a pure black-and-white interpretation of the same scene. The lack of color information allows the eye to look at other details more carefully.

◀ Canon 5D, 17mm,
1/30 @ f/4, ISO 400

Old Havana, Cuba 2009.

A more traditional sepia tone of the scene. This has the same advantages of the black-and-white rendering but also adds a warmer mood. For many of us, it adds a more "vintage" feeling to the image because it reminds us of early 20th-century photographs.

A cooler duotone of the same scene that, like the sepia-toned image, adds temperature and mood—in this case, cooler and more contemporary—to the image.

# The Means of Expression

SO HERE WE ARE, six chapters in and only now getting around to discussing the software on which this book is based. Must be a record. Conceptually, this is the middle of the book. The last five chapters were about foundational, important stuff. If you skipped them to get to the pictures of sliders in hopes of discovering the secret of this book, go back and start at the beginning. It'll hurt less when I tell you there is, in fact, no secret. After you finish this chapter, you'll move on to 20 smaller chapters cunningly disguised as one big one, and it's the payoff for wading through the foundational stuff. But this one is about the tools themselves.

The individual tools at our disposal in Adobe Photoshop Lightroom are important because they affect the look of the image. On their own and in concert with others, these are the tools of expression, the postcapture means by which you give voice to your

▶ Canon 5D, 135mm, 1/250 @ f/2, ISO 800

Jodhpur, India, 2007. I wish I looked half as cool in a turban as this man did.

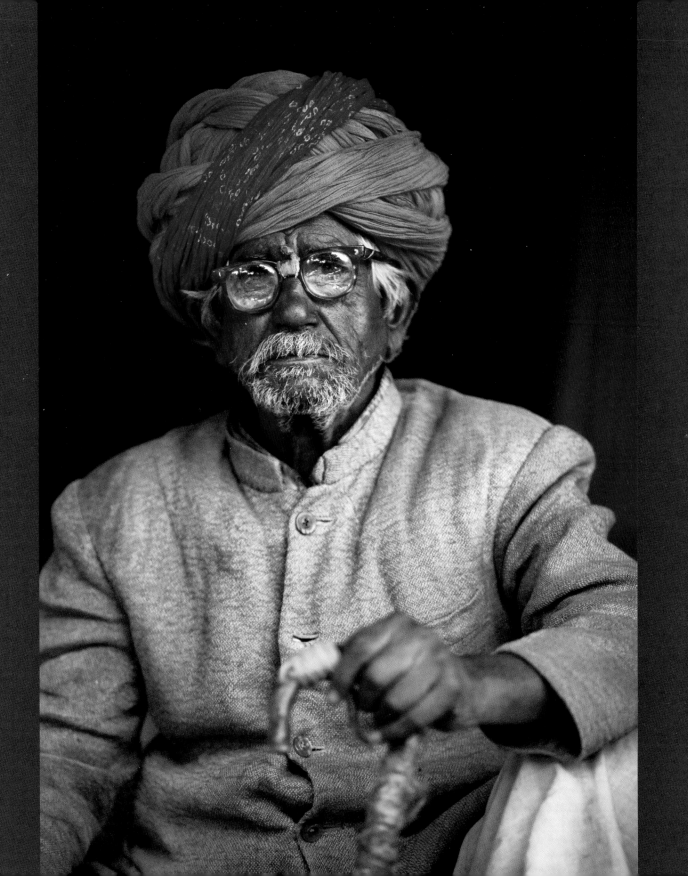

vision. Learning to make decisions about which tool you use—and how you use it—based on how you want your image to look—with *that* decision based on *why* you want it to look one way instead of another—will forever change the way you approach the digital darkroom.

Software will change over the years, but using changes in the aesthetic of a photograph to effect changes in the mood of the image and the voice of the photographer will always be important. Paints and brushes may change, but for the painter the need to carefully and intentionally blend his colors remains the same. It's not about the specific tools—the particular sliders or options available to you; it's about the effect they have on the look of the image, and how the photographer chooses to wield them.

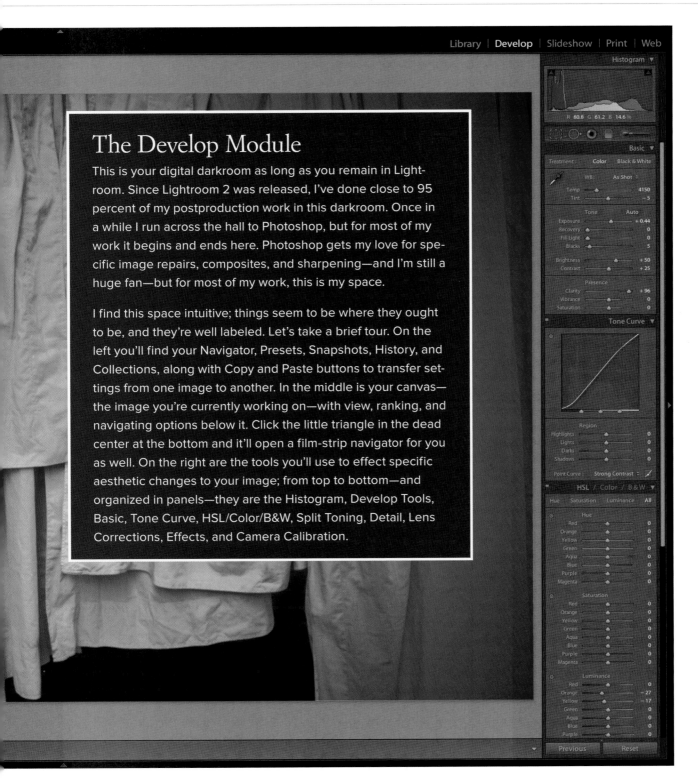

# The Develop Module

This is your digital darkroom as long as you remain in Lightroom. Since Lightroom 2 was released, I've done close to 95 percent of my postproduction work in this darkroom. Once in a while I run across the hall to Photoshop, but for most of my work it begins and ends here. Photoshop gets my love for specific image repairs, composites, and sharpening—and I'm still a huge fan—but for most of my work, this is my space.

I find this space intuitive; things seem to be where they ought to be, and they're well labeled. Let's take a brief tour. On the left you'll find your Navigator, Presets, Snapshots, History, and Collections, along with Copy and Paste buttons to transfer settings from one image to another. In the middle is your canvas—the image you're currently working on—with view, ranking, and navigating options below it. Click the little triangle in the dead center at the bottom and it'll open a film-strip navigator for you as well. On the right are the tools you'll use to effect specific aesthetic changes to your image; from top to bottom—and organized in panels—they are the Histogram, Develop Tools, Basic, Tone Curve, HSL/Color/B&W, Split Toning, Detail, Lens Corrections, Effects, and Camera Calibration.

Remember, this book is not a "How to Use Light-room" tutorial. As such, I'm going to opt out of discussing certain features in depth—and some entirely. My goal is that you'll leave this chapter (and it's a long one) with a feeling of familiarity with the tools and a basic understanding of how they affect the aesthetic of your images. You'll become comfortable with these tools not by reading my words here but through your own experimentation. Working through the images in the latter half of the book is a good place to begin that. If you're looking for a book that covers the in and outs of Light-room's tools, I suggest you pick up Scott Kelby's *The Adobe Photoshop Lightroom Book for Digital Photographers* (New Riders Press).

Take a moment to go through the panels and become familiar with them. We'll delve into details of the aesthetic effects of most of these tools next.

## The Tools of Expression

What we say and how we say it are intricately con-nected, and our ability to say things with greater accuracy, power, or subtlety depends on how well we know our tools. It is not enough to apply a stock preset or filter to an image—as we've been led to believe—if what we are after is a unique expression of our vision.

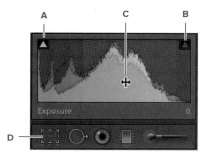

## Histogram

While working in Lightroom, my Histogram panel almost always remains open. You can toggle it on and off with Command-O (Mac) or Alt-O (PC), but I rarely hide it. It's just too helpful. The histogram provides constant visual feedback on the changes you are making within an image, telling you where the tonal values are and alerting you to blown high-lights or plunged shadows. At a glance, the histo-gram tells you what your digital negative looks like and warns you of any weaknesses in it. If it all sits too far to the left, for example, you know that your exposure isn't optimal and there's less data you can play with; in other words, your file has less elasticity and you need to be more cautious about pushing things too far.

Take a look at the Histogram panel above. At the top left is a little triangle (**A**), and a matching one on the right (**B**). These are clipping indicators, and they'll go white when the data begins to clip, as it has on the left (shadows) of this histogram. Clicking these triangles will show you a real-time preview

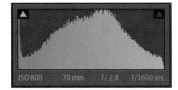

This is a histogram for a black and white image. The white triangle at the top left indicates that there are shadows with no details. Clicking this triangle will show those plunged shadows on your image in blue by default. Notice the highlights on the right are not clipped.

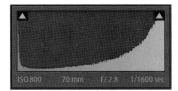

This is a histogram for a black and white image. In this case, both shadows and highlights are clipped. Depending on the image, this clipping may or may not be significant, but it's important to understand.

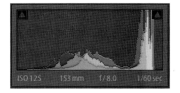

This is an RGB histogram for a color image, showing various color channels. Notice that neither the shadows nor the highlights in any channel are clipped and therefore retain detail.

of the clipped areas in your image. By default, Lightroom shows you clipped highlights in red and clipped shadows in blue. Although the histogram itself is extremely helpful, it's often more helpful to know exactly which highlights or shadows are clipped. Remember, not all clipping is bad. An image with the sun in it, for example, will always show a clipped highlight. Just looking at your histogram and trying to eliminate that clipping is wasted time. Looking at the clipping preview on the image itself will immediately tell you when you've eliminated clipping on all areas except the sun, and then let you move on.

Values on the histogram will move about as you use the sliders in the Basic panel, but you can also move them within the Histogram panel itself. Give it a try. Move your cursor over the histogram and you'll see it change to what's called a scrubby slider (**C**) in Photoshop-speak. Don't click anything just yet, but move the slider from side to side as

you hover over the histogram; see how the words change from Blacks to Fill Light to Exposure (shown) to Recovery as you move from left to right? These indicate the areas you'll be changing as you click and drag. Of course, these changes affect the whole of the histogram—remember there's always some give and take. A little push, a little pull.

Underneath the Histogram panel is the Develop Tools panel (**D**). I'm going to skip that one for now and address it at the end. The Develop Tools panel is a funny beast because I use some of the tools in this panel—like the Crop Overlay tool and the Spot Removal tool—at the beginning of the development process, and I use others—like the Graduated Filter and the Adjustment Brush—at the end.

# Basic

The Basic panel is where your basic global adjustments happen; what you change here is changed on an image-wide basis. If you change the white balance, it changes the white balance on the entire image. In the development process, you'll generally want to begin with the broadest strokes first. Start with the biggest changes first and work your way down to the bottom. This is why I leave any work with the Graduated Filter or Adjustment Brush until the end; they are local adjustments and any changes I make with them are determined by what the whole image looks like at that stage. This is why it's helpful to know what you want an image to look like before you start; you need to know which adjustments will be made globally and which ones made more specifically.

At the very top of the Basic panel you'll find the option to change your Treatment (**A**). Your options are Color or Black & White—and I'm going to leave my coverage of this at that; I never touch the Black & White option here because it's the same thing as doing my black and white work in the HSL/Color/B&W panel (discussed later), and since that's where I have to go to tweak the black and white conversion anyway, it just saves me a step to go straight to the HSL/Color/B&W panel. But if you're looking to do a quick black and white conversion, or to see what a color image looks like in black and white, this is as good a place as any to do that.

# White Balance (WB)

In the simplest terms, White Balance (**B**) is the means by which you determine what in your image is neutral. This decision will have a cascading effect, shifting the color temperature and tint of the whole image. The easiest way to do this is with the White Balance dropper. Click the dropper (**C**); move the tool over an area of your image that you know to be, or want to be, neutral; and watch as the temperature and tint of the whole image change accordingly. As almost all my need for white balance is subjective, I usually take a couple cracks at finding something that should be neutral or near-neutral in order to give myself the best results. (Alternately, a quick way to play with your white balance is to try out the presets.) In my case, the best results are the ones that are closest to my vision—not necessarily the most accurate. Neutral doesn't always mean white; it could be gray as well. It just means something that ought to have no color cast in the final image.

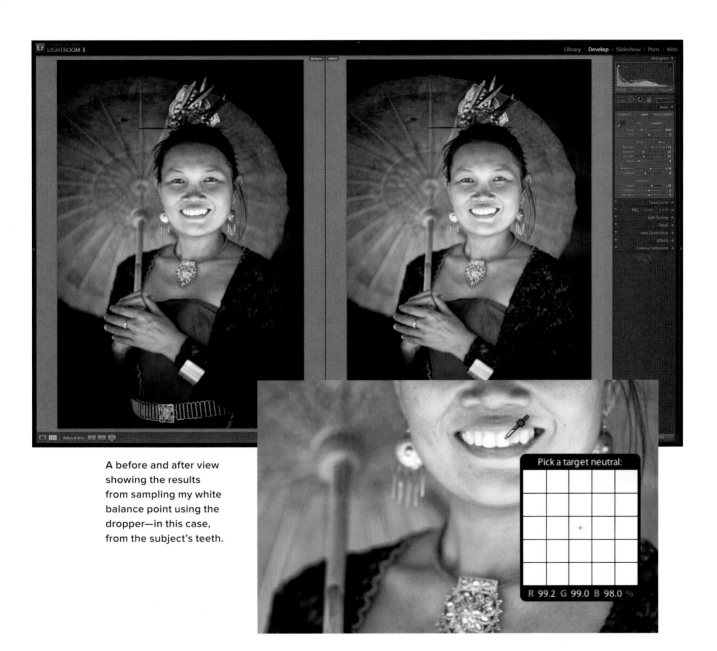

A before and after view showing the results from sampling my white balance point using the dropper—in this case, from the subject's teeth.

Pick a target neutral:

R 99.2  G 99.0  B 98.0 %

## Temp and Tint

Without writing a thesis on this, temperature determines whether your image is more blue (cool) or more yellow (warm). Not the most technical explanation, I know, but I'm trying to slant your thinking in another direction. If your work is color-critical—as in catalog work, for example—then you're going to need a much more complete understanding of this. But your image development on a catalog will not be creative work with as much margin for your whims and preferences. So for now, forget that this can be used to set precise color balance and look at how it affects the aesthetics and the mood of the image. The Temp slider has a significant effect on the mood, or feeling, of your image. I generally set it to roughly approximate the mood I want in my image, and then return later to tweak it.

If Temp affects the color of your image from warm to cool (yellow to blue), then Tint affects it from green to magenta. Tint, too, has an effect on the mood of an image, though it's generally used with more subtlety. Although a large shift from warm light to cool light can occur naturally over the course of the day, shifts in tint are not as natural, so you'll want to use them sparingly.

The takeaway on this one is that color temperature dramatically affects the mood of an image. When we get around to discussing your vision for an image, the mood of the image will be something you'll want to consider. The geek wants to know what the exact color balance should be, and the artist wants to know how the image should feel. Both have their place.

## Tone

The Tone panel (**D**) affects where your tonal values sit from black to white. This is a matter of quantity of light and where those light values fall. If you want your darks to be darker, your lights to be lighter, or your midtones to be brighter, this is where you set those values.

## About Auto Tone

Auto Tone (**E**) has improved over the years and can be a helpful starting place. It automatically sets your white point, your black point, and points in between. Where it reaches its limits is in knowing

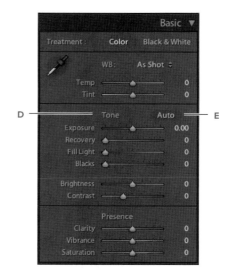

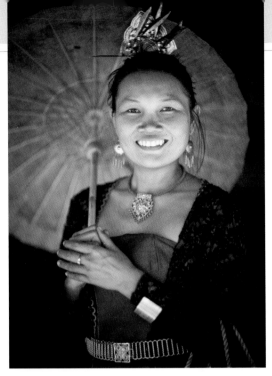

Temp set to 4500.

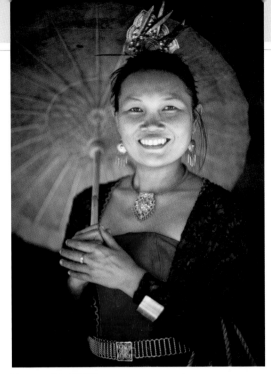

Temp set to 3040.

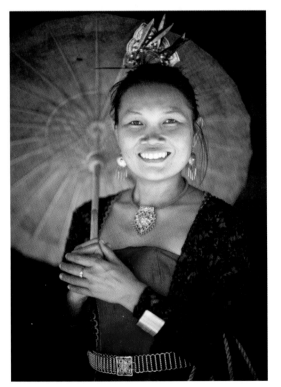

Tint set to +30.

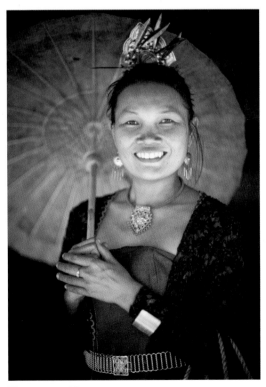

Tint set to −40.

what you want the photograph to look like; as that's the whole point, it's occasionally helpful but of limited use. I usually toggle the Auto Tone on and off to see if it looks at the math in a different way than I do, but in the end that's all it can do: assess my image based on the math. Have I mentioned how little I like math? It has uses—even in poetry it can be used to describe meter and rhyming patterns—but its role is descriptive, not prescriptive. Poetry isn't about math; it's about emotion. The same is true with photography. So in the creative darkroom I eye Auto Tone with suspicion. On the odd days Auto Tone gets it right I assume it's using some kind of voodoo.

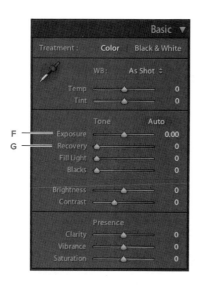

## Exposure

Assuming Auto Tone has done you no favors and you've decided to do this the old-fashioned way, this is where you set your highlights' clipping point. The Exposure slider (**F**) does exactly what you'd expect. Unlike the exposure you create in the camera—the goal of which is to create a digital negative with the most amount of data—the Exposure slider in Lightroom is for making the image look the way you want. Want it darker? Make it darker. Want it bright and luminous? Make it so. Keep an eye on the histogram, and don't blow out anything you don't have to (although sometimes blown highlights are okay). Remember, this is an intentionally creative approach. The geek wants to watch the histogram; the artist watches the look of the image and stops when it looks "right." Fortunately, there's room for them both. I often find myself pushing the Exposure slider to the right if I haven't already clipped any highlights, but that's because I like things bright and luminous. Another photographer might begin with pulling it back and reclaiming some of the darker mood.

## Recovery

I generally use the Exposure slider to set the brightness, or luminosity, of the image. I get the look right; if that means blowing some highlights, so be it. That's where the Recovery slider (**G**) is helpful. If Exposure is the push, this is the pull. Moving the Recovery slider to the right pulls back the brightest values within the image. That's the give. The take is in losing a little contrast in the brighter midtones when you push the Recovery slider too far, but you can solve that later.

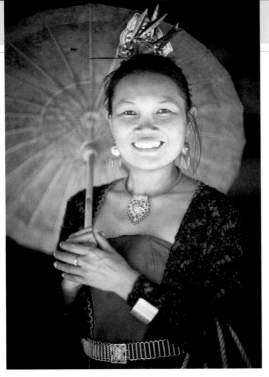

Exposure set to +1.50.

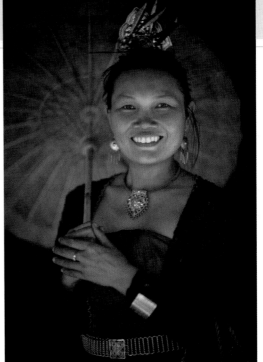

Exposure set to −0.30.

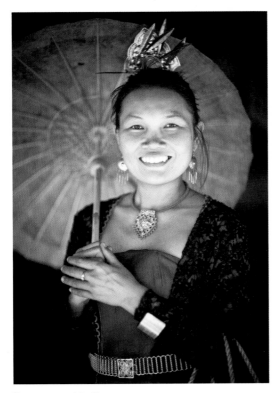

Recovery set to 0.

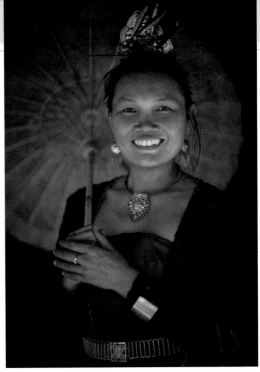

Recovery set to 100.

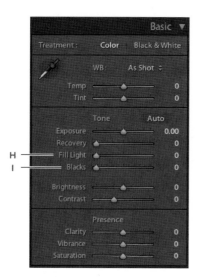

## Fill Light

The Fill Light slider (**H**) affects areas of darker midtones. It can open up shadow areas beautifully and bring a little luminosity back to areas that were underlit. It can also draw digital noise out of hiding, so it needs to be used carefully. If you push the fill too far and the noise gets too noticeable, it's often a good indicator that what you really want is a little more exposure. Not always, but often. Too much fill can also create a fake HDR (High Dynamic Range) effect that can look great in the right hands—or surreal and overdone. When you push something too far, it stops being an adjustment and becomes an effect. Like all effects, it needs to be used sparingly and in service of your vision. Using it because it's the Un-Suck Filter du Jour is rarely a good idea.

## Blacks

The Blacks slider (**I**) is where you set the black point on the image, and although most books will err on the side of overly cautious and tell you to be careful about clipping the blacks, I suggest you let the aesthetics of the image determine how far you push it. If you want a silhouetted figure against a sunset, then by all means clip those blacks. Slide that slider until it "looks right" to you. Your colors will get richer, your silhouette deeper, and you'll know when you've gone too far. Your needs determine your technique, and there's no rule that says you can't clip your blacks. Clipping blacks enhances color and contrast, and if it's a suitable means for creating an image that looks and feels right, then clip away. Just remember the give and take. Clipped blacks means loss of detail in those areas.

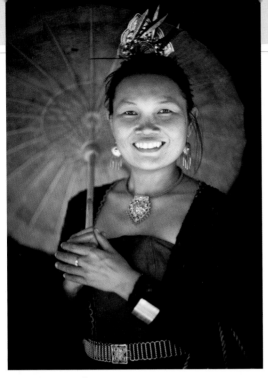

Fill Light set to 0.

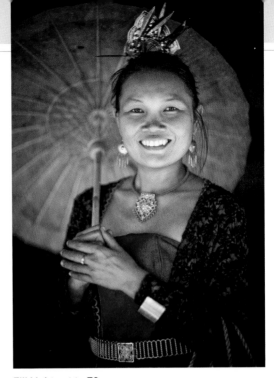

Fill Light set to 70.

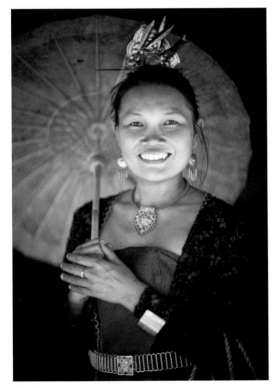

Blacks set to 0.

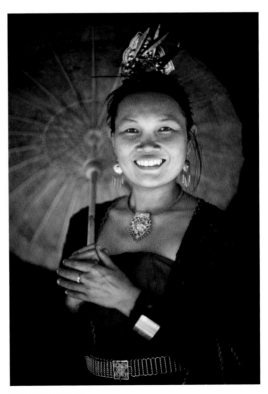

Blacks set to 11.

## Brightness and Contrast

These two sliders hold very little mystery. The Brightness slider (**J**) moves your histogram—primarily the midtones—left or right and has the effect of, well, brightening your image. If you were to do the same with the Exposure slider, you'd run the risk of driving the histogram too far to the right and losing highlight details. Using the Blacks to darken the image will likewise affect the left side of the histogram. Brightness allows you to push and pull the midtones.

Changes made with the Contrast slider (**K**) can also be seen in the histogram, and they have the effect of pushing the histogram to the left and right at the same time. Greater contrast in an image, aesthetically, means darker darks relative to lighter lights. You could do a similar thing by pushing both the Exposure and Blacks sliders to the right, pushing their values on the histogram apart and increasing the contrast. But as the Blacks slider won't allow you to go into the negative, you'll generally need Contrast or the Tone Curve to dial down the contrast.

For me, I usually use other tools to change the aesthetics of the image in these areas. The Tone Curve, for example, offers much more control over contrast. If the Brightness and Contrast sliders work for you, go ahead and use them; they do what they say they do, and in the end the point is making your image look the way you want it to—not how you got there. It's important to remember that, like in Photoshop, there are several ways to push around the histogram and, therefore, change the aesthetic. Use the approach you prefer and are most comfortable with, but be familiar with all of them because they all have different limits.

Brightness set to −10.

Brightness set to +34.

Contrast set to +80.

Contrast set to −50.

# Presence

I'm still trying to figure out exactly why these three sliders got thrown in under the Presence banner. It's not a bad name, as names go, but it kind of feels like they just ran out of creative steam at Adobe HQ one night and just wanted to get it over with, give it a name, and go home.

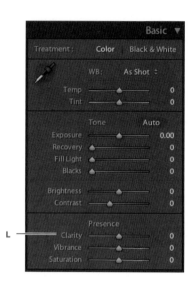

# Clarity

The Clarity slider (**L**) increases or decreases contrast in the midtones of your image. I think of it as a texture slider, as it's the midtone contrasts in an image that will either increase or decrease the appearance of texture. That's the push—great texture. The pull is a weird halo effect on some images if you push the slider too far. Like the Fill Light slider, if you push Clarity too far it becomes an effect, not a finesse, and it needs to be used with intention. Images with a higher positive Clarity adjustment can take on the popular "grungy" effect, whereas images with a higher negative Clarity take on a dreamy, soft-focus effect. Both of these extremes have a strong effect on the mood of the image, so it's an adjustment worth understanding and experimenting with. It's not often I think, "Hey, I need more clarity in my image." But texture? You bet. Thinking about the potential effect on the aesthetic of your image—and not the particular name of the slider—will get you thinking more creatively within Lightroom.

In the images shown here with Clarity adjustments, I've pushed this slider too far to show the extremes, but notice how the aesthetic is not only a dream-fuzzy one, but also an out-of-focus one. Applied selectively with the Adjustment Brush or Graduated Filter, the Clarity slider can be used effectively to guide the eye to or away from elements in the frame. It can also be used to smooth skin tones in portrait work or soften clouds in landscapes.

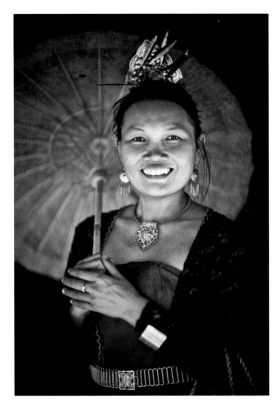

Clarity set to +100.

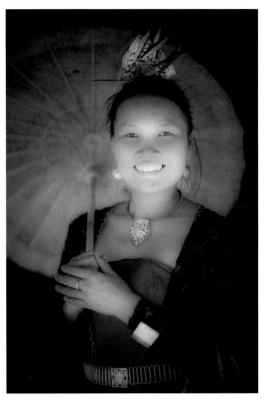

Clarity set to −100.

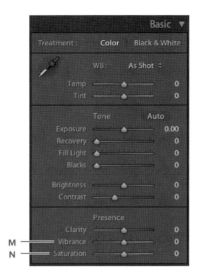

## Vibrance and Saturation

Vibrance (**M**) is like Saturation (**N**), but smarter. Both affect the saturation of colors in the image, but whereas Saturation saturates all colors within an image, Vibrance saturates the colors that are less saturated. It also treats skin tones more kindly; the Saturation slider tends to make skin tones look clownish without much effort. As with other sliders, this stuff isn't magic, and the effect on the image can be determined visually. Push it, and see what happens. Furthermore, try using the Vibrance and Saturation sliders in concert with each other.

In the images showing Saturation and Vibrance adjustments, notice how the effects of negative Vibrance and Saturation are similar, but the effects of both when the sliders are moved into the positive are quite different, particularly in the yellows and skin tones.

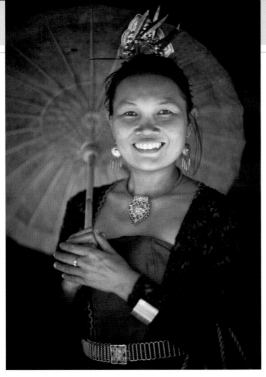

Vibrance set to −50.

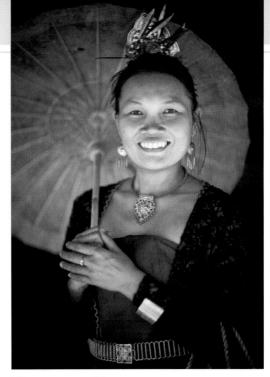

Vibrance set to +50.

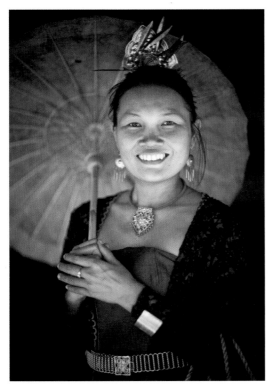

Saturation set to −50.

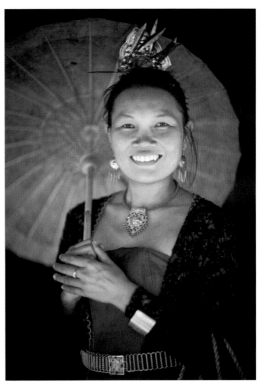

Saturation set to +50.

# Tone Curve

The Tone Curve is the primary control for contrast within the image. Whereas the Contrast slider in the Basic panel boosts contrast globally in an image, the Tone Curve allows you to adjust specific tones—and, therefore, the contrast between those tones and others—making it an extremely versatile tool.

If you've spent time in Photoshop with Curves, the Lightroom Tone Curve might throw you for a loop. (See how restrained I was just then? Could have used a curveball pun but didn't.) The Tone Curve in Lightroom simply operates differently, and worse, the similarities are enough to be confusing. For one thing, the Tone Curve doesn't give you the option of working in different channels. It doesn't offer you the option of setting a white, gray, or black point. It does one thing, and it does it well: it gives you control of tonal values within an image.

For those who've never used Photoshop Curves or the Lightroom Tone Curve, the curve is simply a graph that visually represents where each tone—from black to white—sits in relation to each other. Within the Tone Curve panel there are four ways to manipulate the tones—and I'll get to that in a moment—but here's the most helpful way I've found to begin wrapping my brain around the curves concept.

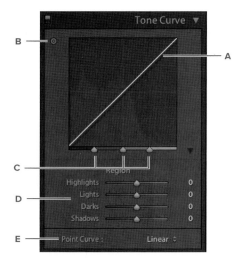

**A.** This is the line that represents the changes you make to the relationships of tones relative to each other.

**B.** Targeted Adjustment tool.

**C.** Tone Range split points.

**D.** Main Control sliders.

**E.** Point Curve presets.

You begin with a straight line from bottom left to top right. When the curve is manipulated and becomes steeper between any two points, the contrast between those tones becomes higher. Make the same area shallower, and those tones lose contrast. So although you can move the Blacks slider in the Basic panel to increase contrast, or you can move the Contrast slider, neither of these tools provides you with this more precise control over the specific tones you are manipulating.

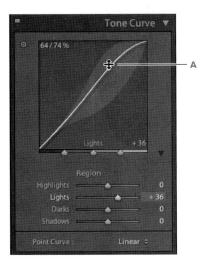

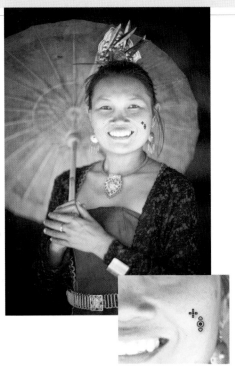

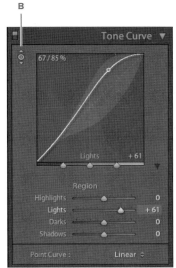

Now, how do you manipulate those tones? Here are four ways to do it:

- Grab the line at any point in the image (**A**) and move it up to lighten those specific tones or down to darken them. Easy, right? But how do you know which tones in the image are represented by which point on the line? You could guess, but there's an easier way.

- The Targeted Adjustment tool (**B**). You'll find this same tool in the HSL panel later on, and it's one of my favorite tools in Lightroom, so don't let your eyes glaze over and pass this one by. See that little bull's-eye to the left of the top of the panel? If you click it, you activate the tool. Move the cursor—now a Targeted Adjustment tool with crosshairs— over the area of the image you would like to

lighten or darken. Click and hold the mouse while dragging up or down and you'll see the tones change accordingly. What you've done is told Lightroom to make a specific adjustment to a specific tone, so remember it's unlikely that this one tone exists only in this part of the image. If you darken a middle gray, all the middle gray tones of the same value in this image will also darken. If what you really want to do is only darken the reds, for example, that's a color adjustment, not a tonal adjustment. You can do that with the same tool in the HSL panel. We'll get to that.

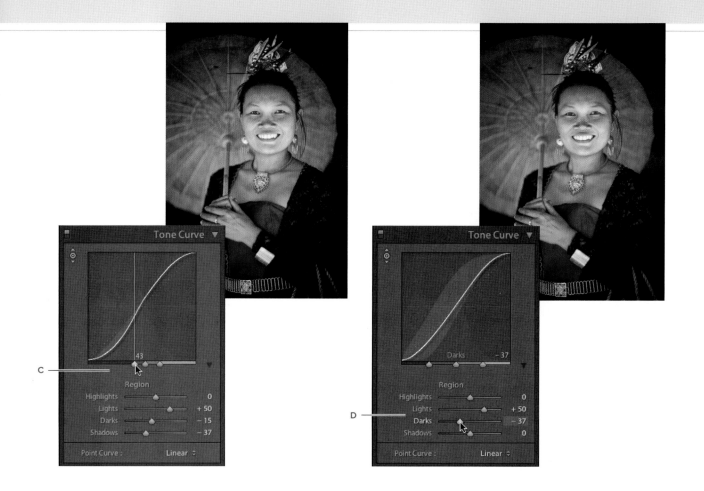

● The Tone Range split points (**C**). If you look at the bottom of the Tone Curve graph you'll see four tone zones: Shadows, Darks, Lights, and Highlights. These zones represent a range of tones in the image and are separated by three split points. Repositioning these sliding split points remaps how large that range of tones is. By default, these split points will sit at 25, 50, and 75. In an image with bright highlights, assuming you've already made changes to the Highlights in the Tone Curve panel, sliding the split point slider that separates the Lights from the Highlights to the far right will reduce the range of the highlights to which your

adjustments in the Tone Curve apply. If no adjustment to the tone curve has been made, sliding those sliders will show no change. Consider the other adjustments in the Tone Curve panel your "Change my tones *this much*" sliders, and consider these split point adjustments your "Change *this many* tones" slider. On their own, they don't make changes to the tones in the image, but in collaboration with other Tone Curve adjustments they define even further how large or small the zones of tonal change will be. Handy when you want just a little more control.

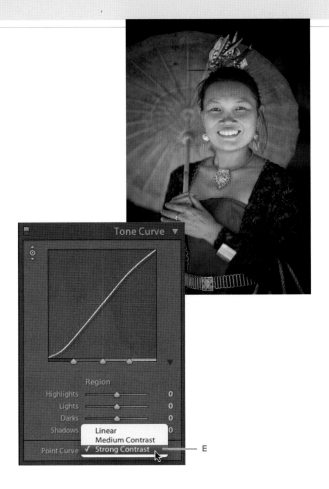

- The four main control sliders (**D**) below the Tone Range split points control the tone curve in much the same way as dragging the curve around manually, and it's generally the way I choose to work unless I want the specific control of the Targeted Adjustment tool or the Tone Range split points themselves, which are usually the last adjustments I make while in the Tone Curve panel. These make the changes you'd likely expect them to, lightening or darkening the corresponding range of tones in the highlights, lights, darks, or shadows.

Finally there's the Point Curve (**E**), which allows you to choose a Linear, Medium Contrast, or Strong Contrast curve. These are good starting points if you're looking primarily to change the contrast of the image. Linear curve applies no contrast. If I am in a hurry to produce a rough first version of an image for evaluation, I'll jump straight to Medium Contrast or Strong Contrast and come back later to tweak it. Ah, the beauty of nondestructive editing.

Tones and their relation to each other have a significant impact on the look and, therefore, the feel or mood of an image. If the eye is drawn to light areas before dark areas, to areas of high contrast before areas of low contrast, being able to manipulate the tones in an image—to create areas of greater or less visual mass depending on where you want the viewer to look—is an important step forward in your ability to bring an image into alignment with your vision and your unique way of expressing that vision.

# HSL/Color/B&W

Whereas the Tone Curve is our tool for the manipulation of tones within an image—gray values from black to white—the HSL/Color/B&W panel is our collection of tools for the manipulation of color in the image. The two are not, however, separate. Changes made in the Tone Curves panel affect the look of the colors in the image, and changes made here in the HSL/Color/B&W panel affect the tones. Where they differ is that the Tone Curve panel is really about the control of tones in relation to each other, whereas the HSL/Color/B&W panel allows precise control of color values. In the case of the B&W part of the panel, even though the changes appear to be strictly tonal, under the hood it's color information being mixed. On a color image you can darken the blue of the sky by pulling down the Luminance of the blues. In a black and white image being tweaked in the B&W panel, this same change—a darkening of the blues—will result in a darker sky. You won't see it as a darker blue because there is no blue on a black to white spectrum, only shades of gray. Under the hood, though, you have the ability to specify what Lightroom does to the color channels. Like the Channel Mixer in Photoshop, this is a powerful tool for making gorgeous black and white images. If you've been content to hit the B&W button either at the top of the Basic panel or here in the HSL/Color/B&W panel and leave it at that, you haven't even begun to see the possibilities for creating black and white images that reflect the mood you want in your images. Let's take a quick look at the ways in which colors can be tweaked in this panel.

The HSL/Color/B&W panel with B&W active.

## About Hue/Saturation/Luminance

Hue, saturation, and luminance are ways of describing different qualities of any given color. Without getting wrapped up in color theory and exact terminologies, let's use red as an example. Hue asks, "Which particular red do you want? Is it more of a magenta red or more of a yellowy red?" Saturation asks, "How intense do you want your red? Do you want a subtle hint of red or a knock-you-on-the-head-and-steal-your-milk-money red?" Luminance asks, "How light or dark do you want your red? So dark it's almost black, or bright and sunny?" I'm intentionally using less technical, more visceral words because emotion and mood are visceral, not technical. You don't think or feel in RGB color values. You think in more descriptive ways. So go with the stream on this one. Precise color values have their place, but for the sake of this book I'm leaving them alone.

 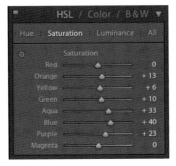 

# HSL

The HSL panel allows you to adjust the hue, saturation, or luminance with two tools, both of which you've used before. In the case of red, the Hue slider moves your red values from magenta on the left to yellow on the right. Click the Saturation tab and use the same slider, and it will change the same red values from desaturated to heavily saturated as you move from left to right. Finally, click the Luminance tab and move the slider in the same direction, and you'll find the reds in your image go from dark to bright. You can do the same without going from tab to tab by clicking All and working in one extended panel. The other means of adjustment is the Targeted Adjustment tool, which is located in the same place in this panel as it is in the Tone Curve panel. Click it to activate it, move it over the image and click on the red value you want to adjust, and depending on whether you've got the Hue, Saturation, or Luminance tab active, it will raise or lower the corresponding HSL value. Pretty cool stuff.

The thing to remember is that it's never as easy as it sounds. First, clicking and tweaking a red ribbon on a woman's shawl will change that same red everywhere else in the image. The second issue is that colors generally don't like to stay in their boxes. There might be reds in the skin tones in your image, and the adjustments you've made will be reflected in those skin tones. It's not a problem—just a constraint you need to be aware of. If this is an issue in the image you're working on, better tools, like the Adjustment Brush (which we'll discuss later), are available for precise local adjustments.

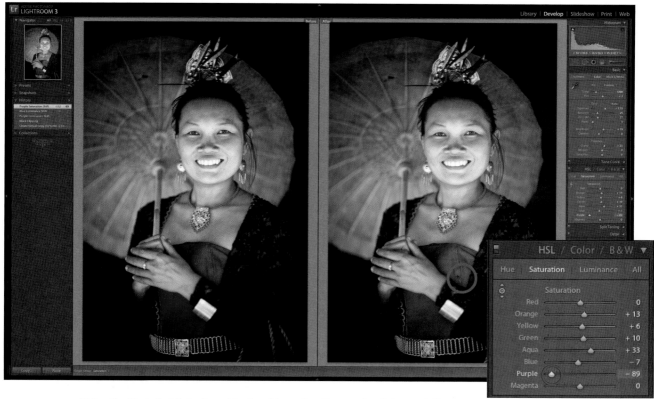

Using the Targeted Adjustment tool and targeting the purple of the model's blouse in the HSL panel with Saturation active, I pulled the cursor down to reduce the saturation of the purple. Conversely, pushing the mouse up would raise the saturation.

## Color

The Color panel allows you the same adjustments as the HSL panel, but instead of offering them to you based first on whether you want to change HSL values, this panel allows you to work with HSL values with one color only. This means you can go straight to red and tweak HSL values right there. I don't use this panel often; it's less intuitive to me, and it offers no Targeted Adjustment tool, so I generally stay in the HSL panel.

## B&W

If there's one panel that I love, use frequently, and still get nervous teaching about, it's the B&W panel. On strictly technical terms, my brain is rubbish at understanding color models, and teaching them is even harder. But I love black and white photography. All my early photography and darkroom work was in black and white, and it laid a foundation that's served me well over the years.

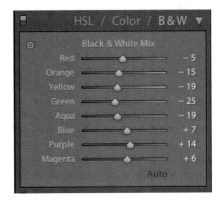

As I described earlier, the B&W panel is a means of mixing color information still present within the image that you see as black and white. It offers precise control over which tones get adjusted and used in concert with the Tone Curve controls, and it gives you nearly limitless control over the look and feel of your black and white image. You can play with mood and emphasis in ways a simple global conversion to black and white won't allow.

Playing and experimenting—playing the "what if..." card—is the best way to let this stuff sink in and become more intuitive. Try doing a black and white conversion and then going back up to the Temp slider and moving it around a little. Remember, the black and white image you are looking at is really still a color photograph shown to you through a complicated black and white filter. Any modifications you make, including a change to the color temperature, will alter the look of the image, and changes to the look of an image is what this is all about—making changes to the image that best express your purpose in creating it. You change the aesthetics of the image, and that changes the response your viewer has.

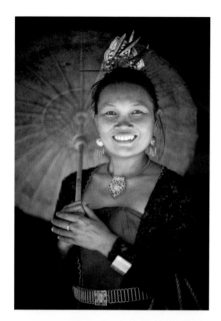
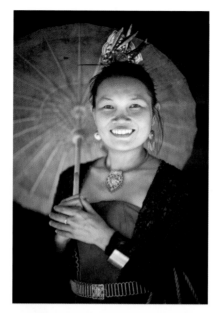
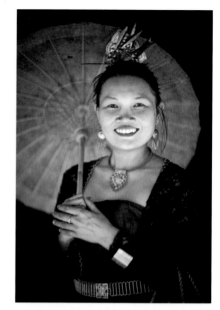

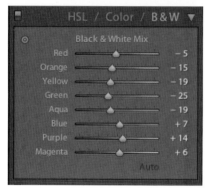

| HSL / Color / **B & W** ▼ |
| --- |
| Black & White Mix |
| Red — 5 |
| Orange − 15 |
| Yellow − 19 |
| Green − 25 |
| Aqua − 19 |
| Blue + 7 |
| Purple + 14 |
| Magenta + 6 |
| Auto |

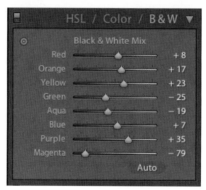

| HSL / Color / **B & W** ▼ |
| --- |
| Black & White Mix |
| Red + 8 |
| Orange + 17 |
| Yellow + 23 |
| Green − 25 |
| Aqua − 19 |
| Blue + 7 |
| Purple + 35 |
| Magenta − 79 |
| Auto |

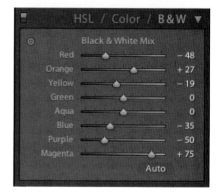

| HSL / Color / **B & W** ▼ |
| --- |
| Black & White Mix |
| Red − 48 |
| Orange + 27 |
| Yellow − 19 |
| Green 0 |
| Aqua 0 |
| Blue − 35 |
| Purple − 50 |
| Magenta + 75 |
| Auto |

Three separate black and white interpretations of the same image. Which one is right or wrong is not the point—and only you can determine which one is *best*. What's important is that you have control over which colors are represented in what way, and that allows you to guide the push and pull of the viewer's eye. Do you want the eyes to pop? Would you prefer the sweater be lighter or darker? What about her lips? All of these are choices you guide.

# So What?

Once you've played with these controls for even an hour, you'll begin to see the possibilities they offer. In the case of color images, they let you hone your visual storytelling abilities. If, for example, the eye is generally drawn to lighter areas before darker areas, these controls allow you—in a black and white image, for example—to bring the focus to certain areas and away from other areas. In the case of a color image, they allow you to work with the blues and the yellows to create greater color depth. If the eye is drawn to warmer colors before cooler colors, the warmer areas in your image will seem to jump out whereas the cooler areas seem to recede, creating an illusion of depth. On a simpler level, these controls enable you to pull focus away from distractions by darkening them or desaturating them; they let you subtly change hues to make the image less color-dissonant; or they let you darken one area over another simply to restore greater visual balance that other tweaks might have slightly undone.

There's give and take with all this; all these adjustments have limits. Remember, too, that what you see on your screen may not translate well to a print job. I'm intentionally avoiding a discussion of color spaces, because as long as you work in Lightroom, they just aren't relevant. But if you plan to send your work to a printer, you'll likely need to convert these images to CMYK, a considerably smaller color space with less tolerance for the brighter, saturated colors. Cross that bridge when you come to it, but be aware that the possibilities are limited by both the digital file—it might not stretch as far as you'd like—and the output technology you plan on using. In the meantime, look to the HSL/Color/B&W panel to begin interpreting your vision through the voice of color.

# Split Toning

Split toning allows you, either in a color or monochrome image, to color your highlights and shadows. Simply, it allows you to specify the Hue (**A**) and the Saturation (**B**) in the Highlights (**C**) and Shadows (**D**) independently, and to change the balance of the two with the Balance (**E**) slider in the middle of the panel. When you first open it and push the Hue sliders around, you'll see no change and assume Lightroom's busted. No change is shown because by default the Saturation sliders in the Split Toning panel are set to 0. Give that slider a nudge and the color toning will appear.

While split toning can create some unique effects on a color image, it is on black and white images where it seems to have the most practical effect for me. Don't let that stop you from playing with split toning a color image, and we'll do just that in a couple of the photographs in the next chapter. Whereas in color images the split toning often renders images surrealistic, on a grayscale image it can create incredible duotone images with warmth and mood that black and white alone can't accomplish.

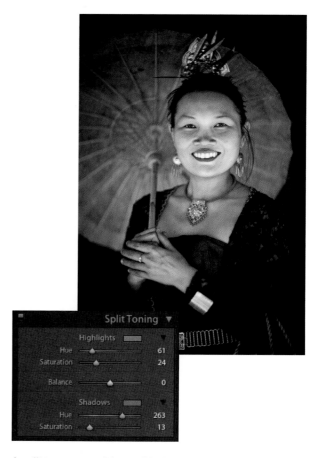

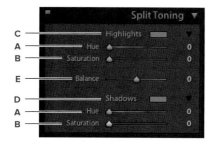

A split tone created from a black and white version of this image. The two predominant colors in the original image guided my choices. The overall warmth of the image—as well as the color of the parasol and the model's skin tone—suggested a warmth in the highlights, while the blouse suggested the cooler purple of the shadows.

On my first trip to India I created a series that was best rendered with a strong split-toned treatment that expressed the meeting of my childhood mental images of India with the country I actually encountered. The treatment of these images was marked by strong vignetting; warmer, golden highlights; and cooler, purple shadows. My intention was to replicate the look and feel of older cameras whose optics tended to darken the image at the edges, whereas the gold/purple split tone was intended to create a feeling of age, warmth, and richness. It was not my intention to show what India looked like, but how it looked and felt *to me*. Some people love this series; others do not. But you can't please everyone, and my goal was not to do so. It was to express how I saw and how I felt. Not everyone will resonate with that, and that's okay.

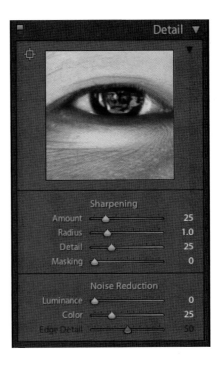

## Detail

The Detail panel is another one of those panels where I spend very little time, and what time I spend here is out of sheer necessity. I know I said that making wholesale changes to an image based on the "Just make it look better, man" method was ill-fated. But there are times when you have to do just that because of weaknesses in the digital medium (noise, for example). If I were to rename this panel, I'd call it the Digital Compensation panel— the place I go to clean up the problems introduced by the digital medium itself: softness and digital noise, both of which are challenges more specific to the limits of digital photography.

# Sharpening

Coming straight out of the camera, a JPEG image will have a level of capture sharpening applied to it. Not so with the RAW file; it needs a little help to pull the most information from its data. Lightroom provides two opportunities to sharpen your image. One is the capture sharpening applied here in the Develop module. The other is output sharpening applied in the Print module. A few hints about sharpening here in the Develop module:

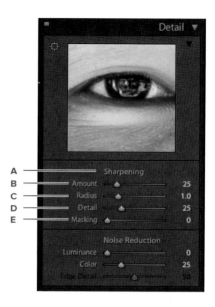

- By default, unless you zero your RAW file, Lightroom will apply some mild sharpening to the image. I generally leave it as is, and if I'm working from a zeroed file I'll usually—though not always—bring the sharpening back to those same default levels. Why? Because the folks at Adobe are way smarter than I am, and I've never had issues with the way my files look when I do this.

- You can only evaluate your sharpening when viewing it at 1:1. Anything lower and the sharpening won't render and will be invisible.

- No one sharpening preset or strategy works for all images because what you want the skin on the face of a model to look like is generally not what you want the side of a mountain to look like.

- Don't oversharpen. You should see no sharpening artifacts as a result of your efforts here. Remember, this is simply the sharpening applied to compensate for the weakness of the medium, not output sharpening, which is based, really, on the weakness of the output medium. You sharpen differently for different papers or for different screen resolutions.

- Play with and become aware of how the four sliders in the Sharpening section (**A**) of the Detail panel behave. Amount (**B**) and Radius (**C**) affect how much sharpening is applied. Detail (**D**) and Masking (**E**) have a suppressing effect, which restrains the sharpening, allowing it, for example, to affect eyelashes but not softer skin tones.

I will cover some basic sharpening and masking, but sharpening is one of those subjects that is particularly specialized. For further study, I suggest you look to the teachings of Bruce Fraser or Martin Evening.

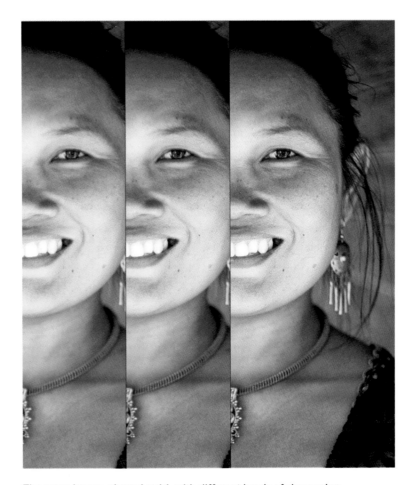

The same image, viewed at 1:1, with different levels of sharpening applied in the Detail panel. The left shows none at all, the middle shows the default sharpening, and the right shows far too much sharpening for my tastes, but that's hard to measure. If this were going on a billboard, the desirable level of sharpening would be different.

# Noise Reduction

When shooting film, we'd deal with low light by shooting a film with a higher ISO. We'd get faster shutter speeds, but the trade-off was larger grain. In the digital world, this trade-off comes as digital noise, particularly when trying to pull details from shadows. Although grain is kind of funky and has its own aesthetic charm, digital noise is just plain ugly. The Noise Reduction (**F**) in Lightroom is a first step in eliminating some of it.

You're given two options with Lightroom's Noise Reduction tool—a Luminance slider (**G**) to eliminate luminance noise, and a Color slider (**H**) to eliminate color noise. Both need to be used with discretion as the result is not only the reduction of noise but a loss of detail or sharpness in the image. Again, the best teacher here is experimentation and observation. Keeping your image view at 1:1 will make it easier to judge the effect on the image. I don't use noise reduction much, but when I do I tend to use

the Navigator to bounce back and forth between areas of noise and areas of detail, making sure that my decisions about noise reduction aren't also reducing details I prefer to keep sharp. Again, it's all about the give and take, and only you can decide how much noise or loss of detail you can live with.

One final note regarding noise: Remember that sharpening will also exaggerate noise, making a strong case for selective sharpening with the Adjustment Brush, the use of masking, or pulling the image into Photoshop.

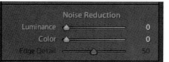
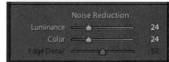

A screenshot of the same image with no noise reduction applied (left) and with both Luminance and Color noise reduction applied (right).

# Lens Corrections

If there's one tool in Lightroom that I could be accused of overusing, it'd be the Lens Vignetting tool. Sure, I'm guilty. And you know something? I'd do it again if I had to. It's a weakness, and I'm okay with that. I like to think there's more to it than a simple matter of preference, but if not, I'm okay with that, too.

In Lightroom 3, Adobe introduced new abilities in the Lens Corrections panel to correct the various optical distortions created by lenses, such as barrel distortions. These aren't something I'd consider creative tools, but like all tools they change the aesthetics of the image and should be explored and considered as you refine your vision. Like sharpening, I'm going to leave this one alone but encourage you to play with it and consider these tools for minimizing distractions or maximizing a particular look.

## Lens Vignetting

The fact that the Lens Vignetting (**A**) tool is found in the Lens Corrections panel tells you all you need to know about the run-of-the-mill view of vignettes: they're a problem, and they need to be corrected. But that's my problem with that viewpoint on vignettes. Words like "correct" just rub me the wrong way when talking about expression. If this was brain surgery, I'd be all for the correct way of doing things. But it's not, and while you're more than welcome to use these tools to undo unintentional lens vignetting, I'm not sure I've ever done so.

Used subtly, you can't even tell a vignette is there, but it can darken the corners of an image enough such that the center of the image appears to jump forward—creating a sense of depth and leading the eye into the frame toward the subject. A vignette can

also contribute to the mood of the image, and when used more noticeably it can imply vintage or age. I often use the vignette when I've photographed someone against a lighter background and I want to create a little more separation or depth. Darken the background with the Lens Vignetting tool and lighten the subject with the Exposure slider or Tone Curve, and the background will appear to recede.

The Lens Vignetting tool is simple enough to use. The Amount slider (**B**) determines how much vignette is added or removed. Think of this in terms of how light or how dark the periphery of the image is. The Midpoint slider (**C**) determines the size of the vignette itself—how much do you want that vignette to approach the center of the image?

There are two vignetting tools in Lightroom, and they operate similarly but with different effects. The second tool, found in the Effects panel, is called Post-Crop Vignetting. They are similar, but they're used in different contexts and they produce different aesthetics. The Lens Vignetting tool is, by far, my preference. But it's important to know how to use both because that allows you to use the right tool for the right job when the occasion arises.

This screenshot shows before and after views of the image. On the left is the image I began with—already heavily vignetted previously in Lightroom. On the right, the Lens Vignetting Amount slider has been taken to +56, removing some of the vignette. Notice two things: first, a well-applied vignette can have a strong isolating effect, drawing attention to primary subjects and away from distracting backgrounds; second, using the vignette correction to regain some exposure in the shadows can also create a great deal of noise.

# Chromatic Aberration

In recent years, lenses specifically made for digital cameras have started to tackle the problem of Chromatic Aberration (**D**), seen as colored fringing around high-contrast edges. This effect occurs as different wavelengths hit the sensor differently, causing fringing at different parts of the spectrum. If you see colored fringing on an image, come to the Chromatic Aberration panel and play with it until the image looks better. I know that's not very helpful, but honestly I've never used this tool. Chromatic Aberration lies outside the scope of this book, which focuses on creative expression and not image repair.

# Effects

New in Lightroom 3, the Effects panel contains two tools: Post-Crop Vignetting—which was present in Lightroom 2 but housed in the Vignettes panel—and Grain.

## Post-Crop Vignetting

Where Post-Crop Vignetting (**A**) shines is in applying a vignette after the image has been cropped. If you crop your image and use the Lens Vignetting tool in the Lens Corrections panel to apply or remove vignetting from an image, it will be applied to the full frame of the original image, allowing you to see only a partial effect because of the crop. Post-Crop Vignetting, as the name implies, lets you apply a vignette to the image after you've cropped it.

Post-Crop Vignetting has the same two sliders as Lens Vignetting—Amount (**B**) and Midpoint (**C**)—but also has Roundness (**D**) and Feather (**E**). Roundness affects how circular the effect is, and Feather controls how soft or graduated the vignette is. Highlights (**F**), also new in Lightroom 3, controls highlight contrast and, according to Adobe, is suitable for images with small highlights like candles and lamps.

Post-Crop Vignetting is much improved since Lightroom 2. In the past, I've limited my use of vignetting almost exclusively to the Lens Correction vignetting tool simply because the Post-Crop vignetting tool seemed muddy and flat by comparison. I still prefer the first vignetting tool (in part, I think, because it has fewer options), but the Post-Crop Vignetting in Lightroom 3 certainly gives much greater control.

New to Lightroom 3 is the choice between Highlight Priority, Color Priority, and Paint Overlay as a style at the top of the Post-Crop Vignetting section (**G**). Highlight Priority allows the vignetting to perform some highlight recovery but can cause colors to shift as they darken. The Color Priority style keeps color shifts down but does not pull back lost details in the highlights. To my eye, Paint Overlay seems to be the closest to the way the Post-Crop vignetting tool looked when it first came out, and seems to be the muddier of the three options, essentially laying down a layer of darker gray on top of the vignetted area; I don't use it much. Like all these tools, the best way to learn them is to try them all out and get a feel for the aesthetic changes each tweak can create.

These Post-Crop capabilities are new to Lightroom 3, and any images that were first processed in an older version of Lightroom will now need you to update the Process Version before finding these options open to you. From the menu, select Settings > Process Version, then choose 2010. The new style options should become immediately available.

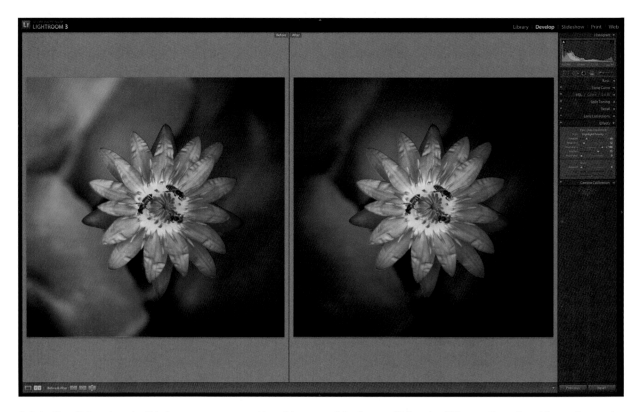

Originally a 3:2 rectangle, this image was cropped to a 1:1 square. Using the Lens Corrections > Lens Vignetting tool to add a vignette would only show a vignette on the right side of the image. Using the Effects > Post-Crop Vignetting tool allows you to add vignettes that correspond to the crop, not to the original image.

## Grain

New to Lightroom 3, the Grain tool gives us the ability to replicate the look of film, something anyone who loves the gritty look of grainy film will welcome. I cut my teeth on Kodak T-Max and lots of cheap black and white film purchased in bulk, and the ability to bring some of that grit back to my digital images is great.

The Grain tool allows you to control the Amount, Size, and Roughness of the grain. Amount is about more or less grain, Size is about big or small, and Roughness is about how uniform or random the grain texture is.

Before and after screenshots of the Grain tool in use.

# Camera Calibration

The Camera Calibration panel is primarily a tool for fine-tuning the way Lightroom reads the files from your specific camera. Not every camera, even among cameras of the same model, render things in precisely the same way. This panel can be used to correct that. It can also be used with creative effect, though it's one of the features in Lightroom I've yet to find a use for myself. For this book, I'm going to leave calibration alone and let you explore it on your own if your interests lean that way. I don't mean to dismiss this tool; it's just that I've never found a use for it, and I'd rather teach you what I know than fake it for the sake of appearances.

# Develop Tools

Sandwiched between the Histogram and the Basic panels back at the top is the Develop Tools panel, containing some of the most exciting tools in Lightroom. It also contains the Crop Overlay tool and the Red Eye tool, both of which serve a purpose but are just hard to get excited about.

The Develop Tools panel, from left to right, has the Crop Overlay tool (**A**), Spot Removal tool (**B**), Red Eye Correction tool (**C**), Graduated Filter tool (**D**), and the Adjustment Brush (**E**).

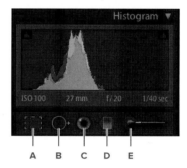

## Crop Overlay

Although it's generally desirable to get your framing right in the camera, there's no shame in fine-tuning your crop in Lightroom. In fact, there are good reasons, at times, why you simply can't do the cropping in camera. You might not be able to get as close to your subject as you'd like, you might be shooting for an art director who insists on wider framing to allow for flexibility with bleeds, or you might want your finished image to be presented with a square aspect ratio instead of a rectangle.

Cropping is about more than the elimination of distractions. It can change or fine-tune the balance of the image or place a key element closer to a power point on the rule-of-thirds grid, making it more predominant in the frame. You might also want to use the Crop Overlay tool to rotate the image—perhaps to correct a horizon that's distractingly askew or to make a slightly diagonal line a little more diagonal and, therefore, more dynamic. Diagonal lines lead the eye through the frame, and when made more diagonal, they take on greater visual mass.

Straightening that same line will decrease this effect, allowing focus to go elsewhere, or giving that line a feeling of strength and solidity. Great if you can do it while shooting, but sometimes it just doesn't, or can't, happen.

Remember that the photograph doesn't just exist within the frame; it interacts with it. The frame is part of what makes the image what it is, so how you use the Crop Overlay tool is important to the way in which the image is allowed to express what you want it to. To overlook this is to deny the power of balance and proportion in photography; to give the camera alone this power is shortsighted and not always possible. (Tip: Hitting the L key a couple times puts the screen into Lights Out mode and frees your cropping from visual distractions. I love this!)

The Crop Guide Overlay can be changed to facilitate cropping to a specific need, including a tight grid, thirds, diagonal, and more, by selecting Tools > Crop Guide Overlay. While the Crop Overlay tool is active, press the O key to cycle through these different views.

## Spot Removal

The Spot Removal tool is one that, to my knowledge, is only ever used as a corrective tool and not as a creative one. This doesn't mean it's not important, but I'm making the assumption that you understand how and why to use this tool. If you want to use it creatively, to change the content of your image, you might better be served by the tools in Photoshop, which is far more suited to the task of selecting, moving, and cloning objects. But if you can find a way to use this tool beyond removing dust and unwanted artifacts to achieve your vision, go for it. Where it does serve, and very capably, is in removing distractions from an image, and as distractions are, by definition, elements that draw the eye in an undesirable way, the use of the Spot Removal tool to clear out sensor dust or small distractions in the scene itself can make the overall viewing experience stronger.

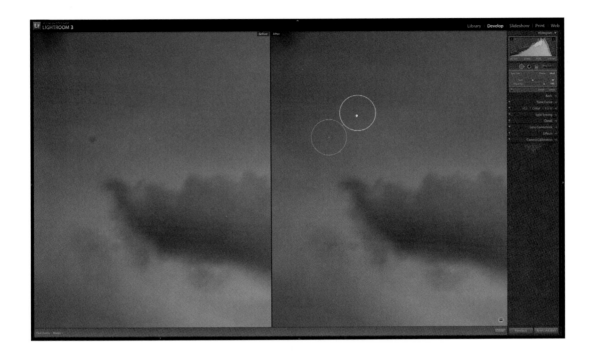

## Red Eye Correction

I'd be lying if I said I've ever used this tool. If you've got a use for it, go for it. Red eye is caused by on-axis flash as the light goes straight off the camera, hitting the back of the eye and bouncing directly back. Moving your flash off camera and to the side will solve this problem. This is a sweeping statement—more like an opinion—but if you've got red eye, you've also usually got some pretty harsh, unflattering light to go along with it. That might work for you, and if it does, great. I'm just saying you might have bigger problems with your image than red eye alone. And the Adobe team didn't even give this one a keyboard shortcut, so clearly I'm not alone in ignoring this tool most of the time.

Let's move on to the final two. When the Graduated Filter and Adjustment Brush were introduced in Lightroom 2, you could practically hear the Lightroom community let out a collective sigh of relief. The lack of these two tools in Lightroom 1 was probably responsible for sending more photographers back and forth between Lightroom and Photoshop than any other reason. Getting them in the Lightroom 2 release was a tremendous gift.

# Graduated Filter

The Graduated Filter applies an adjustable grade of Exposure, Brightness, Contrast, Saturation, Clarity, Sharpness, or Color—or a combination of any of these—across the image. Applying this graded effect can enhance a sky, gradually lighten a foreground, simulate light falloff, or even—with a graduated filter set with negative Clarity—simulate a softer focus, allowing you to draw attention to one part of an image over another.

In this image I've added two filters to the original photograph. The first was for the sky, and it did three things: it darkened the sky and brought out the clouds (less Exposure and Brightness); it softened the clouds (less Clarity); and it added some warmth (notice the yellow hue chosen in the Color box at the bottom of the panel). The second filter was added to the bottom half of the image to treat the ocean and dock together by adding a little Exposure, sliding the Clarity slider to 100, and adding just a little blue with the Color box.

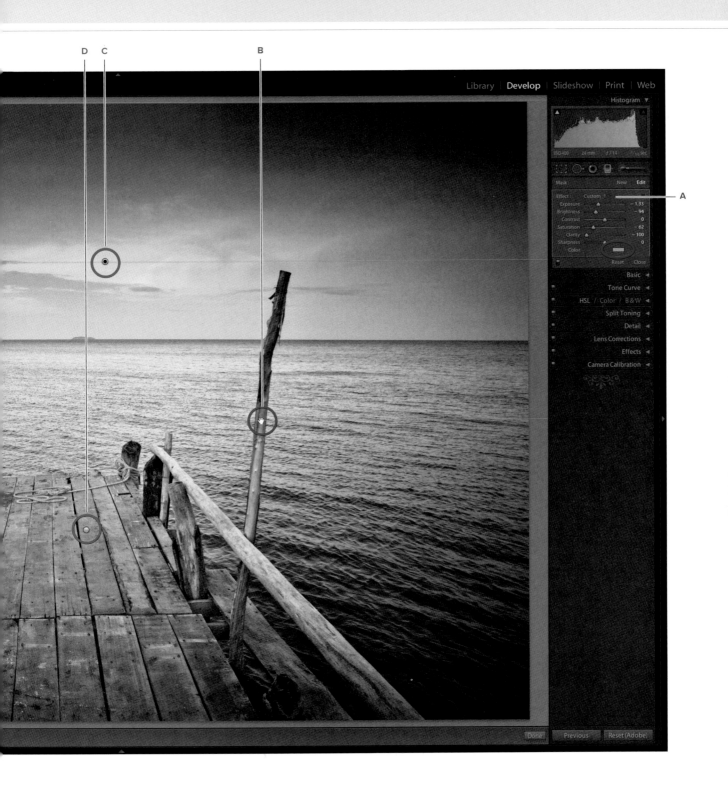

To apply the Graduated Filter, click the icon in the panel and a drop-down panel will appear, presenting you with your available options. The first thing you'll see is the Effects preset menu. In this case, it is set to Custom (**A**). If you click this menu, you'll find presets like Soften Skin as well as options to create your own presets. I usually skip these and manually dial in a rough set of adjustments; if I'm darkening a sky this might include lowering both the Exposure and the Brightness. Then click and hold the mouse within the image and drag (**B**). As you drag the cursor, the filter will expand out in the direction and angle of your pull. Pull the filter up and it will expand up; pull it left or right and it will rotate. Release the mouse to set it.

Once you've drawn your filter onto the image, you'll see a black dot (**C**) on the pin marker in the middle of the Graduated Filter; this means it's still active, and any changes you make in the panel will be reflected in the image itself. You can use multiple Graduated Filters, too, and each will be indicated by a new pin (**D**). To add a new Graduated Filter, go to the top of this panel and click Mask: New. To remove a filter, click on the little pin marker to activate it, revealing the black dot. Now hit Delete and it'll disappear. To edit a filter, click it to make it active, and then make the changes you want.

The Graduated Filter is not unlimited in its control; you can't, for example, apply anything but a linear grade to the image. You can control where it starts and ends, you can control the angle of the Graduated Filter on the image, and you can control how much and in which combination you want the effects applied to the image. I find the Graduated Filter incredibly helpful, and it's my tool of choice when a global adjustment is too much but I don't yet need the specific abilities of the Adjustment Brush. There is so much more you can do with this tool than simply dial in a sky that's too light, and remembering that will make the Graduated Filter much more useful to you.

# Adjustment Brush

The Adjustment Brush gives you the most options of any tool in Lightroom, so I've saved it for last. It's also the tool that brings us closest to the some of the localized adjustment functionality of Photoshop, and it's the reason I now do most of my work in Lightroom. Since the introduction of the Adjustment Brush in Lightroom 2, many tasks that I once did in Photoshop I now do here. As the name implies, the Adjustment Brush allows you to brush effects into an image in a selective way, with full control over Size (**A**), Feather (**B**), Flow (**C**), and Density (**D**) of the brush strokes. Users of Wacom tablets reap the highest benefits of this tool, taking further advantage of the tablet's pressure sensitivity and giving you much greater control than a mouse. There is a Wacom tablet on my desk where I work and, in many cases, when I travel; I can't imagine trying to work with the Adjustment Brush and not taking advantage of the Wacom tablet and pen.

With the Adjustment Brush you can apply the same effects as the Graduated Filter but with specific, local application instead of a linear grade across the image. Whereas a positive adjustment in Exposure in the Basic panel will brighten the whole image, the same adjustment made with the Adjustment Brush will affect only the painted area. Suddenly, old-school techniques like dodging and burning—or lightening and darkening specific areas of the print to lead the eye—are accessible in Lightroom. And they're completely nondestructive, ready to be edited or painted away at a whim.

Imagine the possibilities this allows us, knowing what we do about areas of greater visual mass in an image. Now small tweaks to the brightness of one element can be made to eliminate its distracting pull on the eye. Small areas of a warmer hue can be slightly desaturated or cooled. Even the illusion of sharper, or blurred, focus can be created with the Clarity and Sharpness sliders, painted precisely where you want them. When you have a handle on how the eye behaves in response to these changes, it makes these tools not merely tweaks made "because you can" or "just to see what it looks like," but because you have an intent for your image, and you know that certain changes to the aesthetic of the image will bring about that intent to greater effect than others. To return to the idea of balancing the geek and the artist, learning this stuff lies within the realm of the geek, but applying it is the domain of the artist. One serves the other, and both serve your vision.

Like every tool, this one is best learned by playing, though it takes a little more finesse to master than others. The more intentionally you can control the brush, the better your image will look. Take some time to play with the Adjustment Brush, particularly with the Size, Feather, Flow, and Density options. See how the Erase option takes away the painted effect in the same way painting it adds the effect.

The Auto Mask function (E) is really astonishing, and when you're after an effect applied to a specific area that's well defined by contrasting tones, turning on the Auto Mask relieves you of some of the tedium of precision painting within the lines. Auto Mask detects changes in color and tone, and then confines the painted effect to that area. Try painting with the Auto Mask option on, and then with it off, watching the differences in how it behaves.

We'll use the Adjustment Brush extensively as we go through the 20 photographs in the second part of this book.

# Moving On

The best thing you can do now is probably close this book and go play. We all learn differently, but few of us learn best by just reading and looking. We internalize best when we play, get our hands dirty, screw up a few times, and entertain the occasional diversion and "what if." I've said it before: this book isn't rocket science, and I'm not being coy or self-deprecating. It's merely an encouragement to see things differently, to approach your digital darkroom process as one motivated by your imagination and passion for expression. It would be the height of hypocrisy to make this book a cookie-cutter how-to book that encourages you to move one slider to +10 and another to –10 and call it done. Nothing beyond this point is formula. It's simply the creative use of tools based on their aesthetic effect to accomplish an image that's closer to your vision than when you began.

Pick an image and force yourself to do horrible, unconscionable things to it. Go through each tool and spend 10 minutes with it. Force yourself to spend 10 minutes. Play with combinations, and when you think you've got it figured out, see if you can push past the obvious and create alternate effects. Try describing—even out loud—what the aesthetic effect of these tools is. Forget what the slider or tool is called; describe the effect it creates. Does it make the image more luminous? Moody? Does it make it heavier? Lighter? The more able you are to associate these tools with their aesthetic results, the more comfortable you'll be with them. The more comfortable you are with the means of expression, the more intuitively you'll be able to wield them and give voice—through them—to your vision.

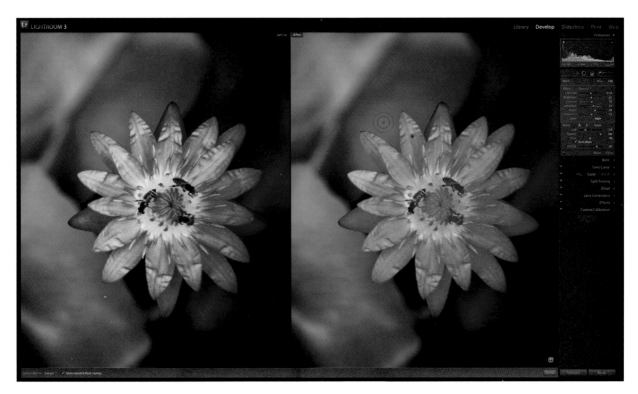

In the case of this image of the water lily and the bees, I've used the Adjustment Brush to paint in a number of small tweaks, including Exposure, Brightness, Contrast, Saturation, Clarity, and Sharpness. By pressing the O key, I've enabled the mask to be shown (by default as a red mask), which makes consistently painting the image much easier. In this case, I've enabled the Auto Mask option and used a small feathered brush with Density set to 81. Auto Mask is amazing at keeping your work within the lines of a well-defined area like this flower; it does less well with faces and other skin tones, where it can appear blotchy.

# 20 Visions, 20 Voices

THE FOLLOWING 20 IMAGES were chosen for all kinds of reasons. Some were chosen for no other reason than that I like them, some because I'm often asked about them, and others because they illustrate something well—even if they aren't my favorite images. Going into this, I think it's helpful to remember that I approach digital postproduction from a particular starting point. Some of you will be surprised at the large difference between the image I start with and the image I end with, so that's why I'm beginning with a note here.

▶ Canon 5D Mark II, 25mm, 1.3 seconds @ f/22, ISO 50

Camogli, Italy, 2010. I did very little to this image except capture it with Singh Ray Gold-N-Blue polarizing and Two-Stop Graduated ND filters.

The first thing I have done in every case with these images is zeroed them. When the image comes into Lightroom, it's accompanied by a basic set of adjustments—brightness and contrast among them. And so they look much better than these zeroed-out images. But the thing is, while this adds a little extra work for me, most of the time I want to begin with a fresh canvas. I don't want my camera or Lightroom interpreting my image for me, so zeroing the file is often—though not always—my first step. Go to the Lightroom Presets in the Develop module and click the General – Zeroed preset. Your image should now look underexposed, bland, and lifeless. It's a depressing place to begin, but it's the cleanest canvas possible.

The next thing you need to remember is that I'm unapologetic about my work being an effort to *interpret* the scene in my viewfinder—both in the camera and in Lightroom. I'm not chasing the "Did it look like that?" I'm chasing the "Did it feel like that?" And although the line between them is subjective at best, that's the way I approach my work. I try to be honest and create images that are true and that express what I saw and felt. I also try to avoid heavy-handedness in my work, but as my outlook on the world is generally hopeful and bright, my images tend to fall in that direction, too. You will have your own outlook, your own experience of the world to express and reflect back to us. And so you will choose to refine your images much differently. (And remember: all of these files are available for you to download. See the introduction for details.) The exercises that follow are not intended to show you how to replicate a certain look but to get you comfortable with the tools of expression available to you, and to familiarize you with a process that will help you bring your images into closer alignment with your vision.

Finally, not every image here is the way I would choose to present it as a final print. There can be several interpretations of one image, and in some cases I've pushed a little further than my own preferred aesthetic in order to make a clearer point or more helpful lesson for this book.

▶ Canon 5D Mark II, 22mm, 1.6 seconds @ f/22, ISO 400

Venice, Italy, 2010. Speedlite fired manually at the end of the exposure.

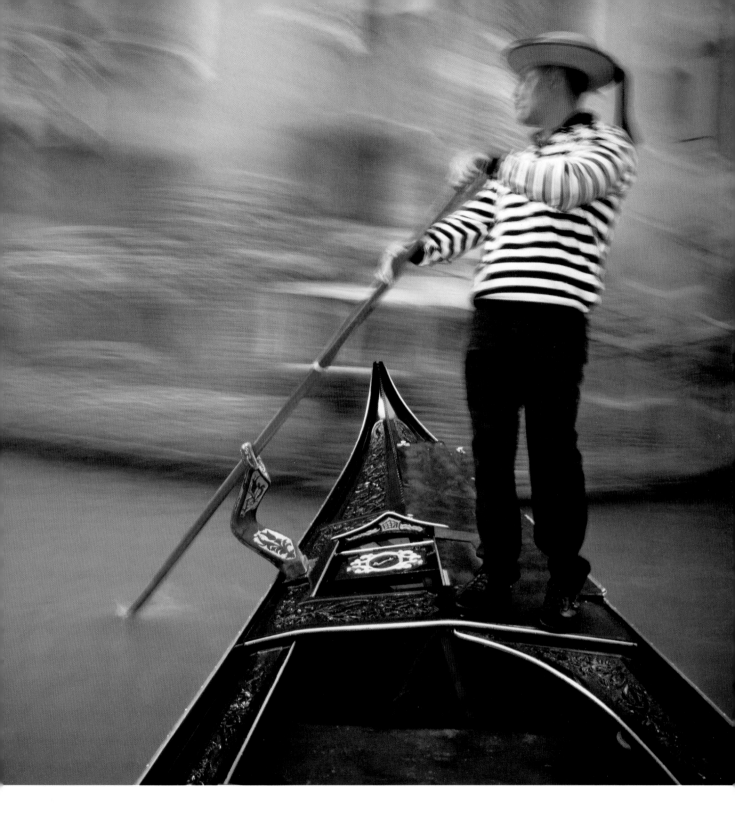

# Pink Umbrella

AS A RECAP, let's review the process. We begin with a) recognizing our intention for the image, b) fixing any weaknesses, c) setting the mood, and d) drawing the eye before e) performing any output adjustments like resizing or sharpening.

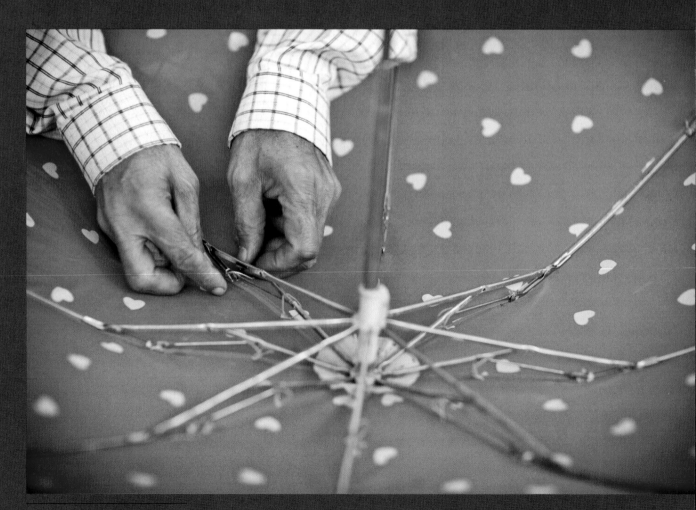

Final image

All I want to do is make my image look better. Okay, it's more complicated than that. But I wanted to begin this chapter with a simple image on which we made simple adjustments. Not every image needs a great deal of work, and if we've done our work well as photographers, this is a finesse of the elements already there, not complete plastic surgery.

I shot this in Chandni Chowk in Old Delhi, India. What drew my eye in this image were the bright colors of what looks to be a child's umbrella. I liked the contrast between the older, textured hands of the man with the bright, smooth fabric of the child's umbrella—and by implication the contrast between childhood and age, male and female. It's not complicated, and the image stands on its own, but as we're working from a RAW file with no adjustments applied, the image needs me to make decisions for it that either the camera or software would otherwise have done. It is with this initial intention, or vision, in mind that I approach my development work.

Not every image is going to need a great deal of time in the darkroom. In fact, as time goes on and you become familiar with your own shooting style—your own voice—you may find yourself coming back to one look time and time again as your starting place. My own vision finds itself expressed most often in brighter colors, solid contrast, and a more luminous look than what my digital negatives give me. Part of this is my past experience with brighter slide film both in my own work and the work of other photographers. I suspect I gravitated to that because something inside me knows this is how I see the world much of the time. So this first image is derived from my own style, is often found in my own portfolio, and is now simply a preset to which I most often go as my starting point. Remember, it's just a starting point, and once I apply a preset I still tweak the individual image—and so should you.

**Zeroed RAW file**

The first place I begin on this image is with the voice of my high school photography teacher in my mind—make your blacks black and your whites white. Remember we're beginning with a completely blank canvas, so if it's not already zeroed apply the General – Zeroed preset. This is a flat file; nothing's really black and nothing's really white. The histogram shows this clearly, too.

The Auto Tone function at the top of the Basic panel is a good place to begin here. It's not perfect, but I'm starting you off easy on this one. The Auto Tone should do a couple things for you. It should push your Blacks to 10, which will make the blacks black. It'll push your Brightness to +22 and your Contrast to +45, both good steps in making up for the low contrast and lack of punch (**A**). You'll also notice it pushes your Recovery slider. If you pull it back you'll see there was no need for this, but for now leave it where it is because I know we're going to use it.

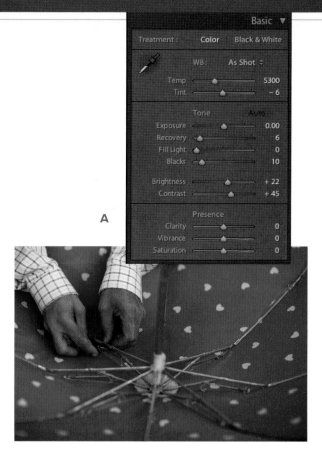

**A**

The image is still not luminous enough for me, so I'm going to push my Exposure to +1.00. This is why I left the Recovery slider where it is—because I'm going to push that even further now to pull back the details on the shirt. In this case, pushing Recovery to 23 pulls the histogram back into line—and with it, the details in the shirt—while retaining the luminosity of the image (**B**).

I'd still like to see more contrast, and I'm going to do two things with this image to do that. The first: go down to the Tone Curve and set Point Curve to Medium Contrast. The second: go back up to the Basic panel and set the Blacks to 15. Basically I'm pushing the blacks—even though the histogram tells me I'm losing detail somewhere—until I lose meaningful detail. In this case, I'm losing detail

deep in the well of the hands. It's not detail that I especially need, so I could let it go. But there's one more thing I want to do to this image that I suspect will take care of that. Going back to the Fill Light slider and moving it to around 22 reclaims that bit of lost detail, but more importantly it keeps this image—which is meant to be bright and fun—from getting too grungy and somber. Bump the Vibrance to +30 if you want to push that feeling a little further, and the big work is done (**C**).

The mood of the image has now been restored. It's luminous and colorful, and as there are no flaws in the image I want to remove or crop out, I can move

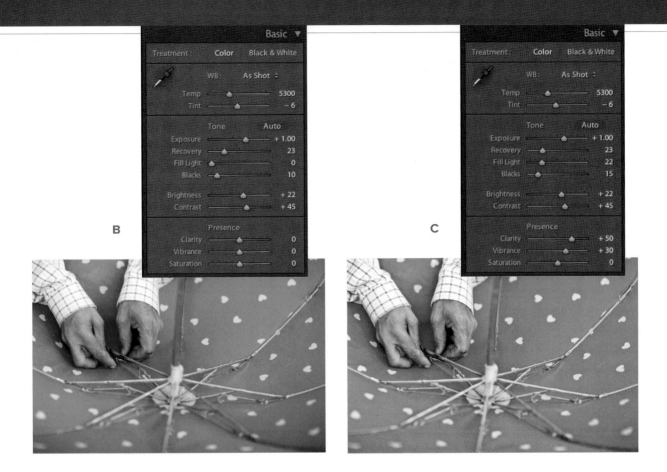

**B**

**C**

on to leading the eye of the viewer a little and putting the last touches on the image.

I'm going to do that, again, in two ways. As my intention was to draw attention to the contrast between the older, textured hands and the child-like umbrella, I'm going to use the Clarity slider in the Basic panel and pull it to +50. As with all tools, you need to apply this in accordance with what you want from the image. In this case, +50 is about right for me. If I use more Clarity, the image begins to feel too grungy, too affected. I think of Clarity as a tool to draw the eye to texture, and it can be applied broadly, as we've just done, or more locally with the Adjustment Brush or the Graduated Filter.

Finally I'll pull the eye in a little more with a vignette. In the Lens Vignetting section of the Lens Corrections panel, I pulled my Amount slider to −80, increasing the vignette, and leaving my Midpoint at 50 (**D**). Sometimes looking at a larger image makes it hard to tell if you're being too heavy-handed with the vignetting; looking over at the smaller Navigator thumbnail on the top left makes it much easier to tell if you need to back off a little.

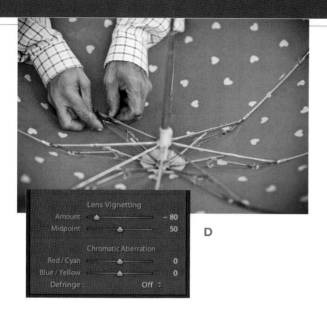

Now all that's left is to sharpen it and export it for print. Output sharpening is beyond the scope of this book, as it depends so heavily on how you're printing it.

In this case, I'll take the image to the Print module, give it one-inch margins, set Print Sharpening to Standard, Media Type to Glossy, and print to a JPEG file. I've specified Custom File Dimensions of 11 x 14 inches as well (E). Then I'll send that file to mpix.com and have it printed on their Kodak Metallic paper. Printing to the JPEG file allows me to create borders and even apply a logo or type treatment before it's printed—all without leaving Lightroom.

What we've done here, with practice, is the work of no more than five minutes. This process becomes intuitive with time and practice. What is important—and what often gets overlooked—is the first part of the process, before your hand even touches the mouse. Awareness of your intention for the image is what drives every movement. You can't set a specific mood or draw the eye to something without first being aware, even vaguely, of the mood you want set and the direction in which you want the viewer to look. We'll talk more later about the role of play, serendipity, and dumb luck in the process, but for now begin to get comfortable with being conscious of your vision and comfortable with the tools of your voice.

▶ Canon 5D Mark II, 85mm, 1/160 @ f/2, ISO 200

Old Delhi, India, 2009.

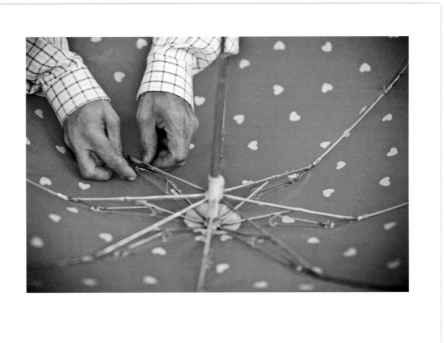

# The Blacksmith

I SAW THIS BLACKSMITH in a small shop off a winding lane in the backstreets of Old Delhi's Chandni Chowk. I sat with him for a while, shooting him while he worked, rested, and had chai. I'm drawn to people like this, people who work with their hands. What was striking about this man was his total lack of facade. He didn't pose, didn't grin for the camera. It was like he saw through me, so his face and eyes will be important to me as I develop this image, as will his context. Aesthetically, I was drawn to the way he and his shop seemed so connected (if not by virtue of being covered in the same grit) and there for the same purpose. To his left, on the right side of the frame, was his fire, and it cast a warm glow. Most of the light came from outside, immediately behind me, and from a small LED light I'd placed near the fire, gelled with a full cut of CTO (Color Temperature Orange) gel, to add to the light from the coals.

In terms of what all this means for my intentions with the image, I know this: that it is a dark image, and that I want the viewer drawn to the grit and texture as well as to the warm, earthy tones of the blacksmith. I also know I want his face and his eyes to carry the bulk of the visual mass in this image.

As for weaknesses that I'll correct, I think only two areas will give me problems—the foremost elbow, which will get a little hot when I begin to bring those values up, and the piece of wood in the lower left, which might do the same. Those two adjustments will need to wait until I'm closer to the end, as the problems will only arise with my other adjustments. So I'll wait until the problems show up, then fix them with the Adjustment Brush; I know I'll be doing some dodging and burning to selectively draw the eye to certain areas of the image, but I'll do that after I've first made the big adjustments and returned the mood to the image.

**Zeroed RAW file**

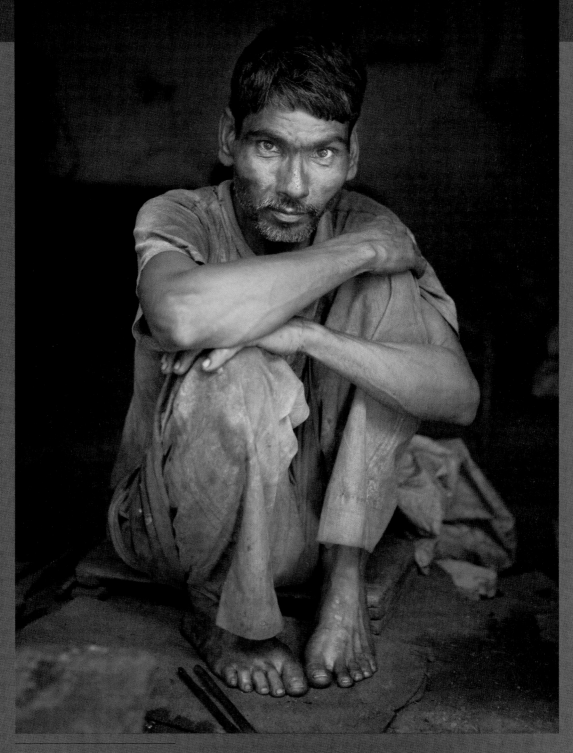

**Final image**

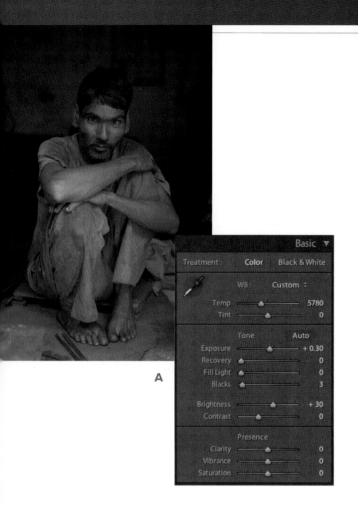

A

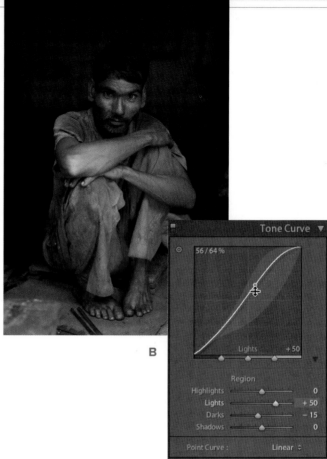

B

Beginning with restoring my blacks and whites, I'm going to push the Exposure slider to +0.30 and the Brightness slider to +30, then push my Blacks to 3. Remember this is a dark shop and there are certainly going to be shadows without detail, and likely no whites. Making your blacks black and whites white only applies if there are, in fact, blacks and whites to be had. I use the Brightness slider because I'm trying to push the midtones up a little more than the highlights, but also because playing with the Brightness slider just gives me a result that feels better. I also push the Temp slider to 5780 to warm up the image considerably (A).

The next step is returning the contrast, and I'll do that manually in the Tone Curve panel by pulling up the midtones and pulling down the shadows. This steepens the curve between those two points and therefore increases the contrast. Be sure to grab the tones in the Lights (not the Highlights) and the Darks (not the Shadows). When you move your cursor over the line in the Tone Curve panel, you'll see the region you're adjusting, clearly indicated by both a gray bubble and the name of that region. In this case, you can see the contrast has been increased between those two regions. The image of the Tone Curve here shows the cursor in the process of adjusting the Lights (B).

C

Lens Vignetting
Amount ——————————— – 100
Midpoint ———————————— 15

Chromatic Aberration
Red / Cyan ————————— 0
Blue / Yellow ————————— 0
Defringe :      Off ⌄

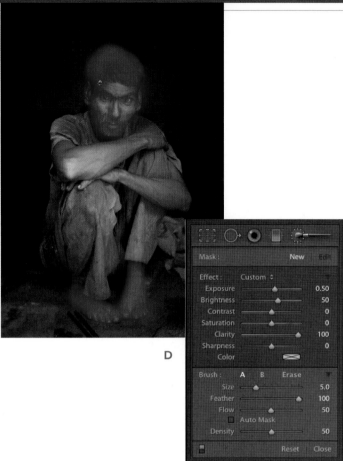

D

Mask :       New    Edit

Effect :    Custom ⌄
   Exposure ———————————— 0.50
   Brightness ———————————— 50
   Contrast ———————————— 0
   Saturation ———————————— 0
   Clarity ———————————— 100
   Sharpness ———————————— 0
   Color        ✕

Brush :    A    B     Erase
   Size ———————————— 5.0
   Feather ———————————— 100
   Flow ———————————— 50
   ☐ Auto Mask
   Density ———————————— 50

                 Reset    Close

I'm going to proceed a little out of order here, and go straight down to the Lens Corrections panel to pull in a vignette. Often I leave vignetting to the end, but as it affects what I do next in terms of pulling my blacksmith visually from his background, I need to darken the background first. So I'll pull my Lens Vignetting slider to –100 (Amount) and 15 (Midpoint) to pull the darkness of the shop back in around the blacksmith (C). Watch the histogram as you do this; any detail that you lose now can be pulled back later if you need to, but it's helpful to remember that all these changes are reflected in the histogram.

Most of the remaining work I'll do with the Adjustment Brush in order to pull the eye to the areas I consider most important. I'm going to kill two birds with one stone by painting in both exposure and brightness, as well as clarity to pop the contrast in the midtones and draw out the textures and grit. So with a medium-sized brush (Size: 5.0, Feather: 100, Flow: 50, Density: 50) and my Auto Mask turned off, I'll dodge the face and hair, the feet, and some of the hands and forearms with a little Exposure (0.50), Brightness (50), and Clarity (100). The screenshot shows the dodging done with the masks visible to show where I've painted (D).

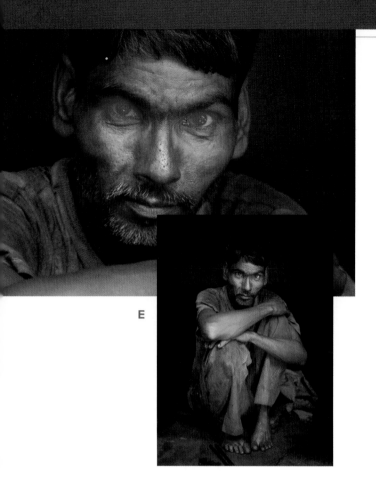

E

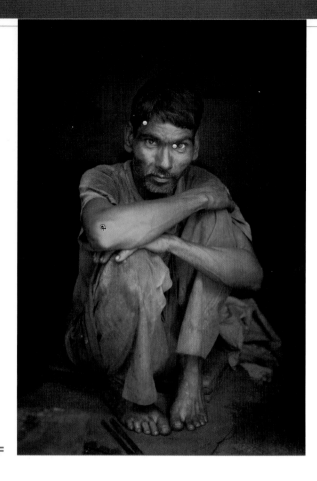

F

But we're not done yet. That's what I call my first-pass dodging. Second pass will be eyes. Zooming in to a 1:1 view, I'll use the same settings and dodge the eyes on their own because I want them a little lighter relative to the face. The screenshot shows the masks (E).

Next I'm going to burn the elbows and the bridge of his nose, just to remove the shine. I've kept the brush at the same settings but inverted the values. The Exposure becomes −0.50, the Brightness

becomes −50, and I've set the Clarity back to 0. I'm again showing the masks so you see that I'm not using a very light touch on these (F).

The only thing left to do is apply a little Noise Reduction—in this case, I bumped both the Luminance and Color to 50—and then sharpen it and print it.

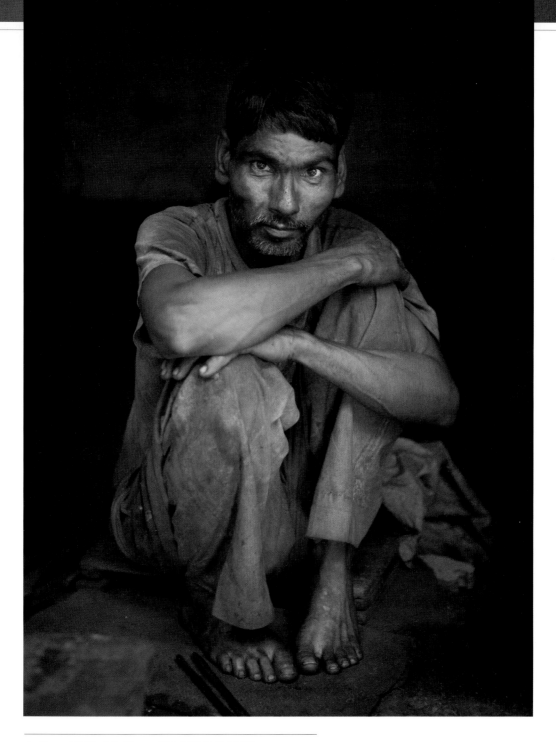

▲ Canon 5D Mark II, 51mm, 1/60 @ f/2.8, ISO 800

Old Delhi, India, 2009.

# Winnowing in Lamayuru

YOU WOULDN'T KNOW IT from looking at the zeroed raw file, but this was shot on a day that was bluer than blue. It was captured in Lamayuru, a village in Ladakh, a high-altitude region in India. It was harvest time, and several impressions from the day remain with me, the most visual being the clear blue of the high-altitude sky, the golden color of the harvest, and the dust and chaff everywhere. These are the things I can reclaim in my image because they were there when I shot it.

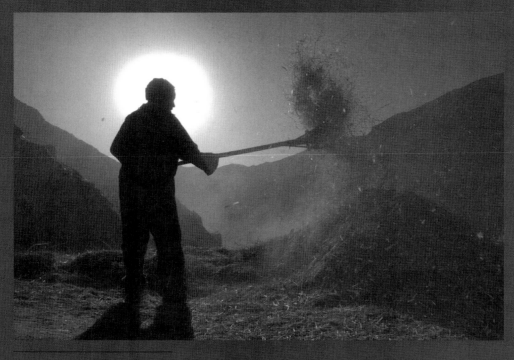

**Zeroed RAW file**

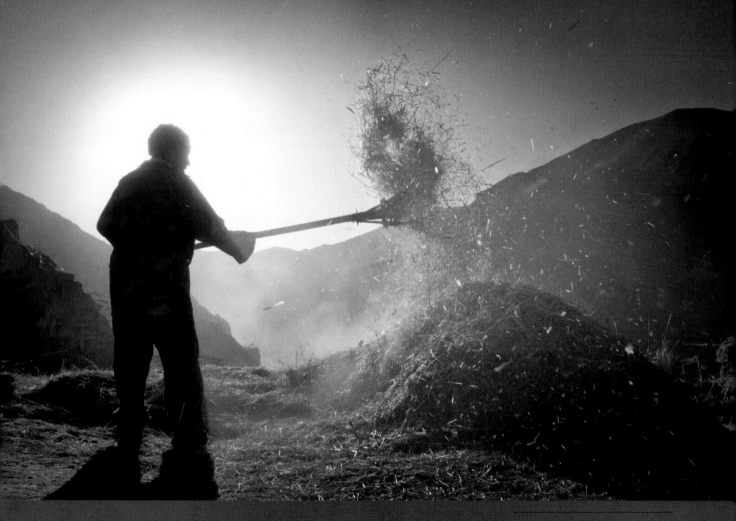

**Final image**

The problem with the RAW file as it is when zeroed is that it doesn't capture the feel. For one, the sun didn't look or feel like a well-defined orb in the sky, so I'm going to work to bring the focus back to the light itself and not just the source of that light (the sun). The contrast is low, so I'll bring that back up and, with it, the blue of the sky. I also want to pull back into the image the feel of the grit in the air.

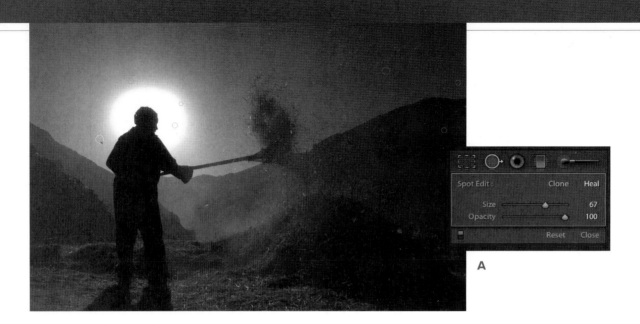

A

The first thing I want to do with this image is get rid of the dust spots. There are a few bits and pieces floating about in this image that don't need to be there, so grabbing my Spot Removal tool and my Wacom pen, I set my brush to Heal, pick a brush size a little larger than the spots themselves, and de-spot the image (**A**). I do this at a 1:1 view so I can see things better, and I do it methodically. I begin in an upper corner and make my way across the sky, then drop down and work my way back across. Holding the spacebar down at any time will turn your Spot Removal tool into a hand and allow you to move the image around. Let go of the spacebar and your Spot Removal tool comes back.

Now we're ready to begin restoring the mood of the image. We'll start by working the Blacks slider because, when we look at the histogram, it's obvious my blacks aren't black, and in a high-contrast, backlit scene like this, it's a sure bet some of the blacks should be hiding details. So I push the Blacks slider to 15.

I'm also going to push my Exposure slider, which might be a little counterintuitive because the histogram tells me my highlights are already blown. That's true, but use the keyboard shortcut J and it will show you *which* highlights are blown. In this case it's the sun, and as there's no point trying to retain detail in the sun, I'll push the slider until it begins to blow out detail I *do* care about losing. Here, I've pushed the Exposure slider to +1.15, at which point some of the chaff begins to lose detail. What I want in this image is the wraparound luminosity of a low autumn sun, so I'm willing to push things a little harder (**B**).

We're still working in the Basic panel. The next adjustments we'll make are with Fill Light, Recovery, and Brightness. I should warn you: it's going to get worse before it gets better. What we're aiming for here is to bring the midtones and the values that represent the hay to a place we can work with. Push Recovery to 25, Fill Light to 25, and Brightness to +20 (**C**). I told you it would look worse. We're going to fix that right now.

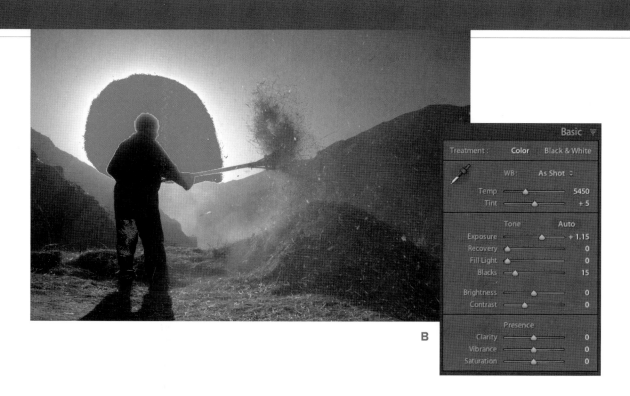

B

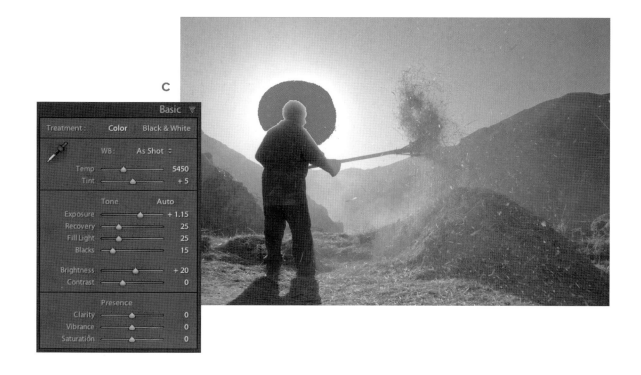

C

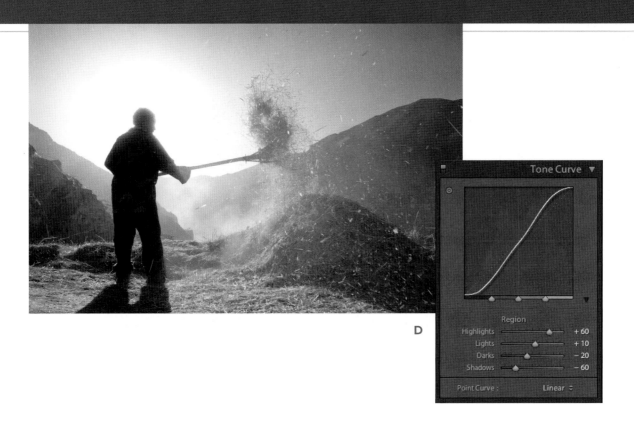

D

Go to the Tone Curve panel and apply a good strong S curve. The values I've used are Highlights: +60, Lights: +10, Darks: –20, and Shadows: –60. These settings restore the contrast (**D**). The image is now beginning to feel luminous and the light now feels more like it is enveloping the face of the farmer than just hitting it from behind. As always, I go by feel. I knew I wanted my darks darker and my lights nice and bright with plenty of contrast. To get more contrast you steepen the curve, and that's what I did, moving the tone curve until it looked right. Of course, what you don't see here is me moving it back and forth and hemming and hawing about which one looks better. But as you're working along on the supplied DNG file, you can do that part yourself. Don't follow the recipe—follow your eye.

The sky still isn't blue, and that we'll do with vignetting. I could use a Graduated Filter, too, but a vignette darkens the image in a circular fashion, which more closely duplicates the look of sky around a sun. Remember, people viewing an image may not be able to put their finger on something that feels odd, but the fact that something doesn't seem right is enough to break their emotional connection to that photograph. In this case, a vignette feels better to me.

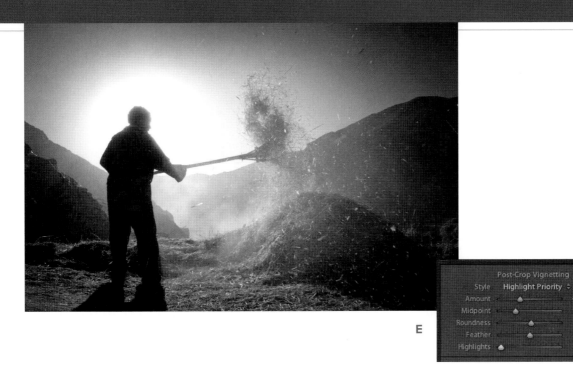

Post-Crop Vignetting

| Style | Highlight Priority |
|---|---|
| Amount | — 32 |
| Midpoint | 26 |
| Roundness | + 7 |
| Feather | 51 |
| Highlights | 0 |

E

Here's how I do it. Here, I think I might want a little more control over things, so I open the Effects panel and do this with the Post-Crop Vignetting tool. And I move stuff around until it looks right. I toggle between the Highlight Priority and Color Priority styles, eventually deciding I like the Highlight Priority. In my case I settle on the following settings: Amount: −32, Midpoint: 26, Roundness: +7, Feather: 51, Highlights: 0 (E). It's not the precise settings that matter—it's that you feel comfortable with the tools so you can finesse things until they feel right to you. Keep an eye on the Navigator panel for the smaller thumbnail view. You aren't going to wreck anything, so play around.

Finally, all I have left are a few tweaks.

I'd like to pull the saturation up a little, so going up to the Basic panel I'll slide the Vibrance slider to +15. I'd also like to draw the eye to the texture in this image. Normally I'd do that with the Clarity slider. But I tried that on this image and I lost the great wraparound light on the face. So what to do?

F

In this image, the texture I want to draw the eye to is almost entirely on the right side of the frame. I could use the Adjustment Brush and paint in the texture with the brush set to Clarity at +100, but there's a faster way in this image. Using the Graduated Filter set to nothing but the Clarity at +100, I drag the filter across the image until I'm clear of the chaff on the pitchfork (F).

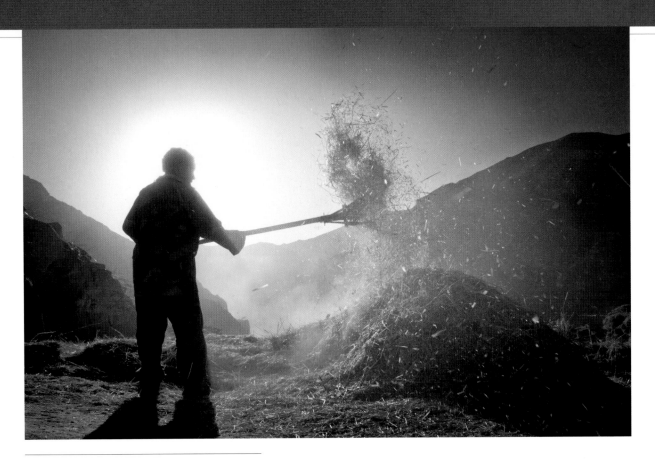

▲ Canon 5D, 28mm, 1/160 @ f/2, ISO 200

Lamayuru, Ladakh, India, 2009.

As I've said elsewhere, it's important to remember that every tweak, or push, comes with a pull. What we get from one place, we pay for in another. Here, we've pulled the histogram pretty hard to the right. I should have, in hindsight, given it another stop of exposure in the camera. But I didn't, and now there's noise—most evidently in the sky at the upper right.

To minimize the noise, zoom in to a 1:1 view so you can see what you're doing. Pick a patch of sky at upper right. Now open the Detail panel and slide the Color slider to the right. I stopped at 40 and kept the Edge Detail at 50 after moving it around and not seeing an appreciable improvement either way.

The final image is now ready to be sharpened and printed.

# Bound

I SHOT "BOUND" In Nizamuddin Darga, in Delhi, India. The darga is a shrine to a Sufi saint and is, at times, a magical and intense place. This woman had prostrated herself and was praying. The shackles on her wrists are promises she's made to the saint or to Allah. It's a simple image and in my mind's eye it draws

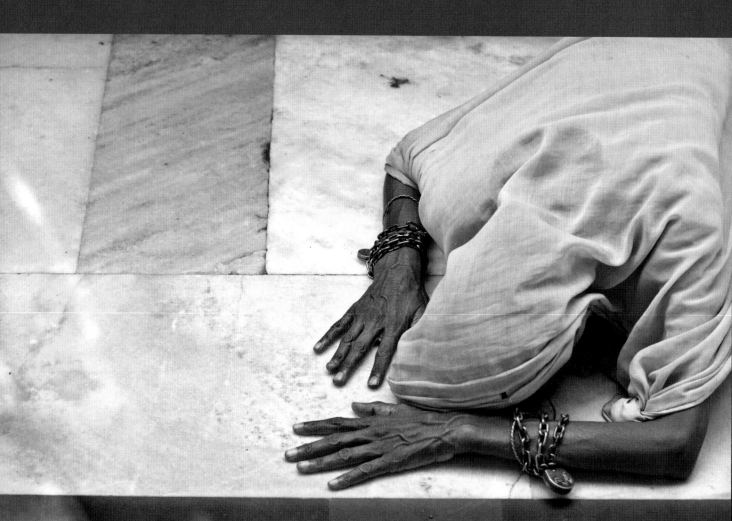

**Final image**

**Zeroed RAW file**

its power from the gesture, so my postprocessing work will go in that direction. There are some lovely earth tones in this image, and the photograph could work rendered in several ways, but I wanted fewer elements competing for the attention of the eye. So I rendered it in black and white.

Before I even touched this image I knew what I wanted from it. I wanted it in black and white, possibly a duotone. I wanted it to feel stark and a little harsh. This is not a gentle image. It's an image with a woman pouring her heart out, and she's physically, if not also metaphorically, in chains. And I wanted the eyes of the viewer to go where mine went—to the intersection of her hands and head, to the texture of her skin and the juxtaposition of the

chains on an otherwise soft and feminine figure. That's my starting point.

Correcting flaws in the image will be easy. The only thing I feel needs fixing in the original file is the slight skew; it's just not straight, and the horizontal lines on the marble make this not only obvious but easy to fix.

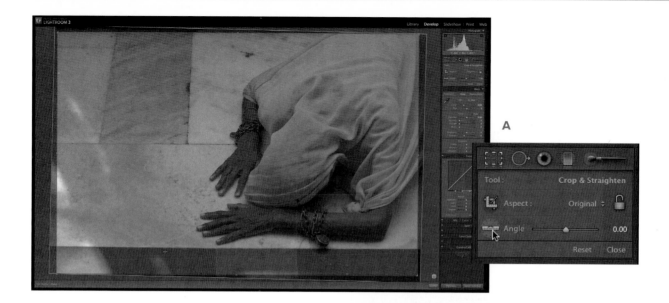

A

Click the Crop Overlay tool, or just press R on your keyboard to bring it up. Now you can eyeball this—grab a corner of the image and rotate until straight—or you can use the Straighten tool. Click the icon for the Straighten tool to activate it, then click and drag it across the horizontal line of marble at the bottom of the image (**A**). Press Enter to make the change. This works great for any image in which there's a line you know to be vertical or horizontal—it takes the guesswork out of straightening an image.

Because I want to get straight to the black and white conversion for this image, and there's not a lot of fancy tweaking I want to do with the exposure, I've used the Auto Tone function in the Basic panel to get me to a starting point faster (**B**). I'll come back later to tweak, but as you can see it gives me a good place to work from without doing anything weird to my histogram.

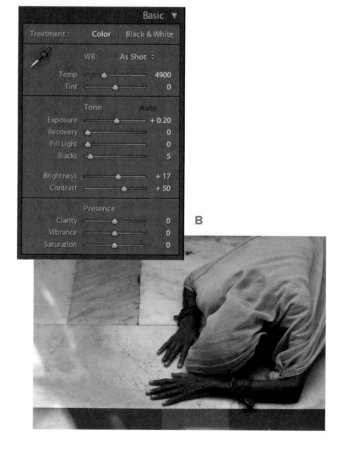

B

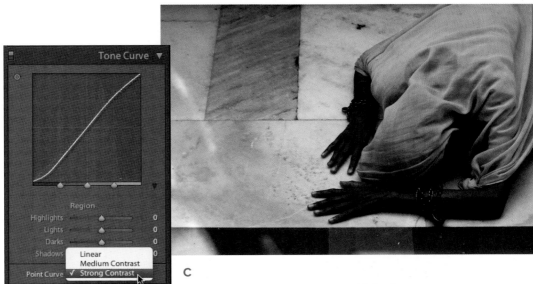

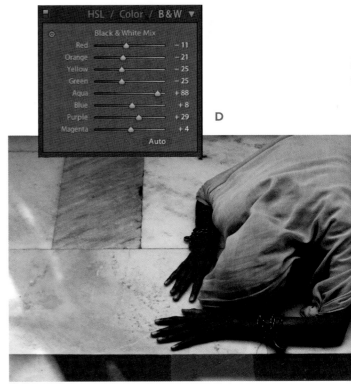

C

D

Before we do the black and white work, I'm also going to introduce a little more contrast to the image, this time with a simple Point Curve preset. Open your Tone Curve panel, go down to the bottom, and from the Point Curve drop-down menu select Strong Contrast (C). This is a decision made by preference—I like strong contrast in my black and white images—but it's also specific to this image because I know that a stronger contrast is going to accentuate the stark feeling I want in this photograph. A gentler imager—something I wanted to be softer—would likely benefit from a softer contrast as well.

Now we're ready to tweak this in black and white. Go down to the HSL/Color/B&W panel and click the B&W option. This immediately converts the image to a black and white representation of the underlying color file, but will keep those color channels intact, allowing you to push and pull the tonal values according to your tastes and vision for the image (D).

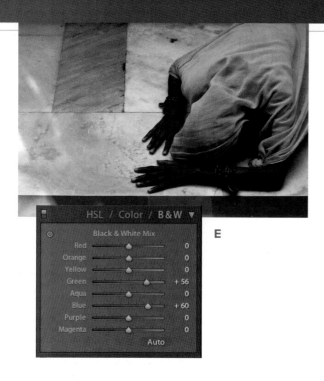

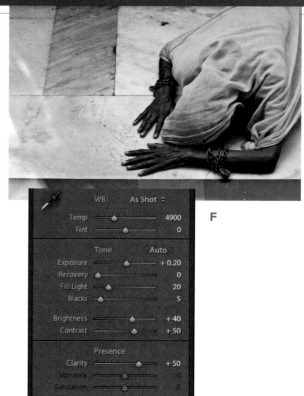

The default values will need some tweaking, but first take a moment to push each slider back and forth. You'll notice the Red slider doesn't affect much more than the dark skin of the woman's arms. Orange also affects the arms but alters the tonal values of the marble and the woman's covering, as does Yellow. Each slider makes subtle changes to the image. Take a moment to notice what each one does and which changes you might use to push and pull the eye of the viewer. Blue, for example, seems to really pop the chains if you pull the slider to the right.

The values I settled on came from this same exercise. I wanted the skin tones lighter so I pulled them back to 0. I noticed the Yellow slider introduced

a moiré pattern into the woman's garment, so I pulled it back to 0 as well. Green helped lighten the garment without reintroducing that moiré pattern. Aqua got reset to 0 because it didn't do much for me. Blue, as you discovered, made the chains pop a little, and so I've pulled the slider to +60 (E). The changes here are subtle but they're important, and in images with more color you'll notice the changes are less subtle.

Now that I've tweaked my black and white conversion, I'm ready to go back to the Basic panel to tweak the overall feel of the image. I'll do this tweak now because shifting around the values in a conversion can affect the histogram, and it's easier to fine-tune things after you've made the big shifts.

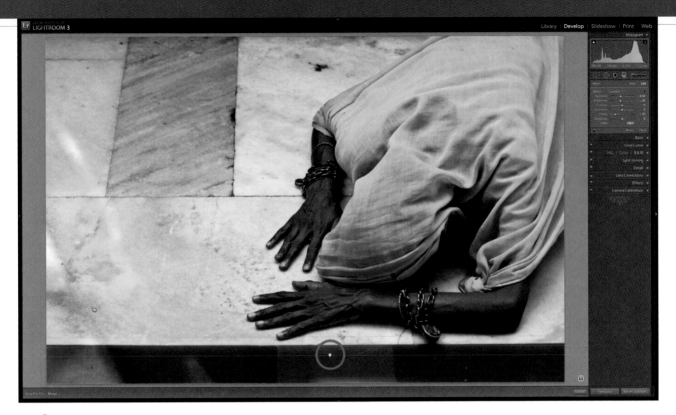

G

The last round of adjustments kept things pretty dark, so let's bring the Brightness to +40 and the Fill Light to 20. Notice how the histogram reveals some clipping in both the shadows and highlights? Press J to reveal which shadows and highlights are being clipped. They're few, and we can correct them later. Remember: fix the big issue first. In this case, it's the need to brighten the image. The small bits of clipping are easily fixed with a brush or gradient filter later. While we're here, pull the Clarity slider to +50 to pull a bit of focus to the textures in the shawl, the hands, the chains, and the marble (F).

The final tweaks will be made with two separate gradients. The first will be used to slightly burn the lower-left corner, the second to both darken and slightly defocus the dark slab of marble at the bottom of the image. I want to darken it to further anchor the image and give it more weight, and I want to slightly defocus it in order to make it less distracting. Again, subtle changes.

The first gradient is pulled from bottom left and up to the end of the first triangle of light with the Exposure at −0.50 and Brightness at −20. The second is pulled from just inside the black strip of marble until it touches her little finger, with Exposure at −0.50, Brightness at −30, and Clarity at −65. Hold the Shift key down as you drag the gradient and it'll stay straight (G).

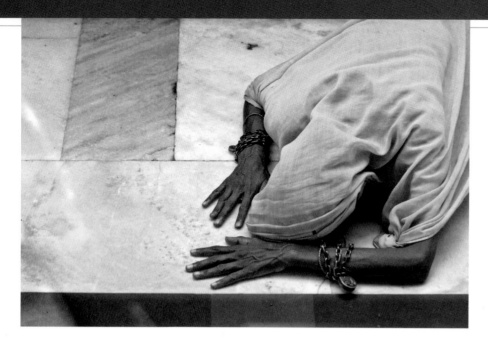

◀ Canon 5D, 85mm,
1/125 @ f/5.6, ISO 100

Nizamuddin, Delhi,
India, 2008.

The image, as it is now, is where I stopped the first time. But the more I played with it the more I wanted two more things, so these are optional. I wanted to try pulling the eye even harder to the hands, chains, and folds of the cloak, and I wanted to introduce a subtle tone.

For the first, I simply painted in the changes I wanted. With my mask visible (the keyboard shortcut is the O key), I painted in a little Exposure, Contrast, and Sharpness, along with a maxed-out Clarity slider (**H**).

Lastly—and I really mean it this time—I used the Split Toning panel to create a slightly warm tone for the image. I chose warmer earth tones, kept the saturation quite low, and kept them evenly balanced (**I**). I'm still undecided on which of the final prints I like more, but the final image with the warmer tones and the slightly more dramatic hands and folds seems a little closer to what I felt about this scene to begin with.

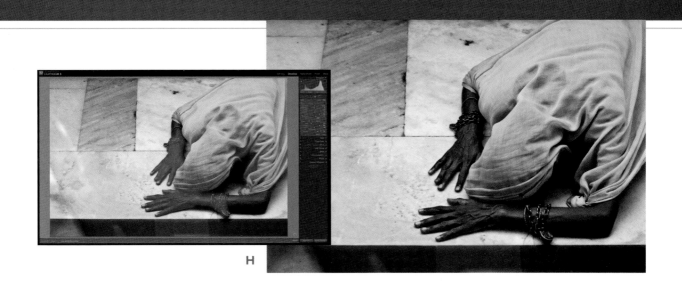

H

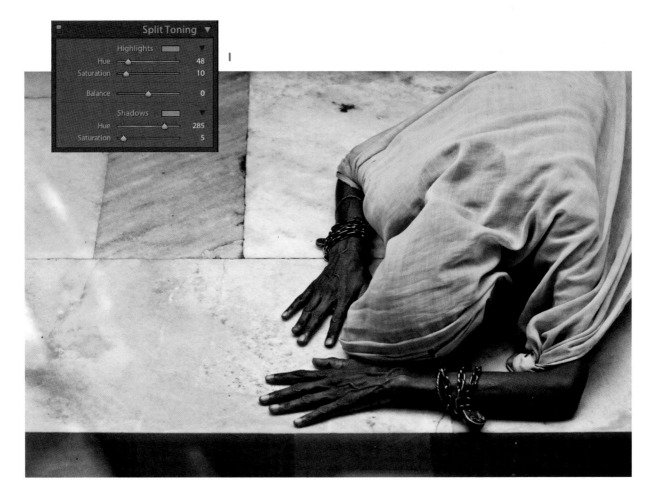

I

# You Go Your Way

I SHOT THIS IN TUNISIA in 2008 in the small town of Kairouan, a city on the edge of the desert and full of the subtle colors that desert towns often are. My intention with this image was to do a couple of things. The first was to bring back to the image the memories I had of the place, particularly the way the colors interplayed, warm and cool so subtle and well balanced. The second was to draw the eye of the viewers of this image to the divergence of the two figures, the woman and the cat each walking out of the frame in opposite directions.

I have resisted the urge to place the images in this chapter in a particular order, in part because I believe we need to take each image on its own merits, and discussing things in terms of basic techniques and advanced techniques isn't helpful. Everything I cover in this book is what I consider basic, but that's not the point; the point is that we learn to recognize our intention for an image and to choose the tools to best realize that. Whether it happens in five steps or twenty steps is not important. Only that we achieve our vision is important.

Beginning as we have with the other images so far, I'll start by zeroing the file. Even as it is, there is something I love about this image. Had this scene, and the town in general, not initially grabbed me with its colors, I might have chosen to do very little to the photograph. The muted tones of white and orange are lovely as they are. But I'm guessing you could say the same about a blank canvas as well—lovely on its own terms but not what I envisioned.

**Zeroed RAW file**

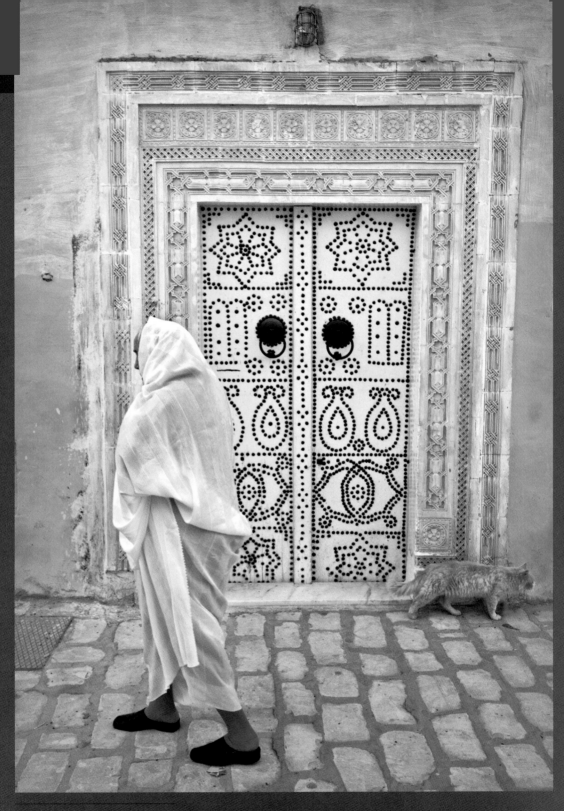

**Final image**

The first thing I did to this image was crop out the distracting bits of rebar poking into the top right of the frame, and then the small edge of window, also on the right side of the frame. Holding the Shift key as I crop it allows me to keep the original aspect ratio.

Now I'll turn my attention to the histogram and push things to recover some highlights and return my black values to black. Being able to predict your adjustments will save you time, and the more you do this, the more you'll come to see the patterns in your workflow. I know I want to bring back the contrast to this image. I also know I'll use a steep tone curve, and inevitably that means I'll push my highlights a little far. So pushing the Recovery slider a littler further now means less of a tweak later. Again, not everyone will choose to do it this way, as not everyone likes the look that the Recovery slider creates. So I begin refining my vision in this image by pulling the highlights back, with Recovery set to 20; then I pull my blacks in by pushing Blacks to 20 (**A**). Right now it all looks like a step backward. Every act of creation begins with an act of destruction, so get comfortable making things look worse before they get better.

The next step is to begin to restore the mood of the image. Pushing the Clarity slider to +80 will pull out some of the texture in this image, particularly around the door, which is rich with contextual details. Pushing Vibrance to +30 begins to bring back the richer colors (**B**). When working on this image originally, I cranked the Vibrance slider, and it was seeing those colors that made me want to reintroduce them to the image. The Vibrance or Saturation tool was not the way I wanted to do that, so I'll push it a little here and then go further with the more specific tools in the HSL panel.

**A**

As we work our way down through the tools, remember what each one will bring to the aesthetics of the image. The next thing we'll do is tweak the Tone Curve, but not everyone is going to want to do that to this image. This image would look great without much change in contrast. It might look

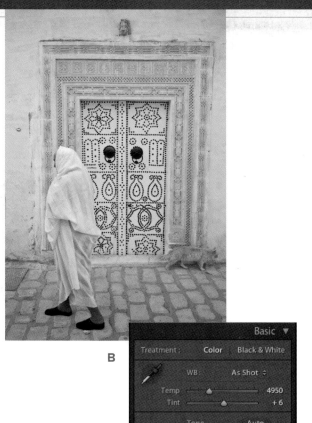

B

C

great as a well-rendered black and white image as well. But that's not the way I saw it. Contrast has the aesthetic effect of intensifying color, so this next change will begin to significantly alter the feel of the image. Push the following values on the Tone Curve panel: Highlights: +60, Lights: +10, Darks:

−20, and Shadows: −55 (C). As you do this, keep an eye on what changes, aesthetically, in the image, and then back off when you begin feeling you've gone too far.

We'll now make the final changes on the image by bringing the specific colors back in and using the HSL panel to do so in a more targeted fashion than we might have with the Vibrance or Saturation slider alone.

I have two goals as I pick up the Targeted Adjustment tool in the HSL. The first is to darken and saturate the blues; the second is to saturate but lighten the oranges. So grabbing the Targeted Adjustment tool next to the Saturation section of the fully expanded HSL panel and hovering over the blue wall, I click and drag up, increasing the saturation. In this case, I stopped at +70. Doing the same—but this time focusing on the cat—I click and drag up to increase the saturation in the orange and yellow tones, stopping when the oranges are at +55 and the yellows at +38. Now moving to the Luminance values, I do the same, pulling the blue values down to −34, and then the oranges and yellows to +7 and +5, respectively (D).

All these numbers make it easy to forget that this is a process guided by your eye. Forget the numbers on this page and try developing this image according to your own taste. You don't have the advantage of being there, so your vision will have to be guided by your reaction to what you see here, but that's as valid as being there. What do you feel, what do you want people to look at when they see your image? Now make it happen with the simple tools at your disposal.

The last thing I did was go back to the Fill Light slider and push it to 12 in order to pull the histogram into line and put a little detail back into the shadows. It's a small thing, but a craftsman is marked, I think, by the attention to details that others might not notice.

D

▲ Canon 5D, 33mm, 1/125 @ f/5, ISO 200

Kairouan, Tunisia, 2008.

# Nizamuddin Chai

THIS WAS ONE OF THE FIRST IMAGES I ever made in India. I was with my friend, photographer Matt Brandon, and he took me to the shrine in Nizamuddin, Delhi. It was my first introduction to India and the impressions of that day, both early in Nizamuddin and late in Old Delhi, are what informed my choice of

**Final image**

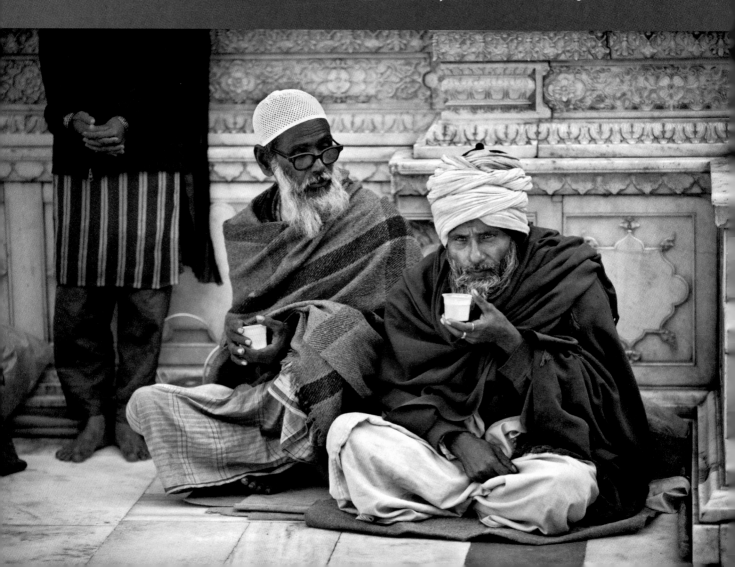

this duotone. Oddly, I get asked about this series a lot, and it's no more than a simple split tone of a black and white image using tones that best invoke, for me, what I felt about this place.

Nizamuddin is a magical place and feels like India might have felt 100 years ago. So I wanted this series to feel antique or old-world, and to have a warm richness to it. I began with a black and white conversion, then started working with something like a modified sepia tone. Sepia is nice, but it often looks merely like a yellowed black and white.

I wanted something richer, so I went with yellows for my highlights and purples for my shadows. That was my intention for the image. Let's see how I got there.

**Zeroed RAW file**

My first steps in taking care of the weaknesses of this image are going to be directed to the highlights that are burned out. A quick look at the initial histogram once the image is zeroed shows you burned-out highlights in the skull cap of the man on the left, as well as on the cups. I'd like to bring those in a little, so I'll begin pulling my Exposure down to −0.20 and my Recovery up to 15. Then I set my Blacks to 17 to really punch the blacks (**A**). I'll change these later on, but this kind of image work is a little circuitous at times as you work with the push and pull of the darkroom; for this lesson, I'm not cleaning up my process so that you can see every step I take in getting there. Remember this is not about recipes for image presets; it's about learning to find your voice—and that can be a messy process. Once you get the hang of this, it'll feel more intuitive and less like total guesswork, but you'll become familiar with things so that setting your Blacks by feel alone or seeing your Fill Light wash out a little before you get to the Tone Curve panel will feel like part of the process—and not some terribly abusive thing you're doing to your photograph.

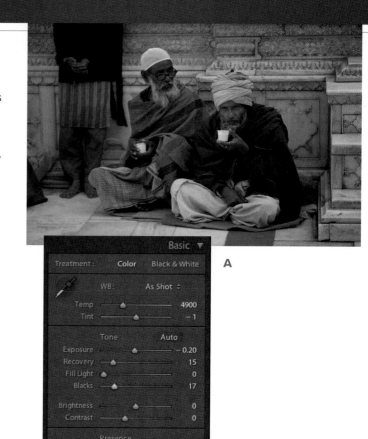

A

So into the mess. Going down to the Tone Curve panel, I'm going to set the Point Curve to Medium Contrast and the curve itself to a gentle S-curve to increase the contrast. Of course, this is going to muck things up a little, sending me back to the Basic panel to do more tweaks, but that's part of the fun. So I set the values on the curve itself to the following: Highlights: +28, Lights: 0, Darks: −7, and Shadows: −15 (**B**). The image is getting pretty dark now, but we'll bring those midtones up after we've done the black and white conversion and the split toning.

The black and white conversion is the important part of this image, as the values you choose will determine your tones and, therefore, the pull each of these elements has on the eye of the viewer. Take your time with this, and for each color pay particular attention to the changes that occur and how they interact with the rest of the image. Here are the values I chose for the conversion and, more importantly, why I did so.

I left the Red at 0 because it had little effect on the image, and the more you push these sliders

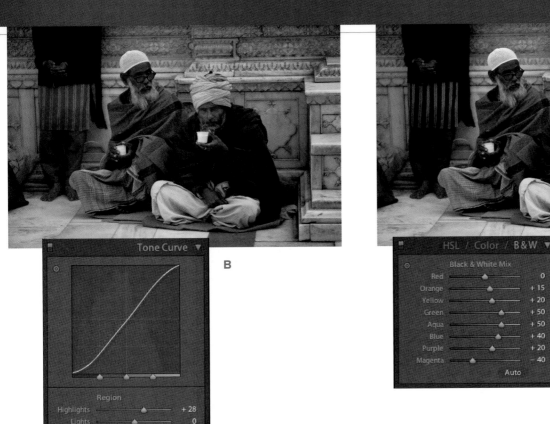

B

C

around the more noise you will begin to encounter. So if it makes no desired change in the image, put it at 0. I pushed Orange to +15 to lighten the faces, particularly the face of the man on the right, who is the one I most want people looking at. I placed Yellow at +20 to brighten the turban on that same man, again to draw the eye with greater pull in that direction. Both Green and Aqua I pushed to +50 to brighten those colors and make the image a little more textured, but I'm reluctant to push harder because of the noise it will introduce—and as I shot this at ISO 800, that's a concern. I pushed Blue to

+40 for the same reason and because it brought out some of the light falling on the shoulders of my main subject. I set Purple to +20. I set Magenta to −40 because it darkened the shalwar kameez of the woman to the left, making the stripes stand out a bit more (C).

You don't always know how you're going to set these values, but as you move things around you're guided by knowing where you want your viewer's eyes to look. The eye is drawn to contrasts, so where you want the eye drawn, increase the

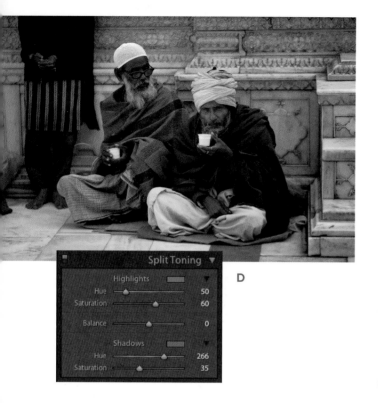

contrast; where you do not want the eye to settle, lower the contrast. There are other ways to do this, as well—it doesn't all fall to contrast to do this—but in a black and white image, this is one of your most powerful tools.

Right now the image is still a little muddy, but we'll do the split tone first, then go back and tweak it.

The split tone values I chose for this image are random. I move things until it looks right. It's no more scientific than the way a chef might approach a new recipe. You do it to taste. I usually begin by cranking my Saturation on both the Highlights and the Shadows so I can more clearly see the Hue when I apply it, then I back off the Saturation. For my entire Classic India series, I chose the following values: Highlights Hue: 50, Highlights Saturation: 60, Shadows Hue: 266, and Shadows Saturation: 35. The Balance between the two I left at 0, but you can play with it (**D**). What I chose may not be your choice.

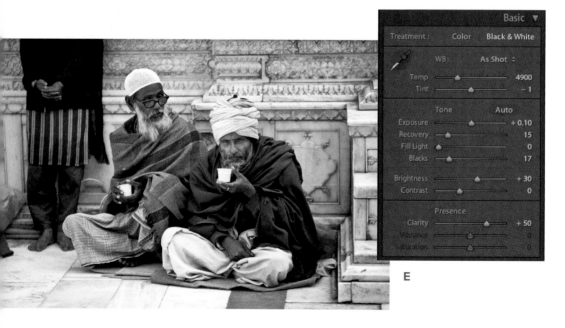

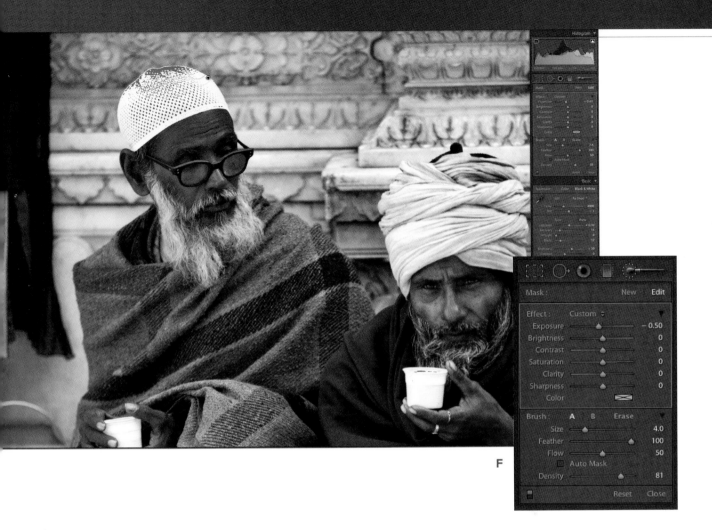

F

If you're tracking with me on your copy of this image, then you're looking at a muddy split-toned version of this image. So let's head back up to the Basic panel and push things around a little now that we have a better idea of what we're working with.

My initial adjustments were to lower the Exposure, but I'm now going to bring that back and push it to +0.10. I'll also push the Brightness to +30 to bring the midtones up and make the image much brighter. And because this image is full of great texture and I want the eye drawn to it all, I've pushed the Clarity to +50 (**E**).

By now your histogram should be showing some burned-out highlights again. You could push the Recovery slider, but as the problematic highlights are really only limited to the skull cap, the Adjustment Brush might be the easiest way to solve this without affecting the whole image. Hitting the J key will activate the visible highlight warning, and using a medium-sized brush with the Exposure dialed down to −0.50, I paint those highlight warnings out (**F**).

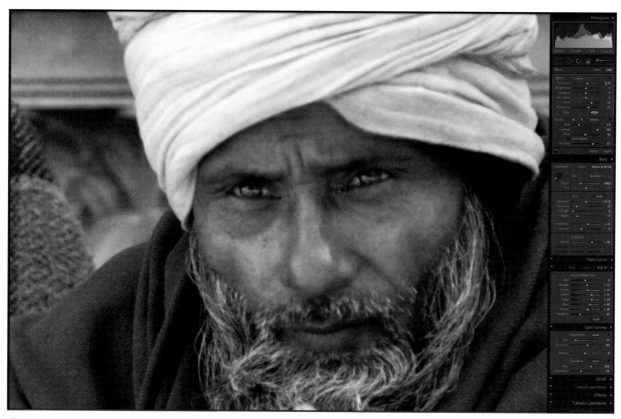

G

Two more steps. Before I finish this image I want to compensate for some of its softness by making the eyes of the man on the right seem a little sharper. Using a small brush and zooming in, I'll paint a little Exposure, Brightness, Clarity, and Sharpness into the eyes. I usually leave the mask visible (press the O key) for this as it makes things a little easier, especially if you're not yet using a Wacom tablet for which this painting stuff is ideal. In this case, I've turned it off so you can see the eyes (G).

The last thing I'll do to this image is apply a vignette. I'm a big fan of vignetting to begin with. When used well, it subtly pulls the eye to the middle of the frame. In this case, I'm less interested in subtle. Older cameras vignetted quite heavily and as I'm after something that feels vintage, I've pushed the Lens Vignetting sliders in the Lens Corrections panel to an Amount of −94 and a Midpoint of 30 (H).

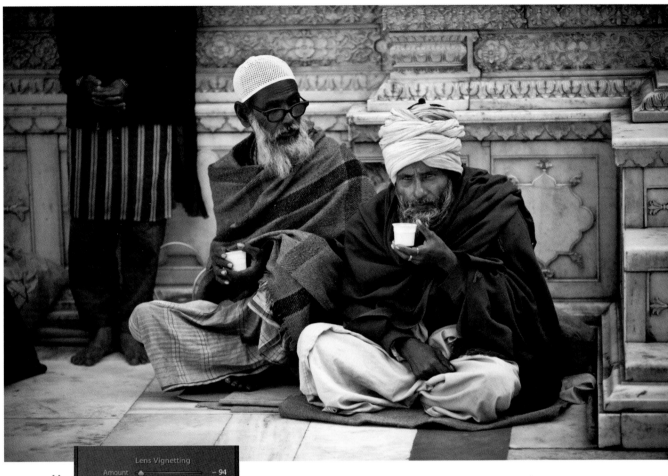

H

**Lens Vignetting**

| Amount | – 94 |
| Midpoint | 30 |

**Chromatic Aberration**

| Red / Cyan | 0 |
| Blue / Yellow | 0 |
| Defringe : | Off ⌄ |

▲ Canon 5D, 135mm, 1/3200 @ f/2, ISO 800

Nizamuddin, Delhi, India, 2008. I know, my ISO is way too high and I could have benefited from a tighter aperture, but sometimes you get distracted. Happens to me all the time.

# Judy

THIS IS JUDY. She's my trainer and a really cool human being, one of those luminous people who always seem to glow from within. So when it came to making a portrait of her I wanted something bright and luminous. My intention with this image was to create a photograph that felt light, organic, and real, with no touch-ups—because that's how Judy is.

**Zeroed RAW file**

You wouldn't know it from looking at the zeroed RAW file, but I began the process with this image well before I shot it, lighting it soft and even against white seamless paper, and keeping the background a little brighter than Judy was, so the background would blow out to complete white when I did my Lightroom work. In hindsight, the only thing I'd change is the color of her shirt, which I ended up changing in postproduction to match the feeling of the series I was doing.

Beginning with an understanding of your intention for this image should already give you a sense of where you'll go with it. You'll want to push Exposure and possibly some Fill Light. You'll want to push the contrast, and you'll probably want to do some tweaking with Saturation and Luminance. To finish this portrait, we'll punch the eyes a little, and use the Lens Vignetting tool to give more wrap to the light. Once you know your vision, the rest is play and responding to things as you tweak them.

By now you should be heading straight to the Basic panel to make blacks black and whites white. Remember you'll take this step only if there are

Final image

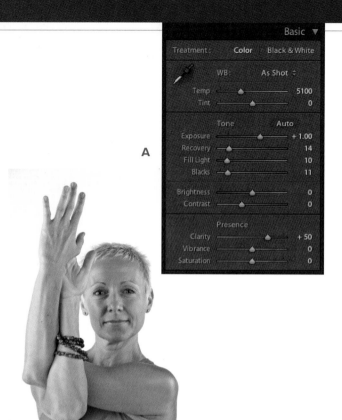

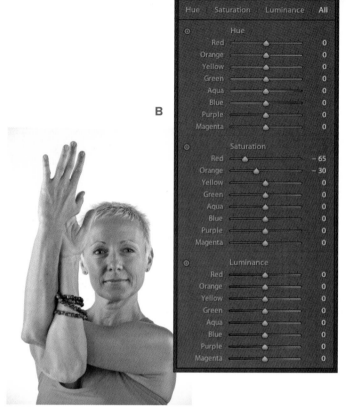

values in the image you want to be black or white. If not, it's terrible advice, the exception to a rule meant to make your image look better, not worse. In this case, we'll push the Exposure a full stop to +1.00, Recovery to 14, Fill Light to 10, and Blacks to 11. For now I'm leaving Brightness and Contrast alone but pushing Clarity to +50 to accentuate some of the image's natural lines and textures (**A**).

I usually go to the Tone Curve panel at this point— and I'll get there—but I want to skip ahead to changes that affect the overall feeling of this image. I suspect that getting the image a little closer to that organic feeling I've identified as my vision will help me make more intelligent changes to the contrast

through the Tone Curve. So let's pull some of the saturation out of the shirt to bring the image closer to the soft, earthy feel I want in this image. Open the HSL panel and click All to display the Hue, Saturation, and Luminance sliders all at once. Activate the Targeted Adjustment tool in the Saturation section by clicking the little bull's-eye to the left of the word Saturation; then click and drag down on a section of the red shirt. This drains some of the color from both the Red and Orange and softens both the shirt and the skin tones. I pulled them down until my Red values were −65 and my Orange was −30 (**B**).

Now do the same with the Luminance, but go the other way. Make sure you first grab the right

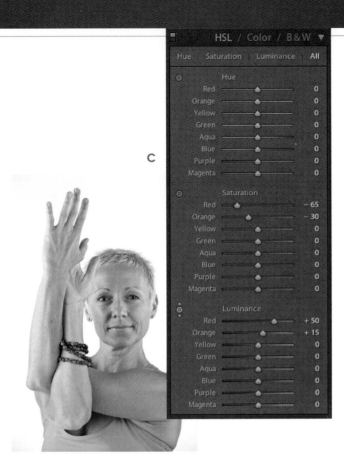

C

D

Targeted Adjustment tool (the one beside Luminance), then click on the shirt in roughly the same place you did before and drag up to increase the luminance. I stopped at +50 in the Red and +15 in the Orange (C). The portrait is still looking lifeless, but the whole feel of the image is beginning to come into alignment with what I was imagining. I may not always know exactly what the image will look like, but I know what it will feel like—and this is getting closer.

Now let's head back up to the Tone Curve panel. The first thing I'll do is change the Point Curve to Strong Contrast, which as you can see has an immediate effect on the look of the image (D). We'll tweak it further, but it's important that you grasp

how fundamental contrast can be in the look of an image. You may not even be thinking, "Hey, this image needs more contrast." You might be thinking, "This image needs more punch, or sharper color, or, uh, chewier textures." Contrast is a technical word and, in some cases, it's a good one to describe an aesthetic change, but just as often it's unhelpful. That's why it's important to know what your tools do to the aesthetics of the image, not just what they're called.

To fine-tune the contrast, go to the Tone Curve itself and push the Highlights to +25 and the Shadows to −25 by either moving the sliders or grabbing the curve itself and pulling the Highlights up and the Shadows down. Keep an eye on your histogram,

and whether you need to hit the O key to show those highlight warnings. It's okay to keep the background burned out; just don't pull the highlights so far that you start losing detail on her fingers or the edges of her face (**E**).

We're getting much closer. I have two remaining issues. One is that her eyes lack the sparkle I know them to have, and my own eyes—as a viewer of this image—are not pulled to them as much as I'd like others' eyes to be, so we'll brighten them. And the light still doesn't wrap as much as I'd like, so let's do that one first by going down to the Lens Vignetting tool in the Lens Corrections panel, and dragging Amount all the way to the right, to +100 (**F**). See how it now appears that the light is wrapping around her a little more? You'll need to keep an eye on your highlights when you do this. They can burn out easily, but if you've followed along we've just barely avoided it. Too much? You can either back off on Amount, or try pulling Midpoint back a little so it recedes beyond the area you've accidentally blown out. A little give and take, right?

Finally, I want to make the eyes pop a little, so I'll use the Adjustment Brush with a brush slightly larger than the eyes and with a heavy feather to keep things natural looking, because if I'd lit this image better in the studio that change in light would have affected more than just the eyeballs—and that's often where retouching eyes gets dangerously weird-looking. With this brush I'll gently paint in some Exposure (+1.00), some Brightness (20), and a little Contrast, Saturation, and Clarity (10 of each) (**G**). If you want to get picky at this point, you can use another brush, dial the Exposure slightly into the negative, and paint out the hotspots on the nose. But I like them there.

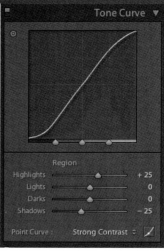

E

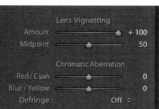

F

G

Canon 5D, 153mm, 1/60 @ f/8, ISO 125

Vancouver, Canada, 2008.

# Toward Lamayuru

WE DON'T ALWAYS KNOW what first draws us to photograph a particular subject. Sometimes it's no more than a visceral reaction that only later we begin to understand. But for this image, the reason was clear to me from the beginning, and that's rare. What attracted me were the ascending lines that rise from the bottom of the image toward the peaks, as well as the sense of scale. When I photographed it, it felt much the same way as when I was a teenager poring over Ansel Adams' work. So when it came time to do my postproduction, I knew I'd want to draw on the aesthetics that Adams' work was known for: high contrasts, dark skies, and beautiful tonal range.

Bear in mind, my goal isn't to copy Ansel Adams—I just want to re-create a feeling his images once gave me.

Aside from the importance of the black and white conversion, the changes I'll make in the Tone Curve panel are going to be critical, so I'll go there—and also do other tweaks in the Basic panel. I also want to do some dodging and burning to selectively pull out details and create stronger implied lines. If careful dodging and burning was good enough for Ansel Adams, it's good enough for me—and it's much easier with Lightroom than in a darkroom.

**Zeroed RAW file**

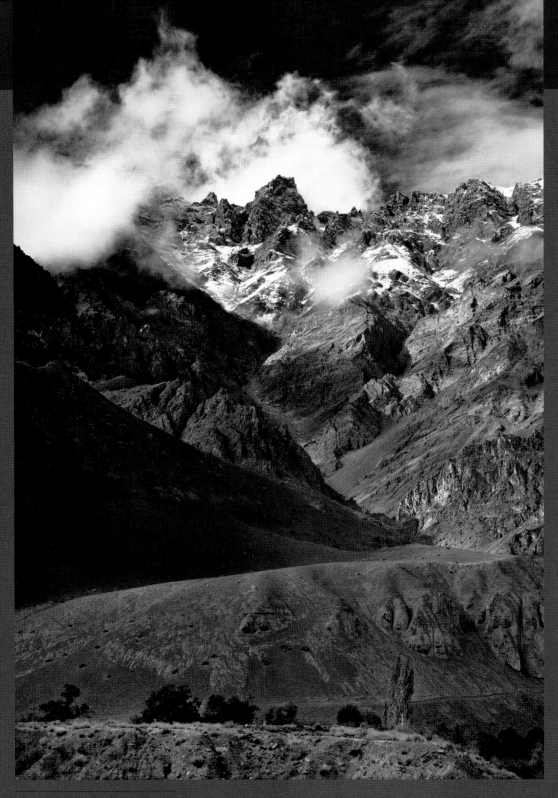

**Final image**

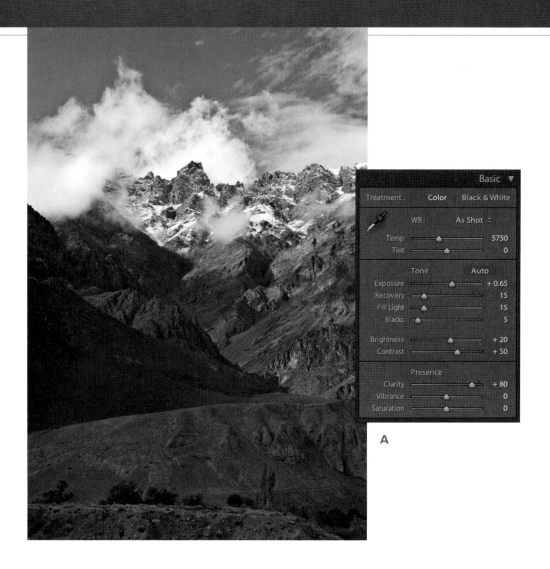

A

My first changes are in the Basic panel, and they're going to be pretty speculative. I'll be introducing a sharp tone curve that will darken the darks and lighten the lights, so until I've done that I'm not going to be very accurate here. My initial adjustments are as follows: Exposure: +0.65, Recovery: 15, Fill Light: 15, and Blacks: 5. I set Brightness to +20, Contrast to +50, and Clarity to +80 (A). All of these decisions are aimed at creating a base image

for me to work on, and I've chosen them based purely on the look they create as I move things around. Be careful to keep some room in the histogram for the work to come in the Tone Curve panel.

Moving down to the Tone Curve panel, it's important to keep in mind the end goal. What I want is a high-contrast image with great blacks and snowy whites, so I'm going to give the curve some real

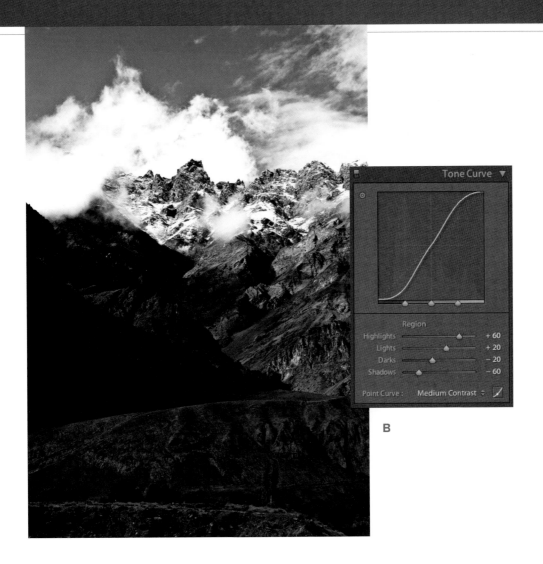

B

steepness. More steepness, more contrast, remember? So I've set my values as follows: Highlights: +60, Lights: +20, Darks: −20, Shadows: −60. You might be disappointed to learn that I chose these values randomly, and I left the symmetry alone for no reason other than I had no incentive to make it otherwise. I've also set the Point Curve to Medium Contrast (**B**). You'll see the histogram beginning to run off the edges of the graph. Don't sweat that for now; we'll bring it back.

Right now the contrast is over the top, but we'll take care of that. Knowing which tool to use comes with time, and it's less a question of right and wrong and more a question of which one you feel most comfortable using. Let's tackle the black and white conversion now.

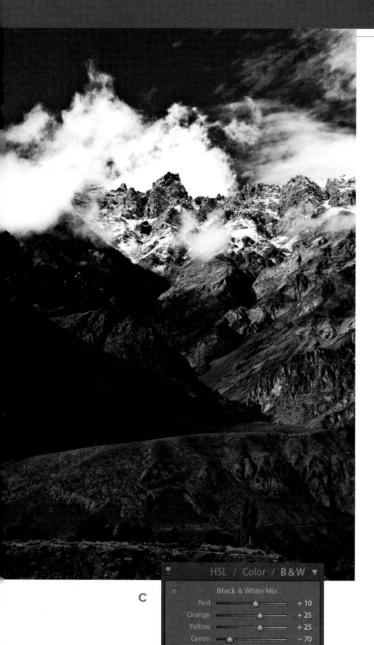

Go down to the HSL/Color/B&W panel and click B&W to activate that panel. Your image will immediately turn black and white and should now look more dramatic and less garish. Still not what we want, but closer. My settings in the B&W panel started with the default setting imposed by Lightroom. My method with B&W conversions is to move every slider. I already know I'll wind up wanting to push my blues to darken the sky. I also know the yellows and oranges will affect the soil and rocks. So I'll move the sliders around and settle on a relationship of tones based on what I like. Where there's no significant change, I'll just zero the slider and leave it at that. In this case, my values are Red: +10, Orange: +25, Yellow: +25, Green: −70, Aqua: 0, Blue: −52, and Purple and Magenta both 0 (**C**).

In a moment we're going to do some dodging and burning, selectively lightening and darkening the image to give greater visual pull to some areas. But I have one more thing I want to do first. You'll notice that there are now some burned-out highlights in the snowcaps. I want to recover them, but I don't want to be too heavy-handed with the Recovery slider as that affects the whole image and lowers contrast. So first I'll push the Recovery slider to 40, and then I'll drag a Graduated Filter about a third of the way down the photograph with an Exposure setting of −0.82, which further darkens the sky and pulls the details back (**D**).

Now before we grab the Adjustment Brush and rush into dodging and burning, take a moment to ask yourself, "What is my intention for this tool? What do I need to accomplish in this image?" You've already created excellent mood, but does the eye go where you want it to? My answer is no, not yet.

C

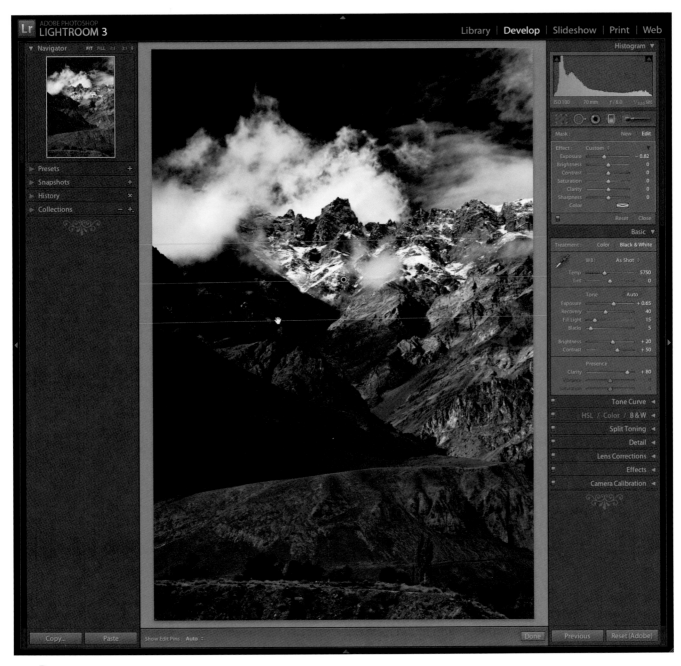

D

It's getting there, but I want a much less subtle visual pathway for the eye to follow. The question now is this: where do I want the eye to go? Once I answer that, I can lighten or darken those areas around that path. In this case, I'm going to dodge some of the ridges and create a stronger implied path of ascent. I've left the mask active so you can see exactly where I've painted, dodging these visual paths with an Exposure setting of +0.51 and Brightness of 30 (**E**).

The final touch is a slight crop to get rid of the small bush on the lower right and to bring the central peak a little closer to center, which makes the image feel more balanced (**F**).

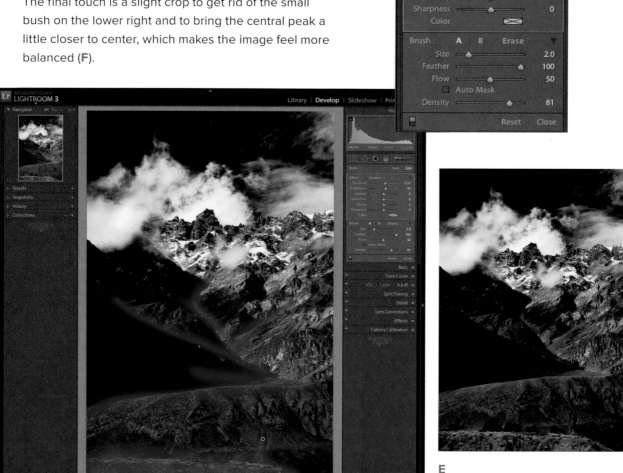

E

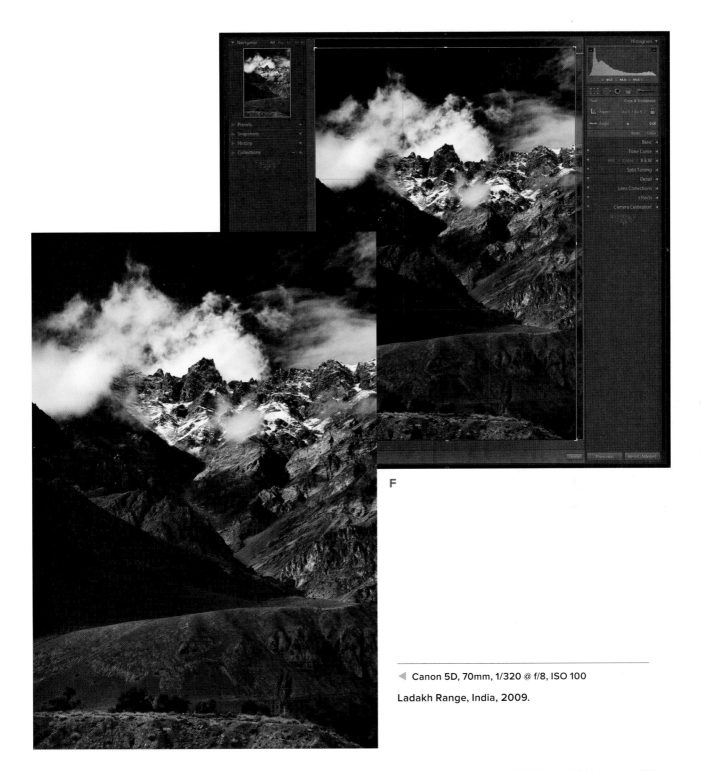

F

◀ Canon 5D, 70mm, 1/320 @ f/8, ISO 100

Ladakh Range, India, 2009.

# Green Bike/Yellow Wall

THIS WAS SHOT IN HANOI. It was part of a larger scene that just never worked for me until I realized that everything I was trying to capture in the larger scene was better told in this smaller glimpse. I was drawn to the decay and the bright colors, and because Hanoi—particularly Old Hanoi, where I was shooting that week—is so full of bicycles, this simple scene reflected more of my time in Hanoi than most of my other images. So I knew two things about how I wanted the image to feel and where I wanted to draw the viewer's attention. I knew I wanted the image to feel warm and colorful, and I wanted the texture of the decay to jump out. Ask yourself, in terms of visual language, what is your image about? The answer will push you in the direction in which your work needs to go. This image is about color, texture, and shape, so the changes I make should enhance those things.

**Zeroed RAW file**

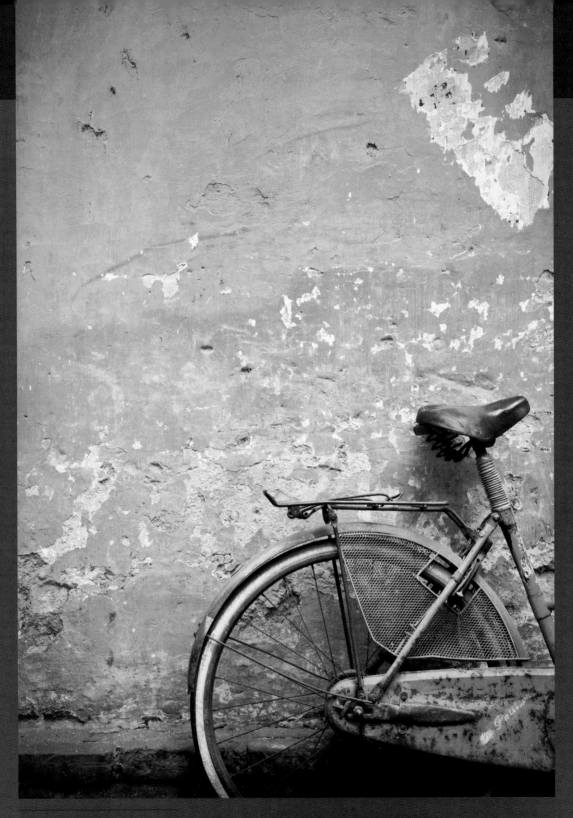

Final image

By now you should be getting either comfortable with or frustrated by the lack of science in my method. I hope it's the former. Play is so crucial to the creative process, in part because it can keep frustration at bay. When you approach an image with the mindset of "Let's see what this looks like" rather than a need for a specific outcome, you often allow yourself to be surprised by a result that's better than you might have planned. This was one such image for me.

The first change I made to this image came simply out of a desire to see what a different color temperature would do. I knew what I wanted from this image and thought I would get there with split-toning. Then I asked myself, "What if...?" So I moved White Balance Temp to 6700 and Tint to +20. I was going for something a little colorful, a little reminiscent of older Kodachromes (**A**). The final image doesn't look like this, but that was the inspiration that started me down this road.

**A**

Now it's time to get this image looking a little less horrific. Still in the Basic panel, let's brighten this up and add some contrast and texture. Move the Exposure to +1.00—something I should have done in-camera. Then push Brightness to +70, Contrast to +30, Clarity to +80, and Vibrance and Saturation both to +25 (**B**). At this point I'm only trying to get the image to a starting point that doesn't freak me out because when you zero a RAW image it always looks horrific, no matter how well you captured it. A side note: don't let yourself get discouraged by the fact that you miss your exposure by a stop; you're shooting RAW for just this reason, and you've got some latitude—especially at lower ISOs. No matter how long you shoot, you'll miss the odd frame. Craft matters—and this is no excuse for

mediocrity—but it happens. Discouragement is a poor companion to creativity. Take notes, get better, move on. And shoot RAW.

Next open your Tone Curve panel. Before you do anything, if you're working along on this specific DNG file, push the curve around to see what changes you can make and which ones appeal to you. This image was a little more experimental for me. I was going for something I hadn't done before,

B

C

and that takes play. In the end, I settled on these values: Highlights: +25, Lights: −30, Darks: +5, and Shadows: −31, with a Point Curve set to Strong Contrast (C). This is a steepened curve, so it increases the contrast, but why I chose these values can again only be attributed to taste, and the sooner we all stop asking how things "should" be done and find our own preferences, the sooner we'll be closer to the whole point of our work—unique expression.

Now it gets fun. For all my teaching about vision and creativity I get into ruts like everyone else, and I find it hard to jump those ruts without steering hard to one side, and that's what I was doing here. When I work in the HSL panel it's rare that I tweak the hue. I am usually okay with changing the intensity of a color but not the actual color itself. For "Green Bike/Yellow Wall" I ignored that impulse and changed the hues in Orange, Yellow, and

Green. The rest I left alone, except for Aqua, which I cranked because I like that decal on the seat tube and wanted it to stand out a little more (**D**). You can see my values in the screenshot, but I encourage you to play with them yourself.

I could have stopped here but I've always loved the results of cross-processing and thought I'd see what that looked like. Cross-processing was a technique—not always intentional—where film was processed in chemical developer intended for

a different kind of film, and it would render some interesting color shifts. Here I decided to play with that in the Split Toning panel, which gets a lot of use from me on black and white images to render duotones but rarely do I use it on color images. Time to change that. I chose an indigo hue for the highlights (Hue: 240) and a green-blue for the shadows (Hue: 180) and set both to a Saturation of 30. Then I tweaked the Balance to –15 to favor the greens in the shadows; it just looked better to me (**E**).

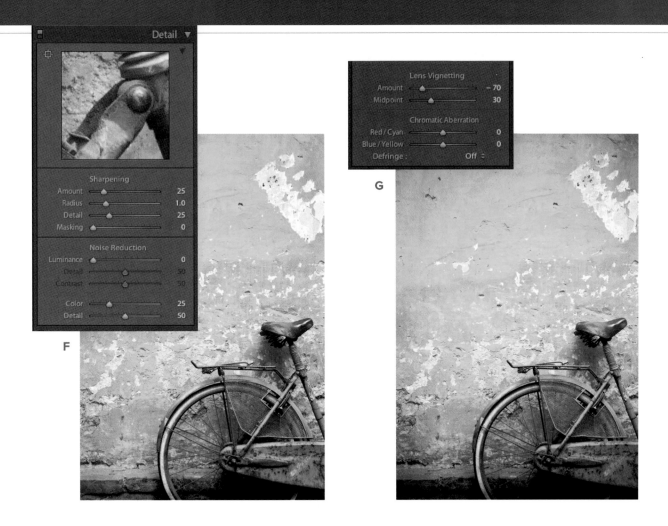

F

G

Two last tweaks to finish it up, and then a bonus for the overachievers. I've done some input sharpening using Lightroom's default Sharpening settings, as well as the default Noise Reduction (**F**). And then I applied a vignette with the Lens Corrections > Lens Vignetting tool (**G**).

And this is the final image, ready to do output sharpening according to your chosen output and then presented to the world. However, some among you might want to take things a step further. At the risk of encouraging such reckless attention to detail, you'll get bonus points if you slightly dodge the lines on the bike to draw it out more. And if you look carefully, there's a name painted onto the green chain guard at the bottom; it says "Phillips." You get double-extra bonus points for creating an extra small brush and dodging that with a little Exposure, Brightness, Clarity, and Saturation to pull it out a little (**H**).

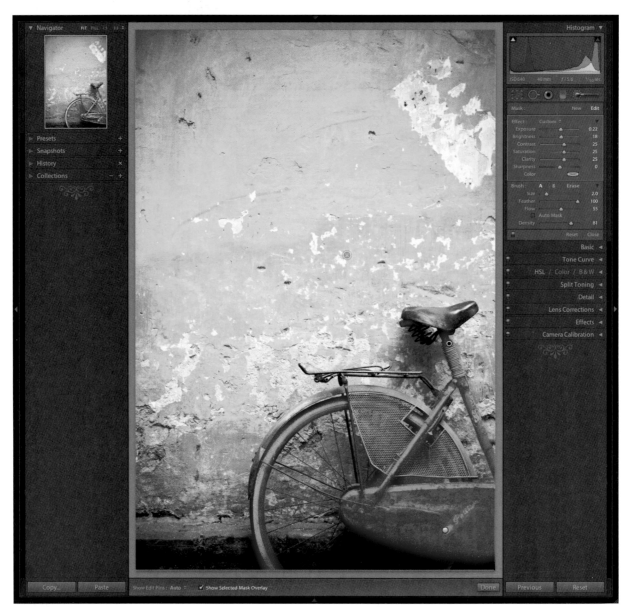

H

▶ Canon 5D, 40mm, 1/50 @ f/5.6, ISO 640

Old Hanoi, Vietnam, 2009.

# Brothers at Dawn, Bangladesh

IN FEBRUARY 2009 I was sent to northern Bangladesh to shoot for World Vision Canada. It was my first time in Bangladesh and I fell immediately in love with the country. Every morning we'd drive through a misty dawn to a new location, past impossibly green rice paddies and scenes that broke my heart to not stop and shoot. When you're on assignment on someone else's dime, you shoot the brief, not what catches your eye. But this one was too good to pass up, and as the Land Cruiser ground to a halt I leaped out with my 70–200 racked out to 200mm and got three frames. Only one of them captured the moment I was hoping for.

This image is about two things. It is about the moment shared by brothers or friends—and the very iconic childhood shapes these silhouettes created—and it is about the context, their environment. So although the treatment I end up giving this image is interpretive and not strictly realistic, it very much echoes how I saw and felt Bangladesh, and specifically this moment. Being this interpretive is a luxury the fine art photographer has that the journalist does not.

**Zeroed RAW file**

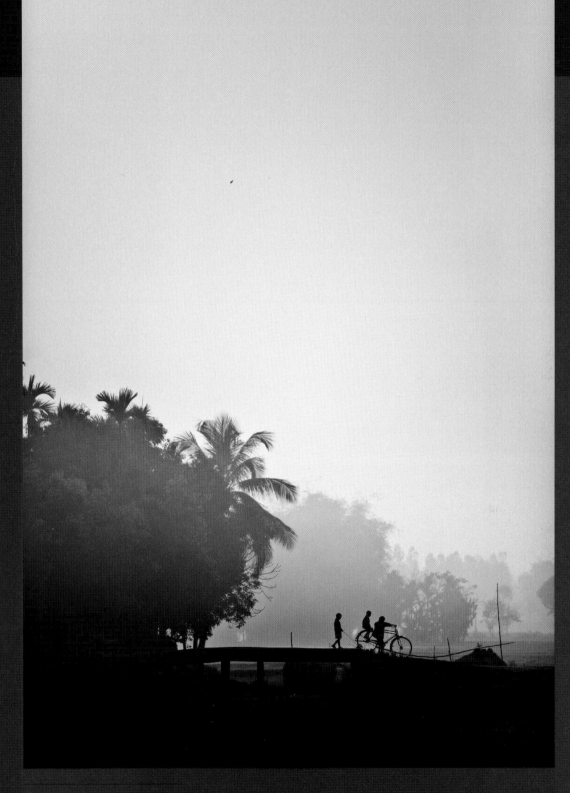

**Final image**

My vision, or intention, going into the postprocessing on this image was to draw the eye primarily to the boys because this is an image about childhood. And because it's a photograph specifically about childhood in that place and moment, I wanted to create a mood reflective of the green, tropical, and humid feel of early morning in Bangladesh.

Here's how I got there. The first thing you'll notice about this image is how dark it is. I missed my exposure by a long shot and simply didn't have the time to adjust. One of the reasons I shoot in Aperture Priority mode is that when I get distracted or react quickly to things, Aperture Priority mode, used in conjunction with my EV compensation, gives me something close to Manual mode—but with the camera paying close attention when I forget to. Looking at the histogram on this image, it's pretty clear where my first moves might be. In the end there will be no true whites in this photograph, but I want it to be brighter than it is. However, there will be blacks—especially as I want this image to be closer to a silhouette—so I'll need to lean on the Blacks.

I pushed Exposure to +1.00 and the Blacks to 20. Then I brought the Brightness up to +80, the Contrast to +35, and the Clarity to +100 to sharpen the shapes within the image (**A**).

The next step is to make decisions about contrast, and I toyed with doing this two ways. My first option was to lower the contrast in the Tone Curve panel (as well as in the Basic panel) and to go back to Clarity and lower that as well. This supported the feeling of a misty morning and emphasized the feeling of fog. But as it did so it minimized, at least to my eye, the main point of the image: the boys on

**A**

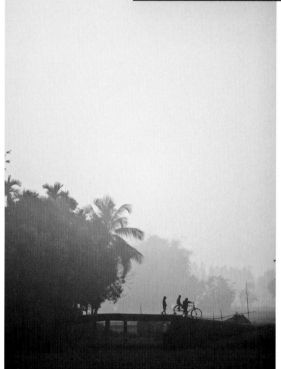

B

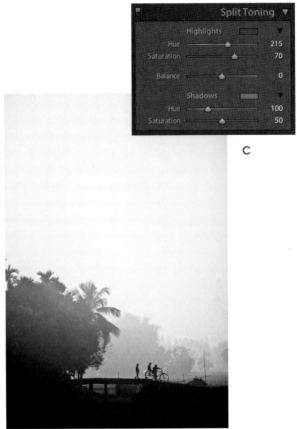

C

the bike. So instead I went in the other direction, adding stronger contrast. In the Tone Curve panel I first added a Strong Contrast Point Curve, and then I made the S-curve even stronger by pushing the Highlights to +25 and pulling the Shadows to −25. With the added contrast, the foreground figures of the boys and the bicycle become stronger silhouettes with greater visual pull (**B**).

As it is, this image captures a moment and pulls the eye where I want it to go, but it doesn't re-create the mood. For that, we'll turn to the Split Toning

panel again and choose values that bring back the greens and the feeling of an early morning. After playing around, I settled on a blue for the Highlights (Hue: 215) with a Saturation of 70, and a green for the Shadows (Hue: 100) with a Saturation of 50 (**C**). Why these values? The shadows are mostly vegetation, so green makes sense for those, and the lighter values are sky or mist-covered, so blue seems the logical choice.

My choice to darken the sky and foreground had more to do with where I wanted to draw the eye

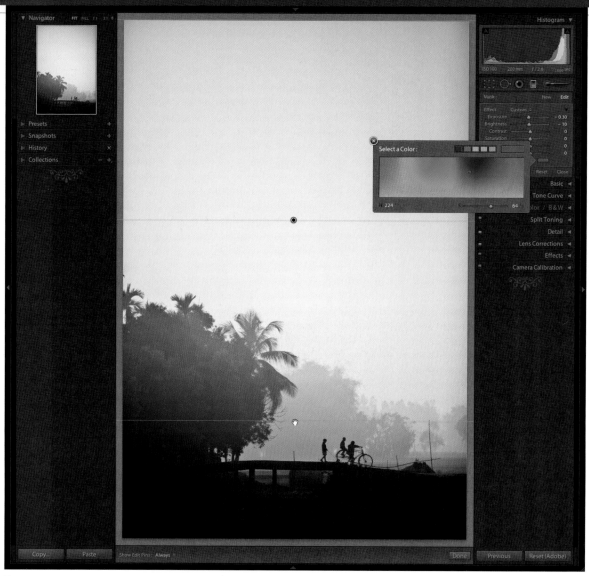

D

than with establishing mood, though happily it does both. What I wanted was something similar to a vignette in the way it pushes your eyes from the corners into the middle, but here I wanted the eye pushed from the top and from the bottom into the middle, to where the figures of the boys are. So rather than using a vignetting tool, I dragged

two gradients into the image using the Graduated Filter. I pulled the first one down from the top with a −0.30 Exposure value and a −10 Brightness value; I also added some color—in this case, a Hue value of 224 with Saturation of 64 percent to both darken and slightly color the sky (D).

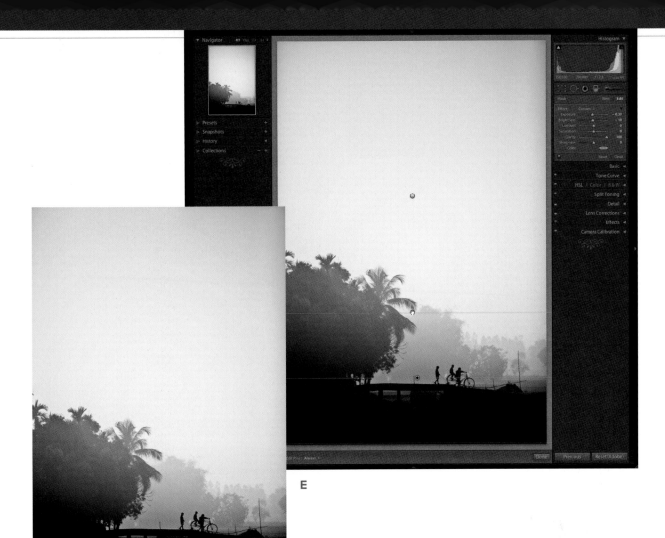

E

The second graduated filter was applied from the bottom upward with the same Exposure and Brightness values but no added colors, and with a Clarity value of 100. Together these darken the sky and the foreground, and allow the midground—the boys on the bridge and the closest trees—to draw the eye of the viewer without competing with other areas of brightness or detail (**E**).

I nearly left the image as it is here, and there are days I am tempted to go back to this version. Allowing yourself to experiment with variations and letting these variations speak to you over time is important. Our memory of these places and events changes, and sometimes our images do well with some reimagining in postproduction after some time has passed. So I'll often do variations on an image and let them sit. As I write this, I'm still sitting on these two versions. Here are the three changes I made to create the second version.

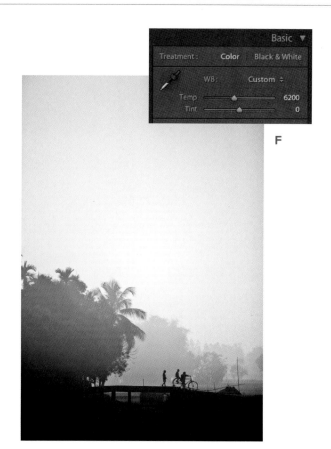

F

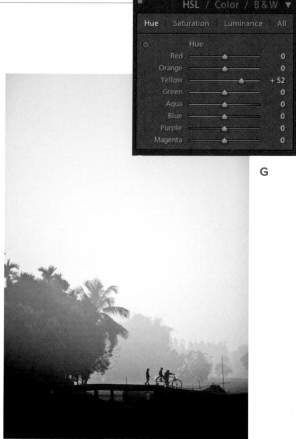

G

The first was simply a return to the Basic panel to push the White Balance Temp to a warmer tone—in this case, to 6200 with no Tint. I did this out of curiosity because although I liked the first variation a lot it didn't feel warm or muggy to me, which Bangladesh certainly did at times. I suspected a warmer color balance might be the fastest way to make that change (F).

The second change was to bring back some of the greens I lost due to the first change. Going back down to the HSL panel, I changed the Hue of the yellows to +52, making those yellows greener, which shows up in the vegetation and sky, giving the image a more illustrative feel (G).

The third and final change was the removal of some noticeable vignetting that was darkening the top corner in a way that felt distracting. A little nudge to the Amount of +21 while keeping the Midpoint at 50 took away some of that discoloration in the top left and right, completing the image (H).

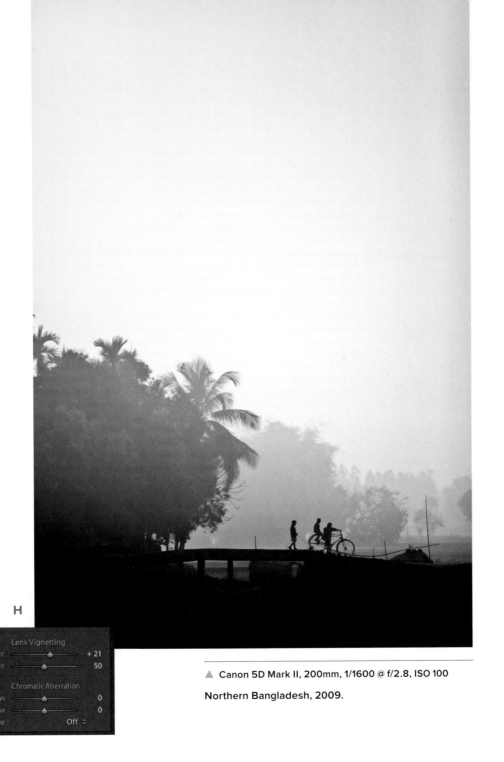

H

Lens Vignetting

Amount                           + 21
Midpoint                           50

Chromatic Aberration

Red / Cyan                           0
Blue / Yellow                        0
Defringe :                        Off ⏷

▲ Canon 5D Mark II, 200mm, 1/1600 @ f/2.8, ISO 100

Northern Bangladesh, 2009.

# Tepees and Rice #1

IT WOULD BE IMPOSSIBLE for me to ride a scooter past rice paddies and North American–style tepees in Northern Thailand without stopping to photograph them. It had been raining off and on all day, and by the time we stopped to spend some time shooting here I'd already been up to my knees a couple times in the rice paddies that day. I shot several frames of this scene, and in the next lesson I'll discuss variations and show you a couple ways I've considered presenting these images. While

**Final image**

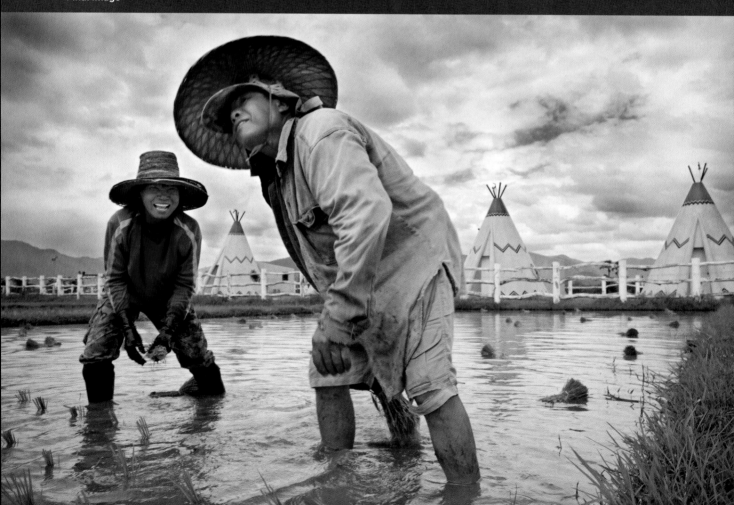

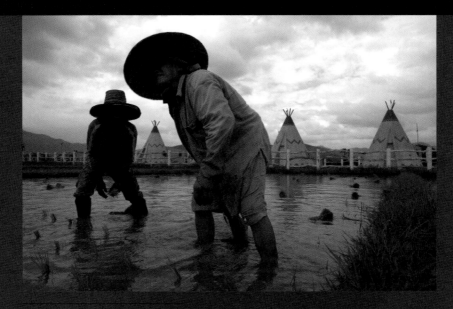

**Zeroed RAW file**

the next lesson presents this scene in mono- and duotones, this one had to be in color for a couple reasons—not the least of which was the laughter and fun present in the image. When I showed up, lumbering along the path between the paddies, nearly slipping in several times, I got a welcoming reception—not unlike the way people seem to welcome the circus to town, I suspect.

This image, like many of my photographs, is not about one single thing, and that can make it hard to decide on a complementary means of presenting those subjects. But in this case it was easy. I wanted to show two things. The first was the comical juxtaposition of the tepees in a context that just made no sense. Complete non sequitur. And the second was the gesture of the men in the water, clearly working but distracted, engaged, and most importantly, laughing. So I wanted this image to have a sense of fun about it, a sense easily accomplished with bright, primary colors. Once I identified that, it was

easy to find my groove. I knew I would be pulling out some of the reds, blues, and greens, and darkening the sky to increase the sense of contrast and juxtaposition that laughter under looming clouds gives. I also knew I needed to lighten the faces of the workers—I'd gone out that day, as I usually do, without a flash.

If it begins to sound like you need to overthink this process, you don't. We all have different ways of working, and you needn't be overly introspective to know where you're going with your work. You have to be aware, consciously or intuitively, of your intent for an image, and then figure out how you can best communicate that intent through the subtle give-and-take of the visual tools at your disposal. With this image, it came down to this: make it fun.

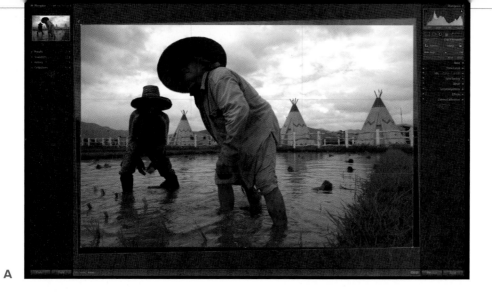

A

Before I did anything else to this image, I used the
Crop Overlay tool to reframe it. There is nothing
wrong with the crop, but a crop is a powerful tool to
direct the attention of the viewer. I believe that the
frame of an image is not just a detail in a photo-
graph; it's huge. The way you frame a shot can give
an image energy or balance; it can direct or divert
the eyes of the viewer. And when you're a little off,
the Crop Overlay tool can help you refine that in
postproduction. In this case, I tweaked the fram-
ing, not because the horizon was noticeably off but
because giving the frame a slight counterclockwise
rotation gives the man in the foreground a more
dynamic lean (**A**). Dynamic is more fun than static,
and fun is where I'm going with this.

B

Restoring the mood to this image is not difficult,
and by now we've done the same process several
times so you should be way ahead of me. Even
without looking at the histogram, you know that
we're going to add some Exposure (+0.75), then pull
back some of the blown highlights with the Recov-
ery tool (25). We'll want to add some Fill Light (25)
to bring out the faces, but as that's best done with

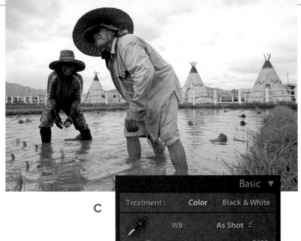

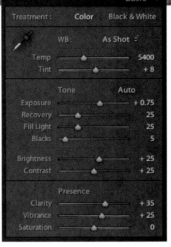

C

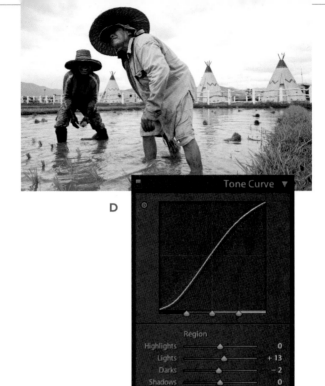

D

the Adjustment Brush later, don't get too heavy-handed with it. Push the Blacks to 5, just as they're peaking, and then stop (**B**).

The next step is to bring Brightness to +25, Contrast to +25, and Clarity to +35 to bring texture out. I'll selectively pull some saturation out in the HSL panel later, but for now take Vibrance to +25 to add some punch to the image (**C**). In fact, Lightroom comes with a preset called General — Punch that adds +50 Clarity and +25 Vibrance, and it was this preset that set me on a path that could make me guilty of overusing the Clarity slider these days.

In the Tone Curve panel I've given this image a subtle S-shaped curve: Lights to +13, Darks to −2,

and a Point Curve set to Strong Contrast (**D**). If it seems as if I'm always making the same adjustments, remember that how we arrive at our images is a question of degree. There's no magic here, just a matter of learning how to use the same familiar tools over and over again to create images you love. Photography, either during capture or in the darkroom, is about the image, not about how clever you are in getting there. In fact, the more distracted your viewers are by your technique, the less they're paying attention to your image. Don't fall into the trap of looking for fancy, complicated technique. Make the image look the way you want it to, then let the image speak for itself.

E

F

The next two steps, within the HSL panel, are ones I do almost in tandem with one another, so breaking them into steps is a bit of a contrivance. But if I have to break it down (and I do), then I suggest we do it in this order: first adjust the Luminance, then the Saturation. Here I've adjusted the Luminance values to darken the Green (−35), Aqua (−10), and Blue (−50) first because it'll be easier to see the Saturation adjustments once I can see some of those colors a little more (E). Notice that I have not touched the Red, Orange, and Yellow values; I want to adjust the reds a little, but doing so here would darken the skin tones as well, and I'm about to go to great pains to lighten those to bring a little more attention to the faces. So I'll do that selectively with the Adjustment Brush.

In the HSL panel, I've pushed the Saturation up on the Red (+55), Green (+15), and Blue (+35), all in an

effort to bring the feeling of this day back to the image (F). In the end, many of you might prefer a more muted version of this image. I should confess that one of the aesthetic goals of this image was to border on the look generally credited to so-called HDR (High Dynamic Range) images, so I've pushed things further than I normally would. Why imitate HDR? There's a quality to some HDR images that I simply wanted to try my hand at replicating. One of the best ways to expand your comfort with these visual tools is to challenge yourself to create an aesthetic that is outside your usual repertoire.

We're in the home stretch now, and the image has turned that corner, at least as far as my goals for this photograph; it's beginning to look better than worse. It was touch-and-go for a while there, I know. I want to add a vignette to push the eye back into the frame, and by darkening the sky a little it'll

return some of the mood of the stormy clouds. I'm
still using the simple Lens Vignetting tool in the
Lens Corrections panel, and I pulled the vignette
Amount in to −60 with a Midpoint of 25 (**G**).

The last changes are three separate dodge-and-
burn tweaks with the Adjustment Brush. The first
is to bring more fill into the faces of the farmers.
Choosing a medium brush with a heavy feather,
I've painted both Exposure (+1.00) and Brightness
(50) into their faces (**H**). It's important for this kind of
work that you keep the Auto Mask box unchecked
or keep an eye on it. I used the Auto Mask during
my first tweaks on this image, and because Auto
Mask works with areas of contrast it left a heavily
spackled effect on the faces and hats. Auto Mask
seems to work best on areas with more consistent
tones than these farmers have on their faces. Keep
an eye on Auto Mask, and if you get unpredictable
results, turn it off.

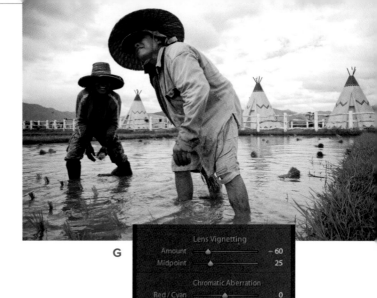

G

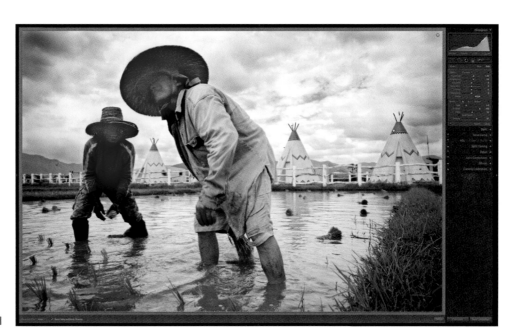

H

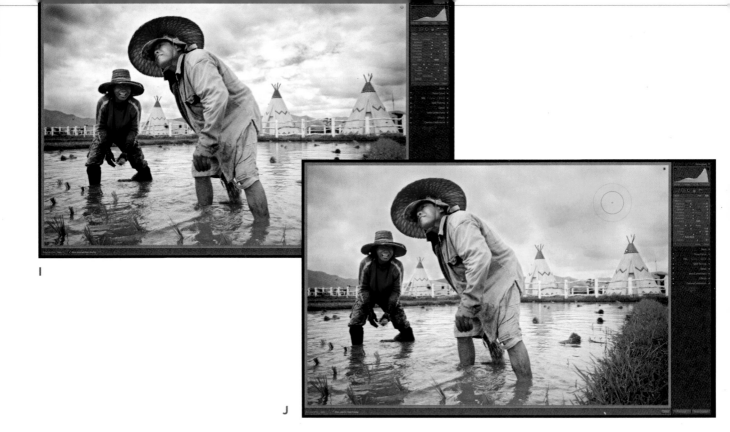

I

J

The second adjustment with the Adjustment Brush tool was the red peaks of the tepees, which here look redder than they are because I've got the mask active. They look far brighter than I want them, but it's easier to paint with the mask active. Before you get too enthusiastic with the painting, remember to create a new brush (you have two options at the top of this panel; one is New, the other is Edit—choose wisely) so the changes you make to the settings are made only to the new areas you intend to paint. If you keep painting with the same brush you used for the last steps and then crank the Saturation, for example, it'll affect the faces of the famers. Given how dangerously close we are to unacceptable noise in those areas, I don't

suggest introducing more! In this case I've left the Auto Mask off but used the Wacom tablet to precisely paint the tips of the tepees with a little Exposure (0.52) and Brightness (26) to brighten them and draw the eye, and some Saturation (100; I didn't hold back) to punch the bright red tepee tips (I).

The final adjustment will be made with another new brush, this time set to Auto Mask to make things a little easier, and to burn instead of dodge, which means you're going to want to pull those Exposure and Brightness values into the negative. What I was after here was to put the final touches on a sky that still seemed too bright and was losing the impact of the clouds. Painting a mask over the sky and pulling

the Exposure (−1.30) and the Brightness (−80) down will bring back that moody feeling I wanted to create in juxtaposition to the brighter colors (J). Leaving the Auto Mask on will make it a little easier.

In the end, this is a treatment that's closer to novelty for me, and is not likely a look I'd repeat often, but it's a look that has suited some photographers so well they've created whole portfolios. And even if the treatment on this image makes your eyes bleed, it's worth remembering that it can all be dialed down, and that the ability to bring fill light back into your image and use dodge-and-burn techniques to direct the eye and establish mood are techniques that photographers used long before the digital era. Whatever your preference, remember that a new treatment or trick will not rescue an image that doesn't succeed on other levels. Ansel Adams said that there was nothing worse than a sharp picture of a fuzzy concept. I agree—although a fuzzy photograph of a fuzzy concept is usually crap as well.

▼ Canon 5D Mark II, 24mm, 1/100 @ f/10, ISO 100

**Outside Chiang Rai, Thailand, 2009.**

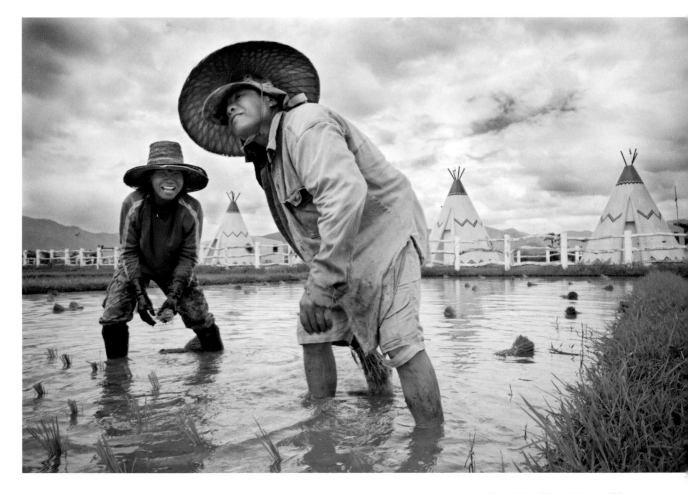

# Tepees and Rice #2

THIS IS A VARIATION on the last image. As if that's not enough, I'm going to end this lesson with three more alternates of this alternate. Photography is a field of creative expression, and one of the more powerful questions you can ask in the creative process is, "What if...?" What if I made the grass brighter

**Final image**

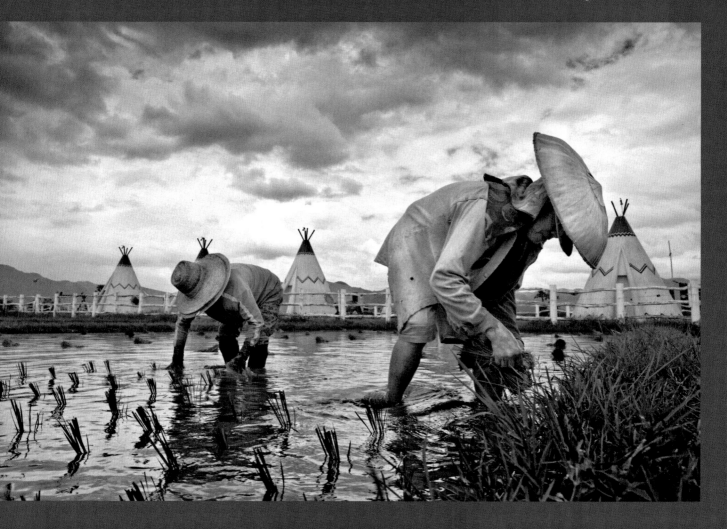

instead of darker? What if I didn't use Fill Light at all? What if I blew my highlights intentionally? What if...? It leads us to possibilities. If I've given you the impression that knowing and expressing your intention for an image is easy, then this lesson ought to give you a little more perspective into my own process. I shot several frames in the series from which I pulled this image (and the last one), and I wanted to explore the possibility that my own intention for the image might be clouded by things like my own proximity to the event. So I left this frame for a while before I tackled it in Lightroom, and then I did so with a mind to creating variations and seeing what each one told me. Here I'll show you one of those, and the variations that then derived from that.

This particular frame, lacking eye contact or smiles from the farmers, is still a little quirky because of the tepees, but it's also a little more somber. It's an image of people at their hard, dirty work. So I wanted something that pointed a little more to the forms and textures in the image. I wanted something gritty, and in my mind that meant black and white.

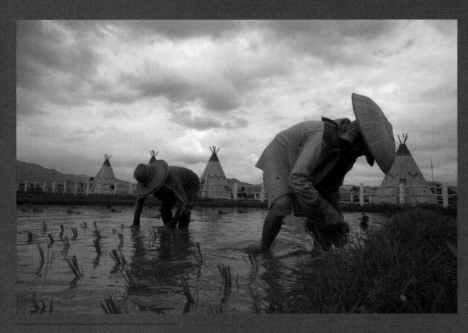

**Zeroed RAW file**

A

My first adjustment was a crop. Pressing R on your keyboard takes you to the Crop Overlay tool, and I made the back line of the rice paddy a little more horizontal. I just eyeballed it and rotated until it looked straight, and then hit Enter to set the changes (**A**). This is one of those things I love about the nondestructive nature of Lightroom: it allows me to make infinite tweaks, or to return later and change my mind.

B

Next, head down to the Basic panel and begin to bring the image back from its current murky depths. I've left the white balance where it is. Later, when you do the black and white conversion, I suggest you try moving it around as it changes the balance of tones in the image and can give you some interesting results affecting the mood in much the same way it would in a color treatment. What it lacks is brightness and contrast, so while much of the time I'll keep an eyeball on the histogram, this time I just pushed things around to taste. Exposure went to +0.25, Fill Light to 25, Blacks to 3, Brightness to +20, Contrast to +25, and Clarity to +75 (**B**).

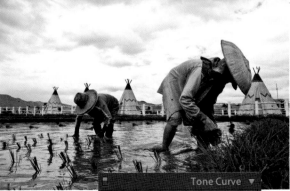

C

D

Before going to the Tone Curve panel, if I'm doing black and white work I'll usually first do the conversion to black and white, then return to the Tone Curve panel to move things around. This is because the conversion—and customizing that conversion with the color-specific sliders—changes the tones and their relationships to each other, and I generally find it easier to make these larger changes before tackling the relationships of light to dark tones in the Tone Curve panel. Opening the Black & White panel, I've made the following changes: Red: –50, Orange: +40, Yellow: –20, Green: –10, Aqua: –20, and Blue: –50 (C). Before you settle on these values yourself, be sure to experiment and take note of the changes each slider affects. The mix I chose may not be the mix you choose, and at the end of this lesson I'll show you a couple of variations with different mixes.

Going back up to the Tone Curve panel, I want to darken the darks and lighten the midtones (Lights) and Highlights, so I've added both a Strong Contrast Point Curve and a solid S-shaped curve by bringing the Highlights to +15 and the Lights to +9. The Darks remain at 0 and the Shadows go to –10 (D). While I'm doing this, I'm watching the whole picture. In a moment, I'm going to darken the sky with the Graduated Filter, so watching the sky alone isn't a great idea. Work to make changes in the areas you won't be changing significantly with another tool later. This isn't a book about best practices but the less work you have to do twice, the better.

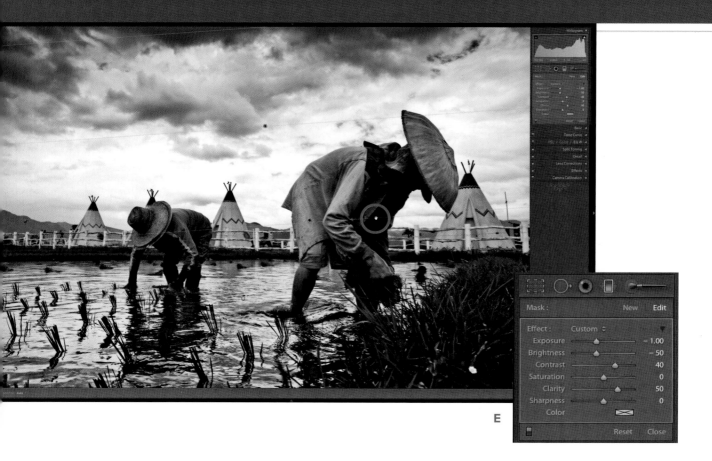

E

The sky still has a great deal of mood in it that's sitting there undiscovered, but a Graduated Filter can help out with that. A darker sky will not only enhance the mood but will also keep the eye of your viewer from going out of the frame at the top. It will also keep your viewer's eye moving from one important element to another instead of to a bright sky, which draws the eye—and then pushes it out of the frame entirely. Here I've pulled a soft-transition Graduated Filter from the top down to just over halfway through the image, and on a slight angle to keep the filter from overly darkening the man on the right (**E**). I chose to use this filter to not only darken the sky but to make it more menacing, so I added Contrast (40) and Clarity (50) in addition to pulling

back the Exposure (–1.00) and the Brightness (–50). Remember, the further apart the lines on the Graduated Filter, the softer the transition from dark to light. Want to tighten up that transition? Once you've pulled it down, go back to the top line of the guides and pull it down. The bottom will remain in place, but the top will slide down and tighten the transition.

Once I added the darker sky, I picked up the Adjustment Brush to do a little dodging. I tackled dodging the farmers first, painting Exposure (1.60) and Brightness (80) over the workers to pull the details a little more out of the shadows they created by bending over. Notice how light the mask overlay

appears (**F**). My brush is set to a flow of 55, so much of the coverage is pretty light. Alternately, I could have laid a heavier mask and used lower Exposure and Brightness settings.

Before putting the brush away, I created a new brush and lightened up the tepees with Exposure (0.60) and Brightness (23). But if you look carefully, you'll see I also added in a negative Clarity value. Brightening the tepees was intended to add a little more tonal contrast to the image, but pulling down the Clarity was intended to soften up the lines a little so the eyes go first to the farmers (**G**). Strong zigzag lines have a lot of visual mass, so I thought I'd try pulling that back a little. I think the effect is pretty subtle, but give it a try. If that doesn't do what you want it to, push the slider to 100 just to see what happens. You might like it.

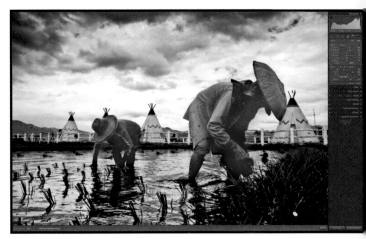

F

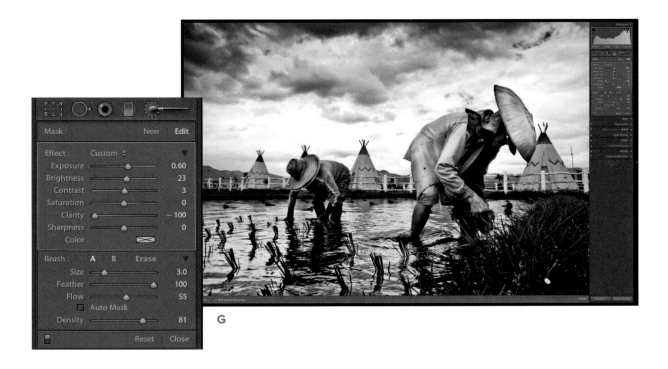

G

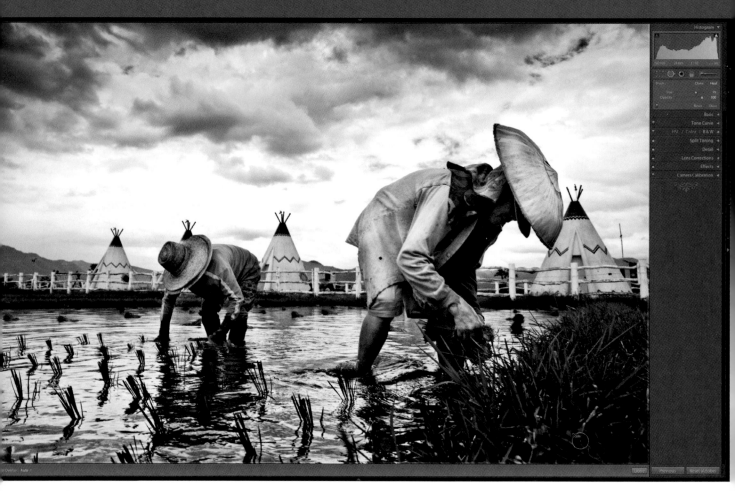

H

While we're touching on the issue of elements that draw the eye, there are two small things I want to remove from the picture, neither of which bothered me at the beginning of my process (which is when I would normally do these things). I want to get rid of a flower at the lower-right corner because I keep looking at it—and if I keep looking at it, so will others. And halfway between the hat of the farmer on the right and the upper-right corner is what looks like a sensor-dust spot. In both cases, using the Spot Removal tool set to Heal makes quick work of them (**H**). Lightroom's Spot Removal tool doesn't

hold a candle to what can be done in Photoshop, but for small jobs, and with a little patience, I've been amazed at how capable this tool seems to be.

If there's one thing I loved about the old black and white film I used to shoot in high school and college, it was the grain. The grainier, the better, and I used to love pushing it so the image had grain the size of Grape Nuts. Now I prefer things a little more subtle, but the ability to add Grain in the Effects panel in Lightroom 3 makes me nostalgic, and it should make film buffs happy. Grain is a recognizable attribute of old black and white film images,

and if what you are after is an aesthetic reminiscent of that look, then adding grain is a subtle visual cue to your viewers. Be sure to play with the settings. In this case, I lowered the amount to 28 after feeling my other attempts were too much, and left Size and Roughness at 50 (**I**). Grain also has the benefit—at least on monochrome or duotone images—of hiding some of the digital noise that creeps in. It's not a fix, but it helps, as long as you like the grain more than the noise.

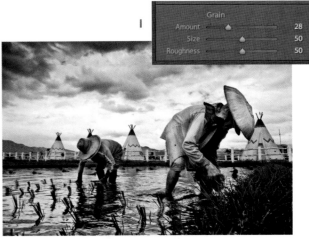

The final image is very much what I thought and felt it should be. Moody, strong contrast, and the eye is pulled to the farmers first, then allowed to move to the tepees and then on to the rest of the image before returning again to the farmers. The grain and the contrast remind me strongly of images I once spent hours on in the darkroom (**J**).

Of course, you could play with each image for months and never settle on a final incarnation of it. Part of that's novelty. We see something new, apply

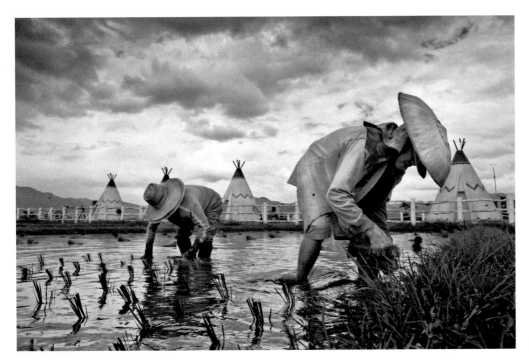

J

it to an image we're already bored with, and we love it! For a couple days. Then we do it again. The other thing to consider is that with time our remembrance of an event or scene changes, and with it our vision for how we want that image presented changes, too. Time can be both a blessing and a curse.

So when I find I'm wrestling with an image, I take advantage of Lightroom's Virtual Copies feature. Make a virtual copy of your final image by right-clicking on your image and choosing Create Virtual Copy, or by choosing Photo > Create Virtual Copy. You can now make changes to these new virtual copies all you like without damaging or undoing the work you've done. And you can compare them side by side to determine which one is the better expression of your intent for the image.

I've created three virtual copies here, and with them created three variations of my original image. The first entailed a different white balance, different black and white mix (notice especially the Greens and the changes in the grasses), as well as the addition of a split tone. The second variation added a little fill light, tweaked the black and white mix, and reversed the hues in the Highlights and Shadows of the Split Toning panel. The final variation was the quickest. I simply applied the Creative – Aged Photo preset that comes with Lightroom. Once you've looked at all four of these images a while, one of three things will happen. The first is that you'll decide you like one more than the other; the second is that you'll confirm that your original processing is your preference and stick with those choices; the third, and more likely for me, is that you'll see things in the new variations that reveal weaknesses in the first. In this case, the tweaks I made to the Greens—lightening them instead of darkening them—made me realize that I'd have to go back and make similar tweaks on the original image before making a final print.

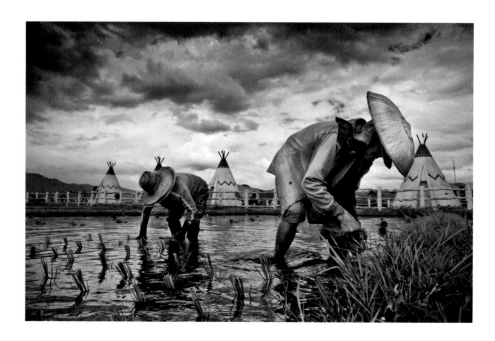

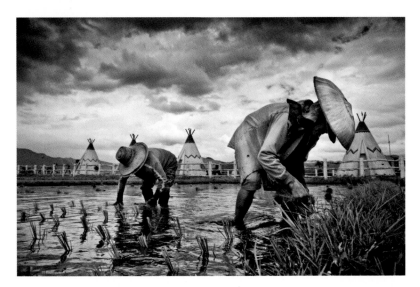

Canon 5D Mark II, 24mm,
1/125 @ f/10, ISO 100

Outside Chiang Rai,
Thailand, 2009.

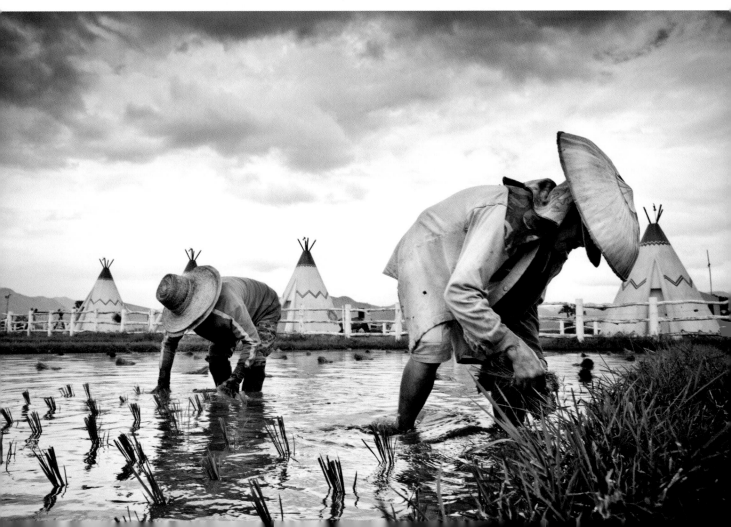

# Spire over Leh

LEH IS THE CAPITAL CITY of what was once the ancient kingdom of Ladakh. It is now northern India and is one of the most magical places I've ever been. High-altitude desert, it's a barren place with dramatic skies and peaks. I photographed this spire on the way down the bare rocky hillside on which sits the Leh Palace, and above it the monastery. I had been shooting that day with a new Singh-Ray Gold-N-Blue polarizer and enjoying the color shift it provides, but didn't have it for this shot (or I didn't have time to find it). The effects of a polarizer can't be replicated with postprocessing, at least not all of them. But when I

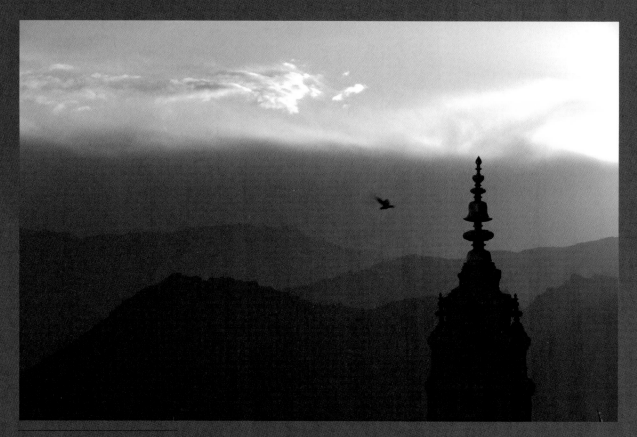

Zeroed RAW file

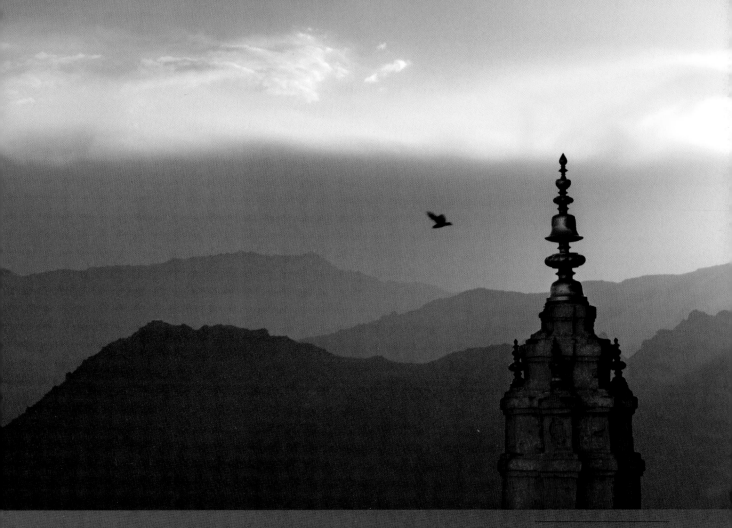

**Final image**

opened this image, I decided that would be one of my goals: to effect an imitation of the aesthetic produced by the Gold-N-Blue polarizer. The reason for that decision is more than just a desire to make this image fit in with a series of images in a visually consistent way; it's the same reason that made me use that unique filter to begin with—a rich color depth that at once captures the yellow earth tones of the desert and the impossible blues of the skies. I wanted my images to carry that rich depth, so I chose a filter that helped me do it. Without that filter I was guided by the same desire in Lightroom.

Among the first things I did to get this image ready was clear out the distractions. My first move was to straighten the image because it was driving me crazy. It's not even a significant crop; it's just a subtle one that made me feel the image was more balanced (**A**). I just eyeballed this one, but you could as easily use the Straighten tool to draw a line vertically down the middle of the spire in order to right it. It was not really the horizon that bothered me but the slightly skewed spire.

Once the spire was straightened, I wanted to make the image less painfully murky before searching out the spots I knew were there. Sensor dust appears more obviously when there is more contrast than in the zeroed file, so I'll do my work in the Basic panel before I move back to eliminating the distractions. The most noticeable difference in my approach to this image is the change in White Balance. I changed the WB Temp to 5434 and the Tint to +35 so that it felt a little warmer and a little, well, a little more purple. The rest of the adjustments were the usual attempt to make the whites white and the blacks black, but as this is a dramatic scene I was totally okay with blowing out some whites and plunging some blacks. Histograms are a guide, not a religion. I pushed my Exposure to +1.15, Recovery to 25, Fill Light to 15, and Blacks to 13 (**B**). I left the rest alone on the assumption that I'd bring about similar aesthetic changes with different, and more specific, tools as I moved through the Develop module.

A

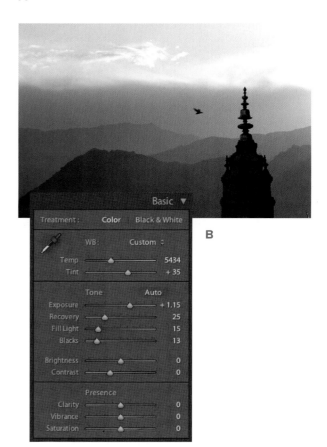

B

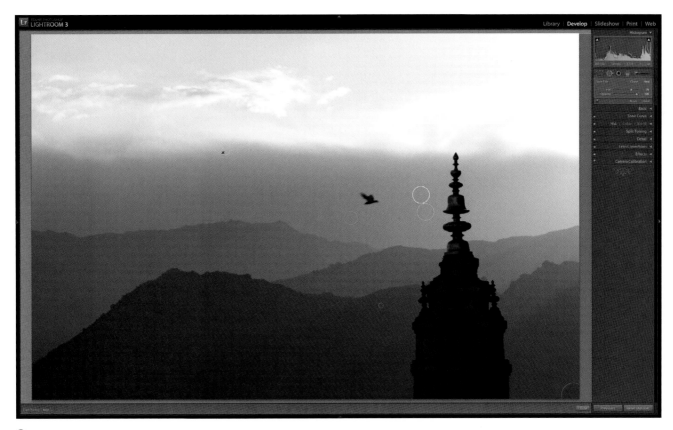

C

Even though you haven't touched the Contrast slider or the Tone Curve panel, your contrast is now greater. You made whites whiter and blacks blacker; that's contrast. The dust and distractions should be a little more obvious now. You could do the de-spotting later—but I don't work well when I am distracted, so I do it as soon as it bothers me. Here, there were four spots I wanted out, as well as a distracting bit of a prayer flag pole I didn't crop out when I shot it, so using the Spot Removal tool set to Heal and at 100% Opacity, I got rid of them (C). I use Heal instead of Clone for spot removal, and Clone only when I need to be more specific about it. Heal does a great job most of the time, but when it falters I switch to Clone and do the removal myself.

Restoring the mood to this photograph will require more contrast, but it's important to have some idea of the road you're following to your destination. For this image, I had thought it through and knew I'd be using a Graduated Filter to burn/darken the sky and the Adjustment Brush to dodge/lighten the spire. So when I did my Tone Curve I was watching the whole image, and was not too concerned when the sky

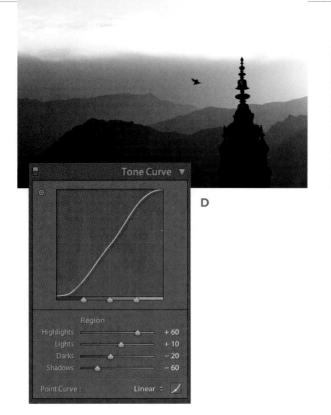

D

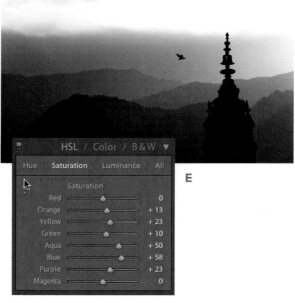

E

went way too light or the spire went too dark. What I really wanted was a lively contrast in the mid-ground where the hills stack against each other. Keeping the Point Curve set to Linear, I created a simple S-shaped curve, with Highlights set to +60, Lights set to +10, Darks set to –20, and Shadows set to –60 (**D**).

Boosting the Saturation on this image didn't make significant changes, and this is one of those situations where you move things around until you just feel it's more in line with your vision. I pushed most channels into the positive without pushing them too hard (**E**). If I were to reimagine this image at a future date, I might reconsider all these values, but as I've said before this is not a book about best practices; it's about uncovering and expressing your vision.

Here's where we begin to emulate the effect of the Singh-Ray Gold-N-Blue filter (my all-time favorite, if slightly overused, filter), which you can only do to an extent. Only a polarizer can remove the reflections from water and gloss surfaces, but where it affects a color shift, as the Gold-N-Blue does, you can replicate that to some degree in the digital darkroom with a simple split tone. After fiddling around for a while, I settled on the following values: Highlights: Hue: 56 and Saturation: 75; Shadows: Hue: 251 and Saturation: 23. I left the balance between the Highlights and the Shadows at 0 (**F**).

Now it's time to bring back the sky. I did three things to the sky on this image with one Graduated Filter. Dragging the filter down to the top of the foremost mountain, I darkened the sky by pulling the Exposure to −0.89 and the Brightness to −62. I softened the clouds with a Clarity setting of −100, and I added more punch to the color by adding a canary yellow to the mix (G). Three changes with one filter; I love it.

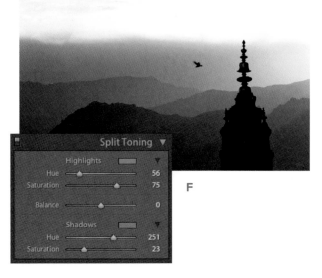

F

G

The last thing I did—and this was after staring at the image for a while—was to bring some of the detail back in the spire. My first version of this image left the spire in silhouette but I missed the details, which I think add richly to the scene in both impact and the information they give in the form of visual clues about the location. So I decided to paint the spire using brushes of various sizes. I alternated between using the Auto Mask when painting around the outside edges of the spire and turning Auto Mask off when painting the rest of it (because Auto Mask would make the image look blotchy). I added a little Exposure (0.37) and Brightness (33) as well as some Clarity (26) to enhance the texture on the stone of the spire (**H**). I also introduced the same yellow I chose for the sky in hopes that the light would appear consistent. I didn't get it on the first try, but I think I found a balance that is believable without losing the mood and the focus of the image.

H

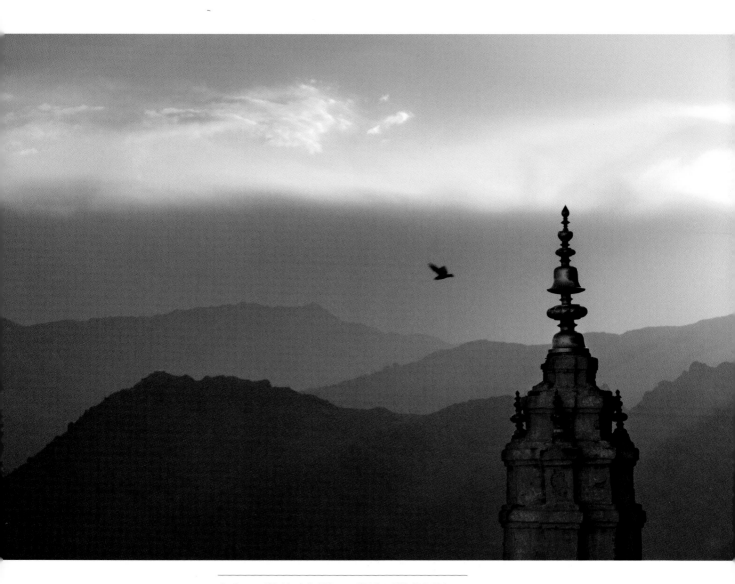

▲ Canon 5D Mark II, 125mm, 1/125 @ f/11, ISO 100

Leh, Ladakh, India, 2009.

# Waiting on Allah

"WAITING ON ALLAH" was photographed in a small mosque in Old Delhi. We stumbled across it on the first day of a two-week Lumen Dei Workshop, which I co-led with photographer and friend Matt Brandon. It was a particularly welcoming place and the shade provided some (minimal) relief from the heat of Delhi.

**Final image**

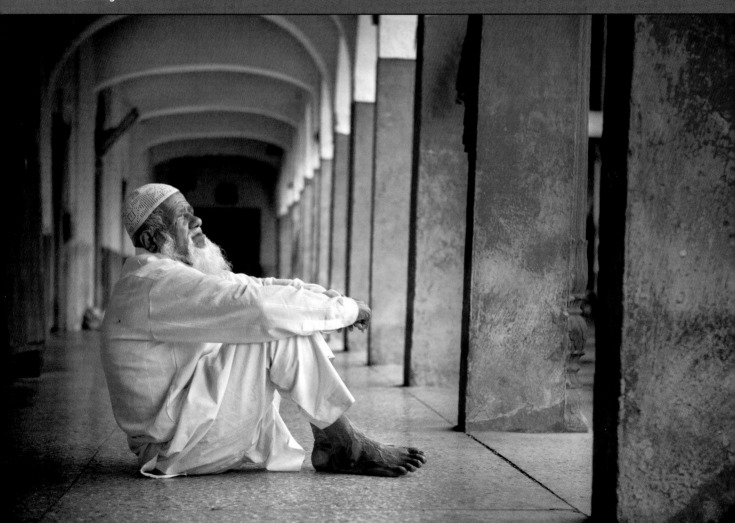

I saw this man sitting and was struck by the serenity, the colors, and the forms in this scene. If you've seen much of my work, you know I am drawn to these serene scenes, particularly in contexts where people are seeking the divine or meeting with God.

My intention for this image was to capture the serenity, but in a way that's true to my feelings about India—and Old Delhi in particular. If there's one feeling I have about Delhi, it's that it's too much. Too much of everything. In Old Delhi, every way in which the senses can be engaged are invaded. So I wanted the mood to be warm and vibrant, almost to the point of too much. I also wanted to draw the viewer's eye to the pillars and arches, which create the strong perspective and vanishing point, in the middle of which sits this man in contemplation. With regard to the man, I wanted to bring out his face, and also push a little attention to his feet, which struck me even then as interesting if not also overly large.

If you're following along on the supplied DNG files, I suggest you begin thinking one step ahead of me at this point. You know the first moves in the Basic panel, so before you look at my settings, I encourage you to open the file and make your own choices about this image. Then look at mine and see where they differ. There is no specific right or wrong—just look at your settings, then look at mine. Is there a reason you pushed further or not as far as I did? Perhaps we achieved a similar aesthetic by different means, and that's fine, too. Being intentional and making your own decisions is the first step in having a vision-driven workflow that is your own.

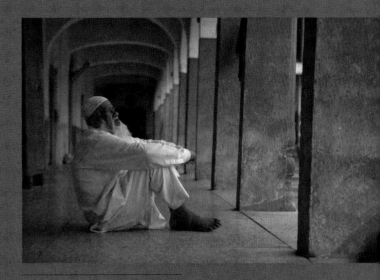

**Zeroed RAW file**

A

B

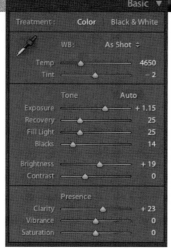

My settings were typical of my work. I pushed the Exposure to +1.15 to brighten things up, Recovery to 25 to begin salvaging some of the blown highlights, Fill Light to 25 to pull a little detail from the shadows, and Blacks to 14. I set Brightness to +19 and Clarity to +23 (**A**).

Again, before looking at my own settings, head to the Tone Curve panel and play around a bit. Assuming your vision for this image is the same as mine, what changes would you make to the contrast through the Tone Curve to bring this image in line with the expressed intent?

I left the Point Curve at Linear, and set what has become for me a standard tone curve: Highlights: +60, Lights: +10, Darks: −20, and Shadows: −60 (**B**). These settings push the highlights a bit too far, but in this case I'm going to leave them and pull the remaining blown highlights back with the Adjustment Brush later. Keep an eye on steep curves; they create great contrast but can lose valuable detail in the highlights and shadows.

I didn't do much to this photograph in the HSL panel. In fact, I only made some selective tweaks to the Saturation. I'll show you mine in a moment, but if you're following along, I'll let you go first. Make your tweaks, then look. No cheating.

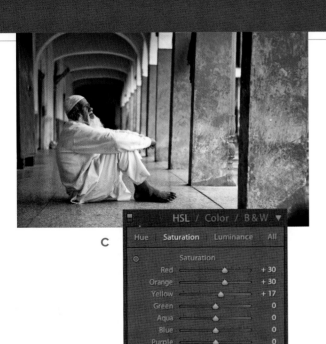

C

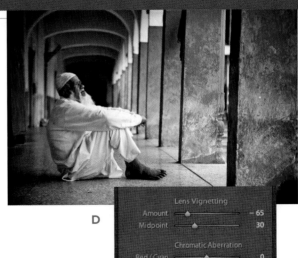

D

I added saturation to three channels: the Red (+30), the Orange (+30), and the Yellow (+17) (**C**). I also initially pulled the blues way down to remove the distraction of the blue doors on the left side, but eventually decided I liked them and left them as they were. But again, this is all to taste, and knowing you can reduce the visual pull of those bright blue doors—or increase it—with this tool is important.

Now that the mood has been established, the rest of the image is about the push and pull of the viewer's eye. In some cases I do this subtly; in others I'm a little more heavy-handed. The advantage of working on the same DNG files is that you can make the identical changes and then second-guess me and make improvements, follow your own tastes, or create a similar look but do so in ways that are more

intuitive to you. I'm going to use the Lens Vignetting, Graduated Filter, and Adjustment Brush tools in the following eight steps, beginning with going to the Lens Corrections panel and setting the Lens Vignetting tool to an Amount of −65 and a Midpoint of 30 (**D**).

My next two adjustments will be a little much for some. Again, it's a matter of taste. Using the Graduated Filter, I dragged two gradients—one on each side of the image—and both of them with the intent to darken the sides and pull the eye in toward the middle. The gradient on the left was set with the Exposure at −0.80, Brightness at −40, and Saturation at −2—which was just laziness on my part (**E**). The sliders don't always respond the way I'd like them to, and leaving it at −2 rather than fussing about getting to absolute zero seemed the way to go.

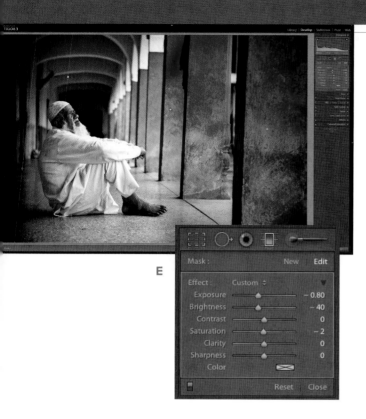

E

F

I dragged the gradient on the right from the far right side of the image with Exposure set to –0.80, Brightness at 9, and Saturation at 4 (**F**). Ignore the Brightness and Saturation settings; they're really unimportant. But the Clarity slider makes a difference to me in this image. With this graduated filter, I pulled the Clarity way down to –100, which has the effect of softening the texture and—like burning areas to push the eye away to lighter areas—this gently leads the eye to the middle in the same way a lower depth of field does.

All the remaining adjustments seem fairly subtle—almost like visual nitpicking—but I think the eye picks up on things we don't necessarily perceive consciously. We may not notice why we are drawn to things, and in the same way our viewers may

not know why their eye is being drawn to one area of an image over another. The eye will be pushed and pulled no matter what; the question is, will it be pulled in the direction you desire as the visual storyteller? I used the Adjustment Brush five times on this image, and the accompanying screenshot shows you all the pins at once, as well as the first one, now active, with which I burned (darkened) the lighter space between the two columns (**G**). I'd love to go back and shift myself slightly to the right in order to eliminate that space, but the moment's gone. Without taking it into Photoshop to reconstruct it, the best I can do (which is not generally the way I prefer to create my work) is to darken it slightly to reduce its visual mass, or pull.

G

The next brush strokes occurred in the arches above the seated gentleman. I dodged these a little to brighten them (Exposure: 0.18 and Brightness: 31) and to draw attention to their form. I also added some color and saturation in order to accentuate the warmth. But I also pulled the Clarity down to −100 in order to soften them. I wanted the viewer to be conscious of the mood and the forms but not distracted by the details (**H**).

As in most portraits, I wanted the attention most focused on the face of this man. In the intricate dance to find a balance between impact (mood) and information (specific details), I wanted the viewer to continually return to the subject of this image, which is not the man so much as it is the theme of seren-ity. It's a picture *of* a man, but it's a photograph *about* serenity and contemplation. In a sense, it's about waiting for God. It's the face of this gentle-man and the look in his eyes that lend these char-acteristics to the image, so it's to the face I want people to look. On the face, I brushed in a little bit of Exposure (0.39) and Brightness (18), and then on

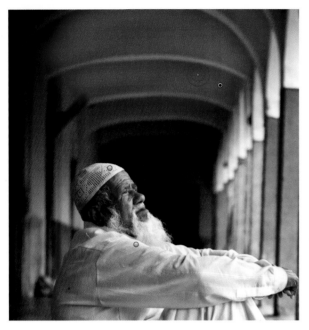

H

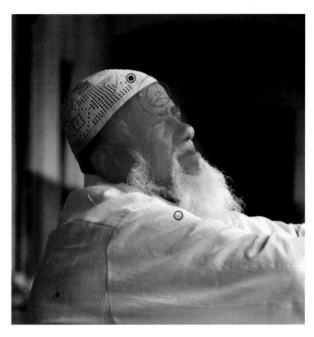

I

a hunch I slid the Clarity to −35 to soften the face. Usually I add Clarity to draw out the texture on a face like this, but our tools exist to serve our vision, and my intention in this image had more to do with the softness of his gaze and the serenity, which was better served with a softer face. I've also added Sharpness (49), so when I say I want his face to be softer I do not mean blurry or less sharp; I simply mean softer, less harsh. Adding the Sharpness pulls the eye just that bit more (**I**).

Two more tweaks. The first is simply to burn back some of the details on his arms and the front of his pant legs until the blown highlights disappear.

Pulling my Tone Curve down a little in the Highlights might also have accomplished this, but I was already doing some dodging and burning and it seemed easier and more efficient just to do it while I had the pen in my hand (**J**).

Finally, I pushed Exposure (0.09), Brightness (−9), Contrast (100), Saturation (−2, but this is left over from a previous brush setting, so call it 0), and Clarity (100) all in an effort to draw just a little more attention to the feet without making them the main point (**K**). They're interesting feet, and they probably look a little bigger than they are, but I don't want people's eyes getting stuck on them. The feet are a secondary or even tertiary detail of the image, not the main point.

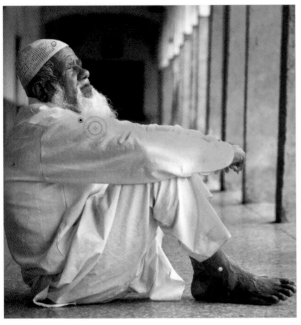

J

K

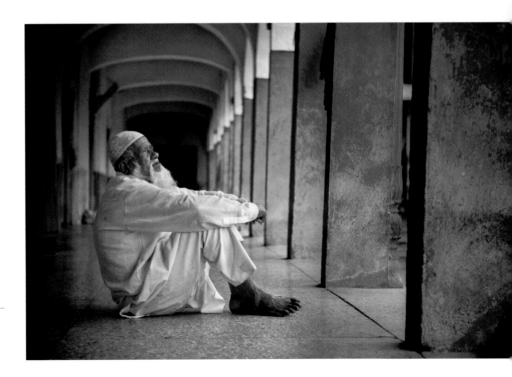

▶ Canon 5D Mark II, 70mm,
1/400 @ f/2.8, ISO 400

Old Delhi, India, 2009.

# Nizamuddin Elder

THERE'S A SMALL MOSQUE adjacent to the shrine in Nizamuddin in Delhi, India. Its door is, like so many mosques, bright green. The walls inside are red, and at the right time of day the light inside is breathtaking, soft, textured. It was in this light that I made this portrait. I sat in the mosque one afternoon, resting during a hot day on a workshop and trying to be patient and wait for something to happen. Patience, like curiosity, is a key photographic skill, and one that seems to always be underdeveloped in me. Seeing takes time. So once in a while I force myself to sit. To wait. To stop chasing and take the time to see. Eventually, my subjects begin to come to me, to ask for a portrait. On this day, my friend Peter Bergmeier and I spent a nice hour taking quiet portraits of the men in the mosque as they asked us to. I'm a big believer in finding a great background and waiting for the foreground to appear, and in this case it was the red wall I wanted to use. I made several portraits in this light, against this wall, and this man was my favorite for the eye contact he made with me. There's something in his eyes—perhaps a vulnerability, or at least a lack of the need to pose—that I like. It's different than many of my other portraits, most of which lean to laughter, one of my favorite photographic subjects.

My intention for this image wasn't complicated, and I'm including this photograph and the way I processed it because I think there's a danger in feeling the constant need to overthink this stuff. Vision or intention doesn't have to address deep themes or complicated aesthetics. But in the case of this image—a simple portrait—the way you want the image to look could take on a million variations unless you first know what you want the photograph to look like. That's your vision, your intent. For this image, I just identified the parts that were important to me, that drew my eye in the first place. The red wall. The gaze of this man, and his interesting face. The muted color of his garments. All I want is for the processing to highlight these things without getting in the way. I want people to notice him, not the processing.

Zeroed RAW file

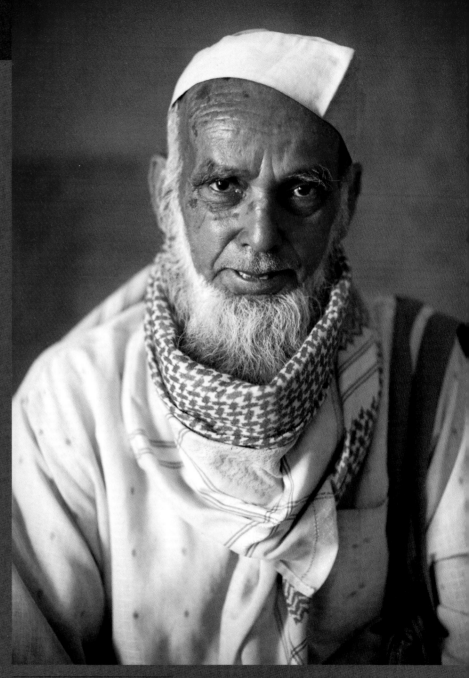

Final image

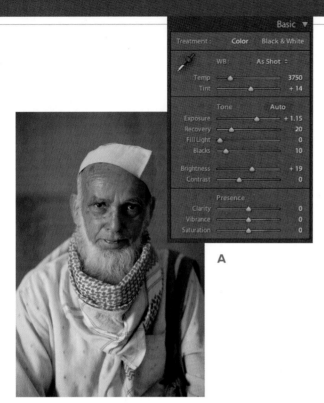

A

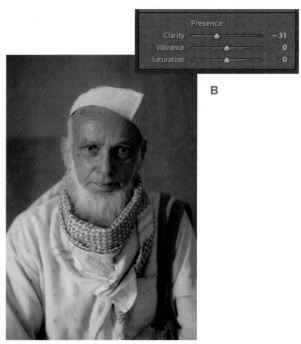

B

The first adjustments are the same steps as usual, and by now this should be second nature. Zero the file. Make the blacks black and the whites white. Go ahead and do that, then look at my settings with a critical eye. The purpose of this book is not to show you how to process images the way I do but to encourage you to engage in a process that makes you conscious of your intent and able to translate that through your tools. I left the White Balance as I shot it, pushed the Exposure up (+1.15), as well as the Recovery (20), Blacks (10), and Brightness (+19) (**A**).

I got to the next step after doing and undoing a number of tweaks. My initial tweak with portraits like this often includes adding Clarity to enhance the texture, but this time I found that I was looking at so much texture I wasn't sure where to look. We're drawn to contrasts, and for me to be drawn to a textured face I want that face to be within a less textured context. So I drew back the Clarity to −31, which softens things beautifully, though it also leaves the face soft and dull (**B**). I'll paint that back in later with the Adjustment Brush and a cranked Clarity slider. Be careful with the Clarity slider— pull it too far to the left and things take on a weird murky Vaseline-on-the-lens look. But if that's what you're going for, then knock yourself out.

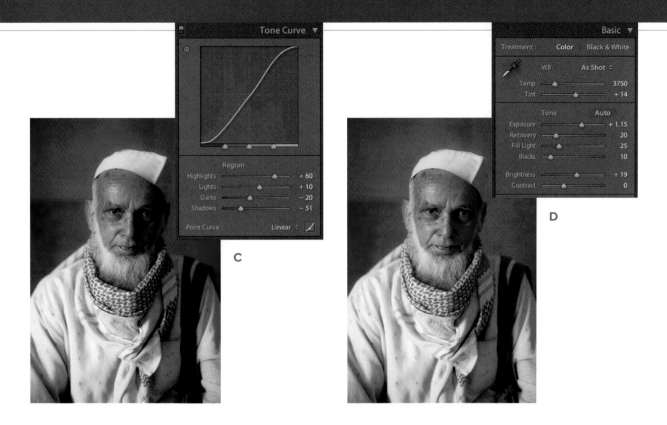

C

D

Working downward into the Tone Curve panel, I steepened the curve, increasing the contrast but being mindful not to crank things so much that I'd create more problems with deep shadows and blown highlights. I left the Point Curve at Linear and set the Tone Curve to Highlights: +60, Lights: +10, Darks: −20, and Shadows: −51 (**C**). This creates strong contrast but makes my midtones a little darker than I want. You can play with the Tone Curve until it drives you nuts, and with time your ability to read and use the Tone Curve will get better. But I chose simply to go back to the Basic panel and make a tweak.

I love the Fill Light slider. I'm unapologetic about that enthusiasm. When I still used Photoshop for

the bulk of my processing work, I'd find that often my final tweak was a Curves adjustment where I just pulled the midtones up. It brightened the image in the midtones, and I find I get a similar aesthetic using a little extra Fill Light. I have no idea what goes on under the hood—I don't even care. I just want it to look the way I envisioned. For me, Fill Light does that. In this case, I nudged it up to 25 (**D**).

If you look carefully at the image as it is before this next set of adjustments, you'll notice there's a blue cast on the man's hat, a bright blue zipper on his bag, and a strange green cast on the rightmost arm (camera-right) that's coming from the big green door to camera-left. I want to pull those distractions out of the image, simplify it to the elements

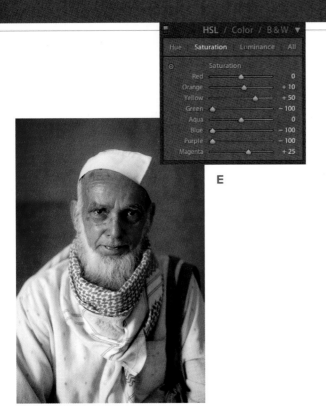

| HSL / Color / B&W ▼ | |
|---|---|
| Hue **Saturation** Luminance All | |
| Saturation | |
| Red | 0 |
| Orange | + 10 |
| Yellow | + 50 |
| Green | − 100 |
| Aqua | 0 |
| Blue | − 100 |
| Purple | − 100 |
| Magenta | + 25 |

**E**

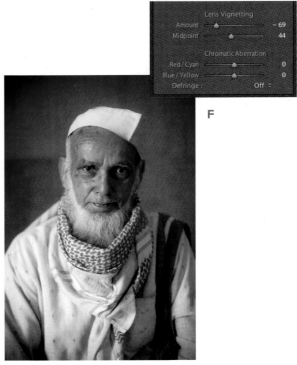

| Lens Vignetting | |
|---|---|
| Amount | − 69 |
| Midpoint | 44 |
| Chromatic Aberration | |
| Red / Cyan | 0 |
| Blue / Yellow | 0 |
| Defringe : | Off ÷ |

**F**

that truly matter—and using the Saturation sliders in the HSL panel can do that. If you look at the adjustments I made, you'll see that I've pulled the Green, Blue, and Purple down to −100 (**E**). As you make these changes, look at the image and see what gets removed, what changes. I also pushed the Orange (+10), Yellow (+50), and Magenta (+25). Take a moment to push these same sliders, but before you do see if you can tell where the resulting changes will take place. I think it's helpful to remember that you can't always do this, as pulling down the saturation in the greens, for example, will pull it down in *all* the greens in the image, and you don't always want that. When it doesn't work well, go to the Adjustment Brush and paint out the saturation that way.

The final adjustments are matters of attention management, where you help the viewer to look where you want her to look, not unlike a magician saying, "Look over here," while doing the dirty work with the other hand. A vignette (Amount: −69, Midpoint: 44) pulls the attention in, and it needn't be overly strong (**F**).

Lastly, using the Adjustment Brush with Clarity set to +100, I painted a mask on the face, beard, and hat (**G**), which compensated for the image-wide Clarity adjustment (−100) that was made in the Basic panel at the beginning. I also added some Sharpness (25) and left all the settings completely off in the Detail panel. I will do a little sharpening when I output this image, but that will depend on my intended medium.

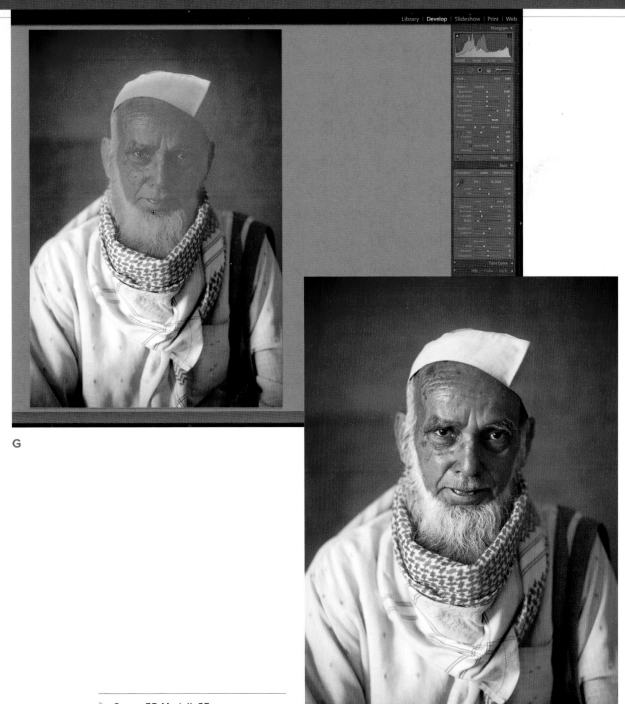

G

▶ Canon 5D Mark II, 85mm,
1/125 @ f/1.6, ISO 800

Nizamuddin, Delhi, India, 2009.

# Harvest Road

ONE OF THE MOST MAGICAL days I ever spent with a camera in my hand was on the 2009 Lumen Dei trip to Ladakh. We spent a couple days in Lamayuru, and the combination of perfect weather and the ongoing harvest was a dream. The sun was out, the hay was golden, and the dust in the air caught the light beautifully. I had given our team an assignment—to shoot a short essay on any topic—and I chose the harvest as my own subject. This was the final frame and was a tough one to capture. I'm almost lying down to catch this angle, and trying hard not to get stepped on while also trying to cut the full blast of the sun with the torso of the Ladakhi woman walking toward me. What I wanted this image to communicate was the feeling of that autumn morning, the quality of the light and, in general, give more feeling than information. I had seen images recently in travel magazines that had a bright yellow/green, almost desaturated warmth to them, and when it came to this image it was that aesthetic I wanted to draw on. Having no specific idea how that might be accomplished, I sat down

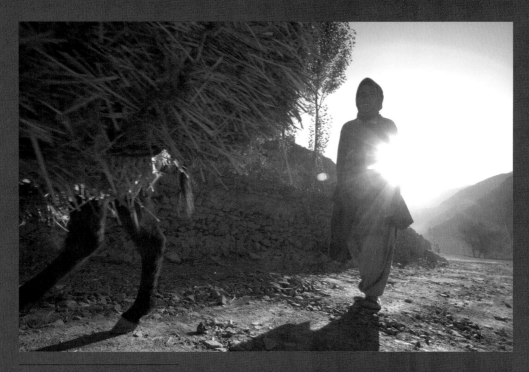

**Zeroed RAW file**

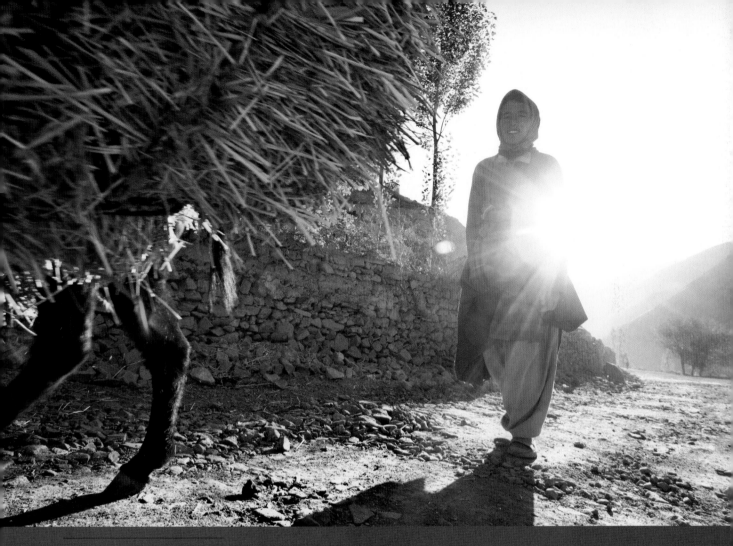

**Final image**

and described the look I wanted. That's how I got to thinking of it as bright, yellow, and desaturated. Based on the look I was trying to replicate, I also suspected I'd need a green tint. But beyond that I didn't overthink it. This isn't a high-information image. It's all about mood, and I won't be pushing the eye of the viewer around much—just creating a mood and letting it be a solid closing shot to my essay.

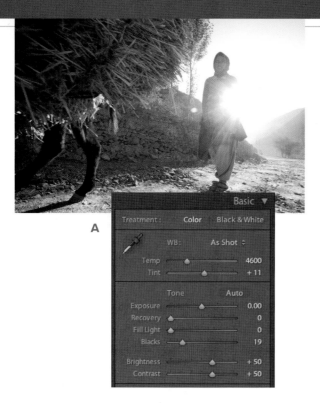

A

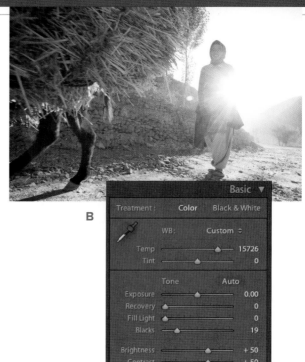

B

After zeroing the DNG file and making it look really lousy, the first step was to punch my Blacks (19) and push the Brightness and Contrast each to +50 (**A**). The rest of the work will be done elsewhere, and as there are no distractions I care to eliminate, I'll move straight to setting the mood.

This is where the ability to anticipate some of your decisions is important. Sometimes that happens simply from the back and forth of this kind of work; sometimes you just learn to predict what you're going to need and that allows you to make decisions a couple of steps ahead—and not worry when you make the image look much worse before it looks better. This image will eventually be selectively desaturated, so I'll make initial adjustments that are over the top, knowing they'll be knocked back a little later in the process. Case in point:

the first thing I wanted to do was heavily push the White Balance to a much warmer color temperature. I wanted it really warm, and then I pushed it even further. I ended up with a Temp of 15726 (**B**).

That last adjustment made the image much warmer, but in the give and take of this workflow it also made it redder than I wanted. Remember, I've got a specific aesthetic I'm aiming for here, and keeping the image warm while also playing with the green tint I earlier suggested was part of my intent. So I played with the Tint slider and pulled some of the magenta out of the image by pulling the Tint value to −41. Still warm, but much less red (**C**).

I didn't go crazy with contrast in this image. I wanted it to be punchy, but shooting into the sun is naturally a lower-contrast situation. So it might

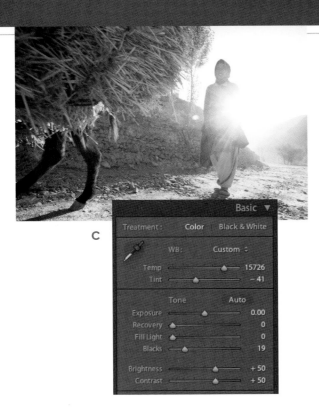

C

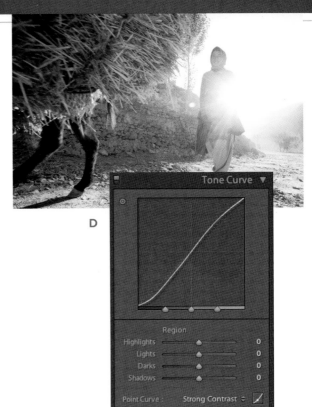

D

seem strange that my adjustment in the Tone Curve is to add a Strong Contrast Point Curve. However, it's strong contrast in name only. On this image it's not so strong. Also, my contrast tweaks in the Tone Curve panel are often a much stronger S-curve, and by comparison this adjustment is pretty self-controlled. Forget what the adjustment is called; look at the change to the aesthetics of the photograph (D).

If there's a danger in making an extreme adjustment like I've made to the color temperature of this image, it's that after a few minutes of staring at it, it stops seeming so extreme. It starts to feel normal. Remember that, because forgetting will tempt you to deviate from your original plan. When I first pulled some of the saturation out of this image, I felt like I'd sucked the life out of it. You can always split

the difference between the look you think you're going for, and the more saturated one you stumble upon as you do the work. But don't let yourself lose sight of what you're going for. Otherwise, you'll end up with images that look great to you but completely overwhelming to people who haven't been staring at the image for as long as you have.

Opening the HSL panel, I pulled the Saturation down on the Red (–46), Orange (–40), Yellow (–31), and Green (–35). By now, you shouldn't be surprised to hear me tell you I just pulled these down until they all just felt right (E). I want warm but not tropical. I want the feel of warm sun hitting a cold stone road. And these are the values that felt right to me. Why did I only adjust these particular colors? Play with the sliders and you'll see there aren't any other colors present.

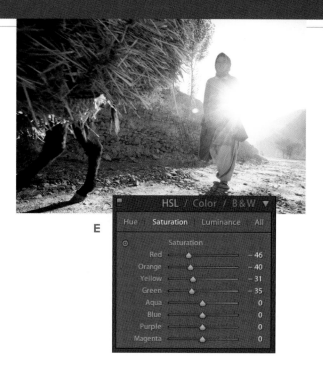

E

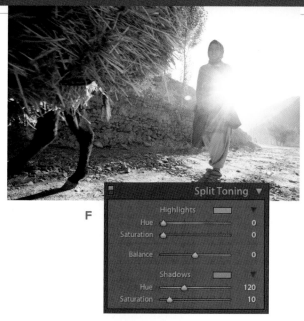

F

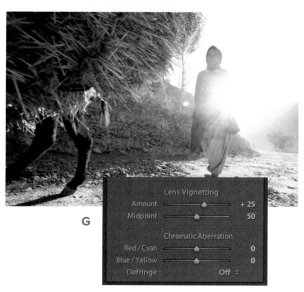

G

The next adjustment is a subtle one, and it was a fluke. I contemplated adding a split tone to the image, and when I started playing it occurred to me I could add a tone to only the Highlights or just the Shadows. That of course means it's no longer a split tone, just a selective tone. So I added some green (Hue: 120, Saturation: 10) to the Shadows and left it at that (F). Highlights don't take on the tone, but the Shadows do, allowing my highlights to retain their warmth. Although the effect here is subtle, it opens up possibilities in other images where other means of selective adjustments don't give you the look you're after. Had I made this adjustment globally with the White Balance Tint, it would have made the entire image—including the brighter yellows—too green.

As I've noted elsewhere, I'm conscious of being particularly fond of adding a vignette to my image, but that can do the opposite of what I'm aiming for in this image, which is a feeling of openness and

brightness. A heavy vignette pulls the eye in, and it can be confining. Reversing that effect, or brightening the corners a little, can open the image up. In this case, pushing the Lens Corrections > Lens Vignetting slider to an Amount of +25 with a Midpoint of 50 does just that (G). I've chosen to keep it subtle, but you might prefer something even brighter.

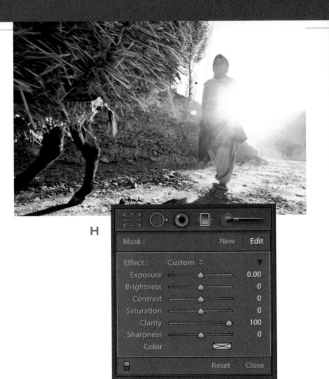

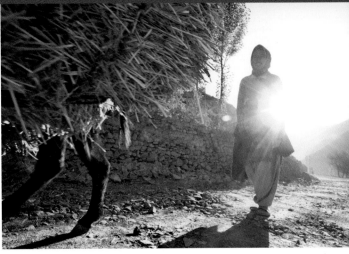

△ Canon 5D, 17mm, 1/160 @ f/10, ISO 400

Lamayuru, Ladakh, India, **2009**.

While I'm freely admitting my fondness for vignetting, I might as well confess a somewhat unhealthy reliance on the Clarity slider. I almost cranked the Clarity slider to 100 in the Basic panel at the beginning of my work on this image, but I decided to try something else instead and introduce the effect of that Clarity (that is, adding texture) more selectively through the Graduated Filter (**H**). So I dragged the Graduated Filter, with the Clarity set to 100, from left to right, stopping before I got to the woman's face. Why did I do this? Take a moment and crank the Clarity slider to 100 in the Basic panel and see what it does to the woman's face and to the background behind her. It kills the airy feeling I wanted and introduces a harsh look I was intentionally trying to avoid. I want that texture in the hay and stones of the wall and road, but as most of that occurs in the leftmost half of the image, why not limit the use of Clarity to that half instead of across the whole

image (which would create another problem to overcome)? In fact, I almost decided to reduce the Clarity in the Basic panel once I'd added the Clarity with the Graduated Filter, as it adds a little more of that ethereal feeling. But in the end I felt the contrast between the halves of the image was too great and I was getting distracted by the technique.

The work on this image was simple, but the difference in mood between the original capture and the finished file is significant, and it illustrates well the idea I was aiming for. Someone might ask me about this photograph, "Did it really look like that?" And the answer is both yes and no, but more importantly, it *felt* like this. As a fine-art photographer, when I do this kind of work it's my mandate and my desire to express something through this image— how it felt to be in Ladakh on that morning.

# Rays on Sapa

THERE'S A TOWN in northern Vietnam called Sapa. It's in the hills and is an incredible place. Or it might once have been before it got overrun with tourists like myself. Nevertheless, it's still a breathtaking place. In the short time I was there, it was cold and foggy, and this was the only time we saw the sun come

**Final image**

out—on its way down on our final evening—creating the crepuscular rays you see here. It was these rays that made me shoot this image; without them the whole scene was flat and uninteresting, but when the light showed up it became a little magical. That's what I wanted to catch in the final image.

My goal for this photograph never quite materialized, but later I re-imagined it and came up with something I quite liked. It's not an image that will make my final collection, but it gave me a chance to exercise some of my creative muscles. Images like this—that have potential but don't quite do what I want them to—often become images with which I play. In this case I wanted to create something a little magical, something more painterly and interpretive. This is a long way from the kind of image I generally create, but playing with it was a good exercise and gave me a chance to work through the process of moving from intention to expression in a way I don't normally do. You can always learn from those kinds of exercises.

In this case I wanted something magical, and I wanted it to feel idyllic and perhaps a little closer to a fairy tale than I've ever done before. And so while that intent wasn't present when I captured it, it became my intent when I sat down to work on this file. That intent would be expressed in warm tones, dramatic textures, and a focus on the light hitting the ridge.

**Zeroed RAW file**

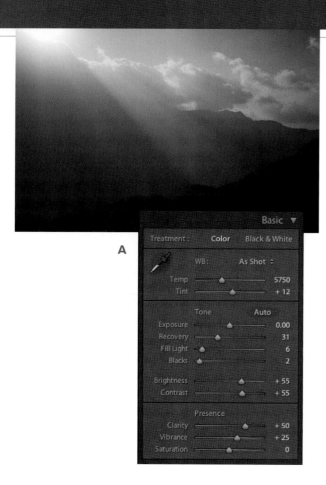

A

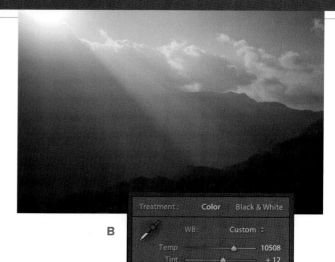

B

My first adjustments were just to bring back the contrast and brightness of the image, which zeroing the file removes. As you can see from the screenshot, I've done a little pushing around with almost everything (**A**). Make the blacks black and whites white, fill in the shadows a little, and recover some of the lost highlights—knowing you'll never regain all of them, and some will be brought back later with a Graduated Filter or Adjustment Brush.

The next adjustment is the first step in bringing the mood back by pushing the White Balance Temp to 10508, warming it up considerably (**B**). I'll make this image quite green eventually, because that's how I saw Vietnam almost without exception—as a very green place—but I want it to be a warm, evening-glow kind of green.

Moving the Tone Curve to a Strong Contrast Point Curve begins to restore the punch and texture to the image (**C**). Remember I said I wanted the image to have a "painterly" quality to it? Well, saying "painterly" is next to useless unless you can describe what that means visually. To me, it's

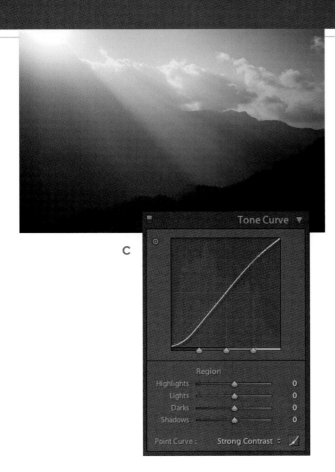

C

D

dramatic, textured, and a little larger than life in a way that I think contrast can communicate. Strong rays of light will create strong shadows—and shadows create texture—so I want those visual cues present in the image. You'll see that in the final photograph.

The image is now quite warm—but it's too warm for me. Working through the image, you may decide it's not warm enough, in which case I encourage you to follow that hunch in the same way I'd encourage you to add salt if we were cooking and your tastes led you in a way different than mine. Opening the HSL panel and playing for a couple of minutes led

me to drop the Saturation on the Oranges to −46. The Saturation on the Reds got pushed around and then came back to +9 (**D**). Again, there's no reason I can logically point you to beyond the "it just felt right" rationale that by now should be either second nature to you or just beginning to sound very suspicious. I knew what I wanted it to feel like, and I knew it when I felt it. If you don't know what you want the image to feel like, you've started pushing things around too quickly; start back at the beginning and come to grips with your intention first.

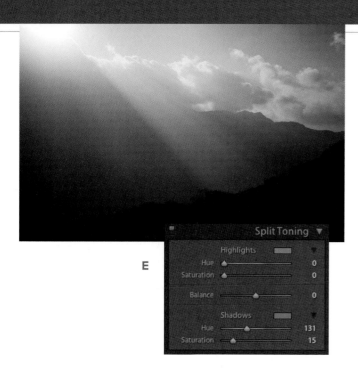

E

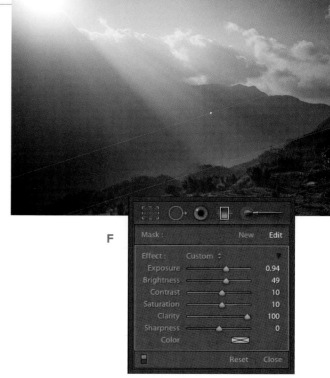

F

The last global adjustment I made was in the Split Toning panel and, like the previous image, "Harvest Road," I opted to only tone the Shadows (Hue: 131, Saturation: 15) to give me a green I associate with bamboo forests—none of which you see in this photograph, but through which I walked while in Sapa (E).

The rest of the work will add to the mood of the image and draw the eye to specific areas of the image at the same time. Most of all, I want to draw the eyes to the crepuscular rays and to the ridge those rays illuminate, so I'll do that with both the Graduated Filter and Adjustment Brush tools. The first filter I applied was across the bottom right of the image, across the fields and the ridge with the

house on it, and I added Exposure (0.94), Brightness (49), Contrast (10), Saturation (10), and Clarity (100) (F). By now you should be familiar with my thinking on these changes, though again, you may choose to find another aesthetic to express a similar vision for the photograph. I just wanted to draw the eye to the field and in a way that was consistent with the light in the image.

I dragged the second Graduated Filter from the top right, darkening that corner by lowering the Brightness (−10) and pushing the Contrast and Clarity to 100 (G). What I'm aiming for is drama in the clouds and a little balance with the heavy lower-left portion of the image. Darkening that corner also forces the eye to see the rays of the sun in a more defined way that strikes the house. It's the house we'll direct the eye to next.

Remembering that this image is intended to be a bit fantastic, and fantasy deals not in what is but in what might be, I decided to be even more heavy-handed with the brush. I painted the house with Exposure (0.34), Brightness (37), Contrast (45), and Clarity (53)—all changes to the aesthetic of the image that would make the house pop and draw the eye, while remaining consistent with being hit by rays of light (**H**). Illusion depends on a willing suspension of disbelief on the part of viewers; hit them too hard and they'll be unable to suspend that disbelief. When that happens, they stop experiencing the image and start looking at it with a more critical eye.

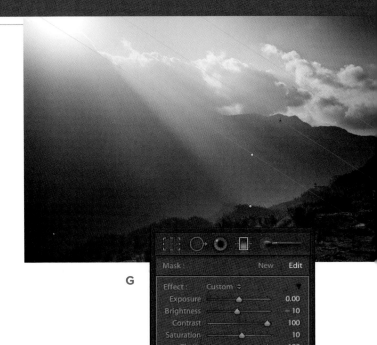

G

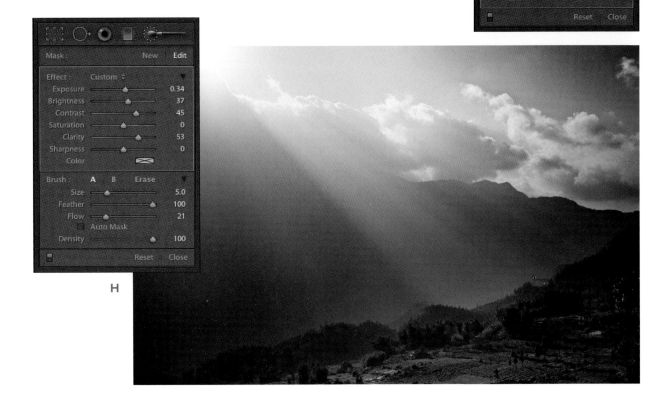

H

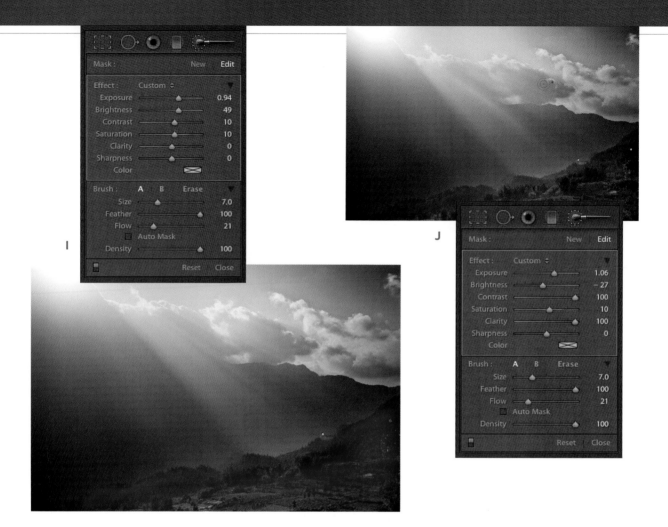

In a similar way, I've painted Exposure (0.94), Brightness (49), Contrast (10), and Saturation (10) into the rays of the sun, as well as the ridge and foreground, to draw the eye and make the whole thing consistent (I). After all, if a beam of light is landing on something it should be lit, or the mind believes the beam of light to be either false—which it is not, in this case—or falling elsewhere, which in this case it is, as it falls slightly behind the ridge I wish it were actually illuminating.

The last adjustments are to the clouds themselves. Pushing the Exposure (1.06) brightens the brightest parts of the clouds, but pulling the Brightness down (–27) darkens the midtones, increasing some of the drama and the feeling of a lighter rim around a darker core—the so-called silver lining (J). Contrast, Saturation, and Clarity add to this, too, and complete the processing on this image.

"Rays on Sapa" was never meant to be more than an image I played with. I created an intent for the image that was separate from the one I had at the moment of capture and ran with it. Different from my usual work, it's something I will likely come back to now and again to tweak and dig around in because there's something in this image I really like; I just haven't put my finger on it. For now it remains a canvas I'll probably keep painting, and that will either teach me new lessons or get me closer to the thing I felt when I first saw this scene.

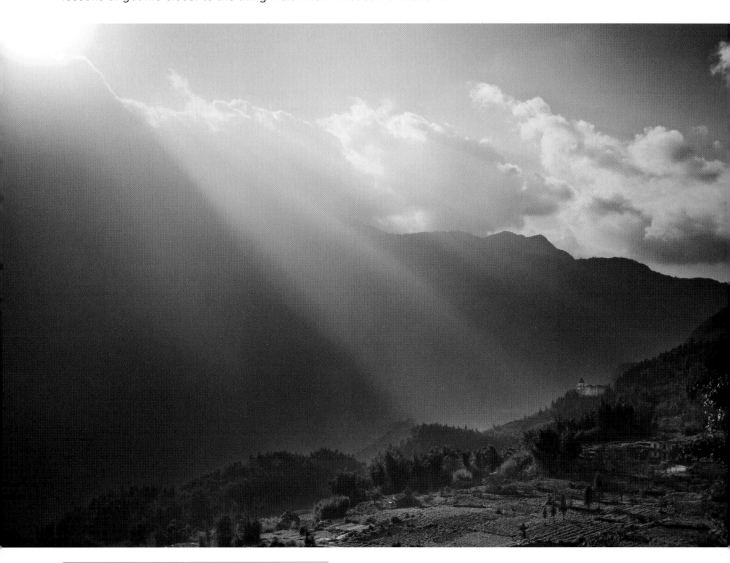

▲ Canon 5D, 40mm, 1/4000 @ f/4.5, ISO 100

Sapa, Vietnam, 2009.

# Through the Paddies

I HAVE A THING FOR REFLECTIONS, and it was the reflections of the palms that grabbed my eye in this scene in northern Thailand. A rainy, moody day, the dark clouds made the reflections in the water stronger than they'd be on a sunny day with lots of glare on the water. I'd been riding my scooter through the rain, and I wanted this image to invoke the feeling of the lush green moisture of wet rice paddies, with the eye of the viewer going to where my eye went as I drove past—down the path toward the mirrored palm trees.

As I will with a few other images in this book, I'm going to encourage you to import the DNG file for this image into Lightroom and take those guiding thoughts as your own. If your intention for this image were to communicate a mood of low rain clouds and wet, verdant rice paddies, and you wanted your viewers to feel pulled down the path to the reflected palms, how would you do it? Take the time to do it first, then look at my own approach.

**Zeroed RAW file**

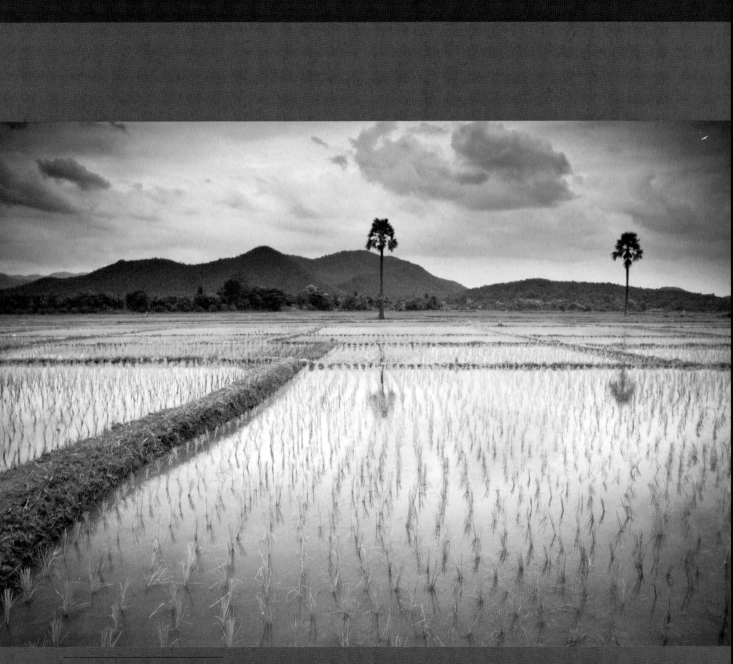

**Final image**

A

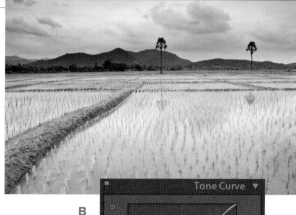

B

I began as I almost always do with the sliders in the Basic panel. But I'm not thinking about Exposure and Clarity—I'm thinking of the aesthetic results I want to see. I wanted warmer/yellower, brighter, and more defined details. I got there with a change in my White Balance (Temp: 6271, Tint: +3), Exposure (+0.92), Brightness (+75), Contrast (+39), and Clarity (+50), but my focus is on the look of the image (A). Understand what you want the image to look like, then reverse-engineer that look.

Thinking in terms of a specific desired aesthetic, and knowing I want good blacks and solid contrast, I went next to the Tone Curve panel and added a Medium Contrast Point Curve, then fiddled with

the curve itself to brighten the whites and darken the blacks. My own tweaks wound up as follows: Highlights: +29, Lights: −29, Darks: 0, and Shadows: −52 (B).

So far, the image looks better, and it probably looks closer to the "Did it look like that?" ideal, but isn't yet close to my "Did it feel like that?" ideal. Two sets of adjustments will restore that, and they both have to do with the color of the image. Right now the foreground looks muddy—and it was muddy—but I want it to be less brown and closer to green. In fact, in general I'm looking for a greener bottom half of the image and a bluer top half, both of which are there but in the RAW file aren't much more than subtle hints.

C

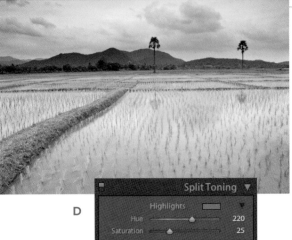

D

pushed the color of the Yellow values in the image a little closer to green (+35) and, with the Luminance tool, I darkened the Orange (−15), Yellow (−21), and Green (−21) values to make them more intense without using the Saturation sliders (C).

The second adjustment I made to bring the color, and therefore the mood, back to the image was in the Split Toning panel with one of my favorite split tones. Setting the Highlights to a Hue of 220 and a Saturation of 25 gives the sky more blue—including the reflections on the water, which are also highlights. I set the Shadows to a Hue of 120 and a Saturation of 20, giving the darker tones a heavier green look (D).

I've almost given up explaining my fetish with vignettes, but in case you flipped this book open and started reading so close to the back, this is more than just an addiction to darker corners. My goal is to push the eye to the middle of the image, to encourage it to take the visual trip down that

People looking at a two-dimensional image are at a distinct disadvantage because they weren't there. They didn't feel the temperature of the air or see the line of green trees off frame to the left. They didn't feel the raindrops. The feelings those things evoke need to be put into the image if they're to be felt at all. Color can help do that. My first adjustments are in the HSL panel. With the Hue sliders I

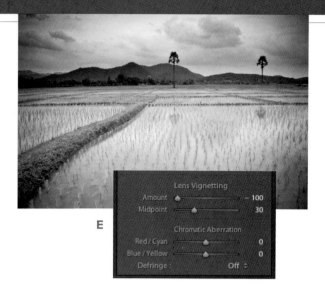

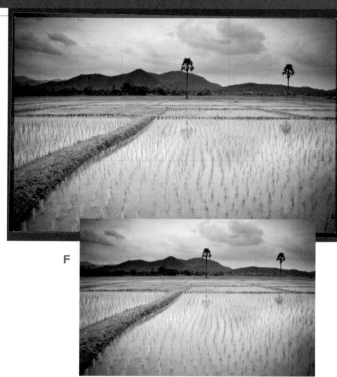

E

F

path. Darkening the edges of the frame guides the eye back into the image rather than out of the frame. There are other ways to do this, and some photographers would rather just shoot with a crappy old garage-sale lens that gives them that vignette more "honestly," but then where's the fun in that? Lightroom's ability to add or remove vignettes is getting really good, but for all the advances in the Post-Crop Vignette tool, I still prefer the simplicity of the Lens Vignetting tool, here cranked to an Amount of −100 with a Midpoint of 30 (E).

The last adjustments will be made with the Graduated Filter and the Adjustment Brush, but as we're heading up there anyway I'm going to straighten the image because it's driving me crazy. You can activate the Crop Overlay tool and eyeball the rotation to straighten the horizon. Or you can do what I did: pick up the Angle tool—the one that looks like a ruler—and just click and drag a line across the back of the field from one side of the image to the other (F). The image straightens with the prominent line—the one people look at to determine whether the image is straight—just beyond the palm trees.

I used two Graduated Filters on this image. The first was dragged from the top down with the intention of adding further mood and drama to the clouds. Less Exposure (−0.62) and Brightness (−13) darkened the sky. Increased Clarity (100) added more texture, and adding an indigo color brought back some of the blue (G).

Adding a second filter from the bottom up—set to the same Exposure and Brightness settings but without the color or Clarity—darkened things up in the immediate foreground (H). The obvious question is, why not just pull back the Exposure and Brightness for the whole image? Remember that the gradient will fade out toward the middle of the frame in both cases, so the middle third of the photograph remains bright, pulling the eye to its center. You'd lose that if you simply made a global adjustment to darken the whole image.

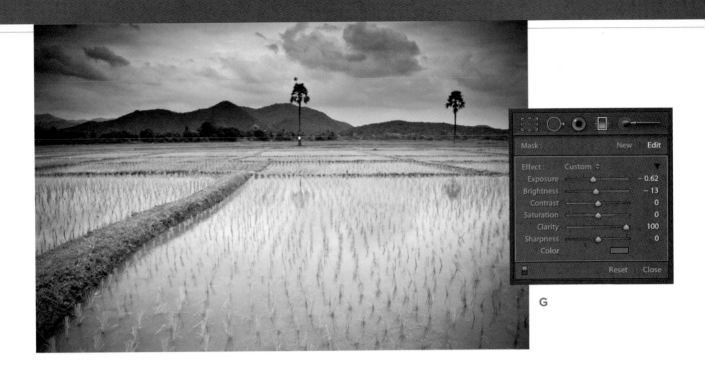

G

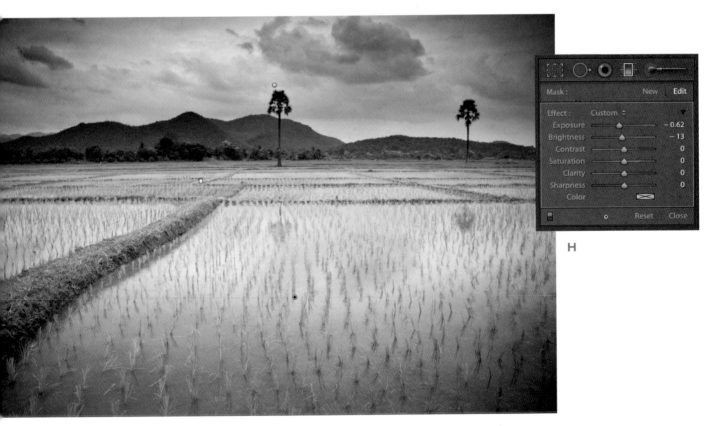

H

Two more adjustments—this time, a little burning. I want to give the path itself some visual mass, a little more weight in the frame. Usually I'd dodge—or make lighter—the element I wanted to have that pull, but context is everything, and as the path is cutting through an area that's already quite bright, I'm going to darken it. In this case, I painted in a mask and used almost all the sliders to give that path the most contrast within its context that I could (**I**).

Before finishing up, I used a new brush and did a similar thing to the reflections of the palm trees, making sure not to paint a mask on the ridges and mounds that border the paddies—dirt and grass don't generally reflect things as water does (**J**). On the water, a darker reflection makes sense, but on the grass it would be a giveaway of inexperienced and overenthusiastic burning. It's important to minimize distractions and point to the subject of the image—instead of your clever technique—so be mindful.

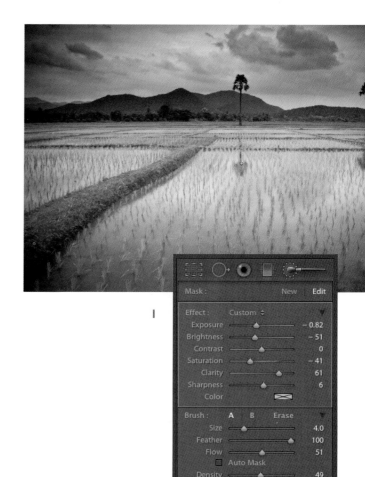

The final image, "Through the Paddies," does what I hoped it would. First and foremost, it reminds me of a place and a moment. While my hope is always that others see the same thing in my photographs that I've worked so hard to communicate, there's no guarantee. Once you put an image out there, viewers are free to react to it on their own terms—to like it or dislike it, to see what you hoped, or to see and feel nothing at all. The one reaction you control is your own. I'd encourage you to let that be the first litmus test of any image. Don't go running to the fans or the critics first; begin by asking yourself, "Does this image make me feel the way I wanted it too? Do *I* love it?" In my case, the answer is yes. The palms are a little blurred and the image isn't as sharp from back to front as I'd like, but photographs are what they are as much for their imperfections as for their technical merits. Remember that technical perfection rarely moves the soul.

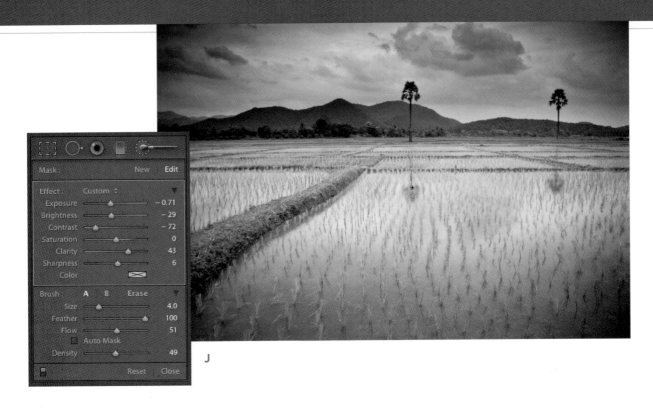

J

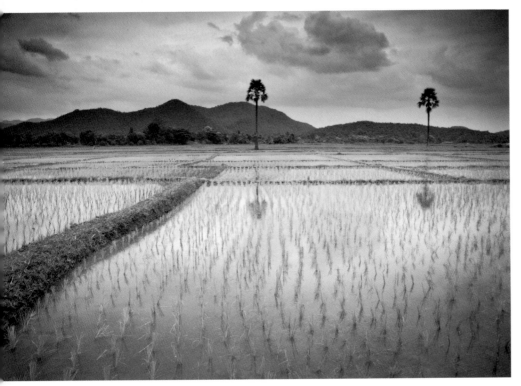

◀ Canon 5D Mark II, 27mm,
1/40 @ f/20, ISO 100

Chiang Rai,
Thailand, 2009.

# Lone Tree, Lone Buffalo

THIS IS THE PENULTIMATE LESSON in the book, and it's the lesson with the most confusing introduction. Before the final image, I wanted to put a simple one in here, and there are two reasons for that. The first is to establish this: how good an image is does not depend on how much darkroom work it takes

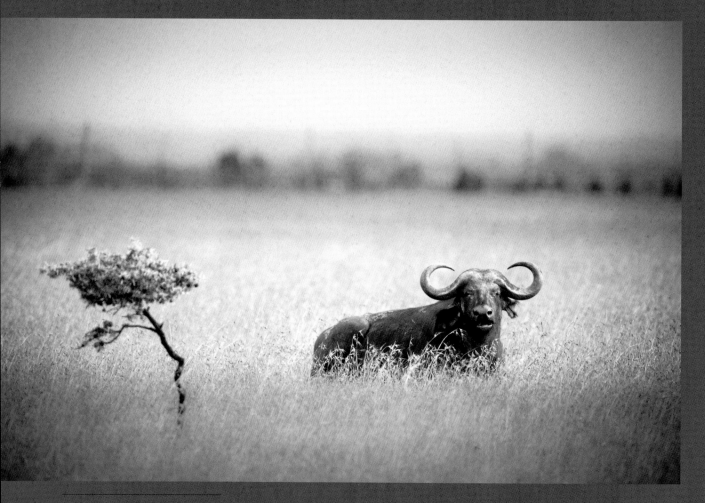

**Final image**

to produce it any more than how good a capture is depends on whether or not you climbed a mountain to get the shot. The second reason is to help you refocus on the core concept of this book and remind you—before you get to the end and send me an email explaining how disappointed you were not to get secret recipes for great images—that this is an inherently simple process. You see the image, you shoot it, and you refine your initial vision by, first, being aware of it and, second, being aware of how your tools will best express that vision. I'm going to streamline this lesson because I don't want you to overthink it. As before, I suggest you run through your own process before looking at mine.

This is a cape buffalo in Kenya. I photographed him as low as I could from a window in a Land Cruiser on a safari. Many of the images I shot on that trip ended up getting treated with this same split tone, so my process on each image was simplified. I already knew the mood I wanted, and it had to be somewhat consistent from image to image. Other than the split tone, which I call Maasai Chocolate, I wanted this: a high-contrast earthy image that allows the viewer to focus on the buffalo. No universal themes here, no complexity. Just know what you want, be able to express it in words, and then work your way there.

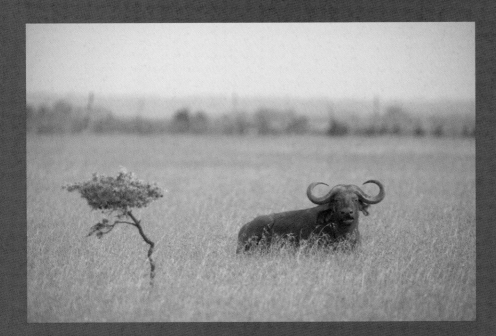

**Zeroed RAW file**

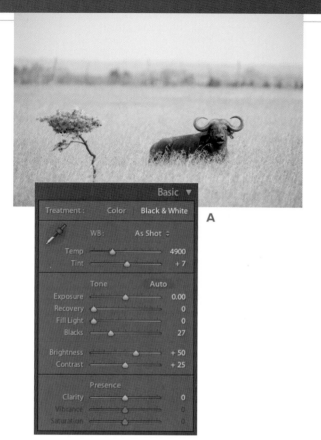

**A**

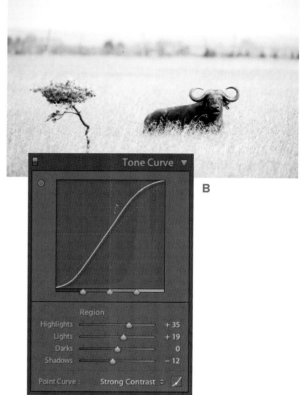

**B**

My first adjustments were simple, but this time I set the Treatment to Black & White so I could see what I was doing all the way through. I'll later tweak that black and white conversion, but for now it helps me to see it in monochrome. I don't have much to do here: push the Blacks to 27 to bring me closer to having some true blacks. Add Brightness (+50) and Contrast (+25), which are my defaults when I have no reason to push the values elsewhere (**A**).

To raise the contrast and further blacken the blacks and lighten the lights, I set the Point Curve to Strong Contrast, then further pulled the Tone Curve and set my values as you see them here (**B**). A strong S-curve means strong contrast.

I found the Black & White mix on this image a little tricky because the changes made less difference in this photograph than others. There's just less color information to work with, and pushed to extremes these sliders produced some nasty noise and haloing. I wanted changes that yielded the most amount of contrast between the buffalo and tree, and the field, while also minimizing the contrasts in the background (**C**). Take some time to push these values around and see if you come up with something you prefer more. Perhaps you'd rather have more contrast in areas where I opted to have less, and that's fine; just be sure it's congruent with your intention for the final look and feel of the image.

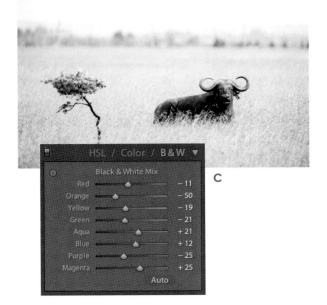

C

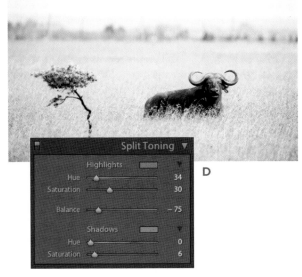

D

The Split Tone I chose for this was, as I mentioned, something I'd already created as a preset for other images in the same series (**D**). It was created from the twin desires to have an earthy look and feel, as well as something that reminded me of my impressions reading Hemingway as a young adult. I was going for something, well, safari-ish. Something with hints of *Out of Africa.* And this was what I came up with—a tone that is essentially just toning the highlights with brown, not unlike the dust that covers everything you own after a day of driving around the Serengeti, or the skin of the Maasai people.

A strong vignette added to the "this image was shot with an old camera" feeling that I consider to go hand in hand with a vintage-feeling photograph. It also leads the eye into the frame (**E**). But before you settle on the same values as I did, try going in reverse with the vignette. Bleached corners of

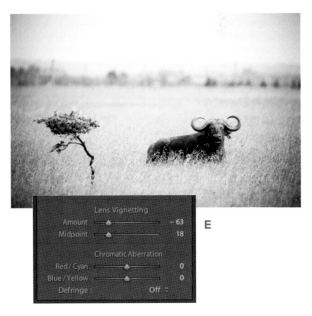

E

an image stand out a little too much to me but can impart a similar vintage feel. I don't use the effect much on my own work, but I've seen others use it well.

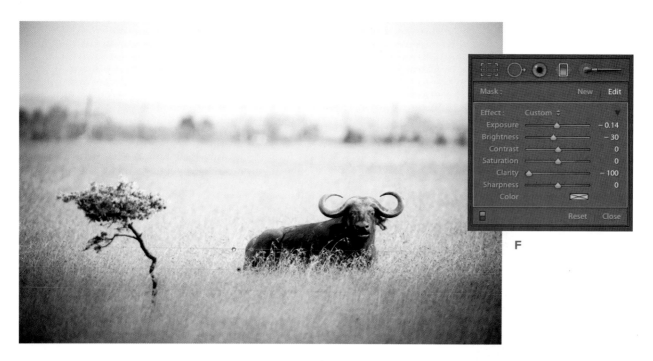

F

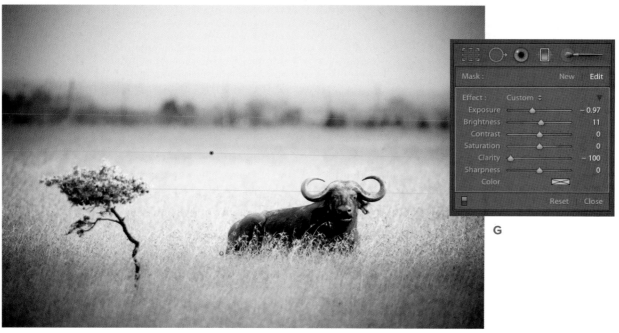

G

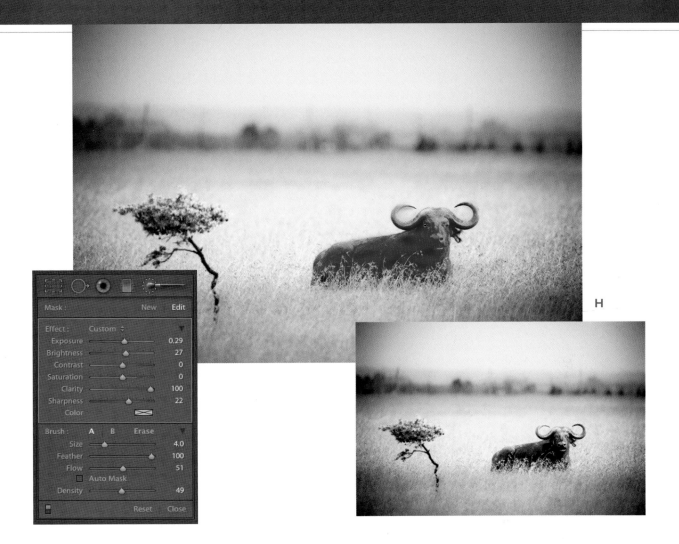

H

I could stop here, but I know when I put this on a large canvas I'm going to want a little more drama and contrast. So to do that I turned to the Graduated Filter and pulled one from the bottom up (**F**), and another from the top down (**G**). On both I darkened the highlights (Exposure) while also softening the midtone contrast and creating an illusion of a more limited depth of field with the Clarity slider (–100). I slightly brightened the midtones in the top gradient (Brightness: 11) to reduce the contrast between the fence posts and dark line of shrubs with the surrounding field and sky in order

to reduce their pull on the eye. On the gradient at the bottom of the frame, I darkened the Brightness to –30 in order to give the lower part of the frame more weight and push the eye into the middle of the image.

To separate the buffalo further from the field, I created a mask with the Adjustment Brush and made the buffalo and the grasses immediately surrounding him brighter (Exposure and Brightness) and sharper (Clarity and Sharpness) (**H**).

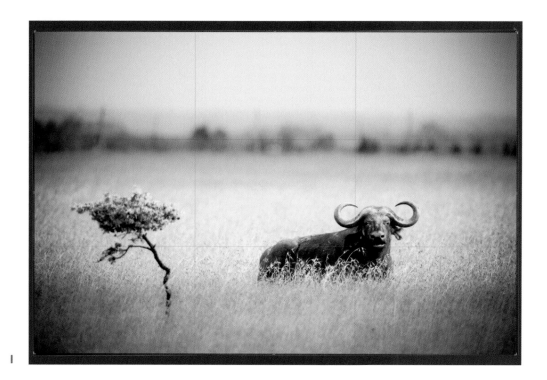

Finally, I used the Crop Overlay tool to straighten the prominent line in the background, and while that line may not have been a true horizon, it will get mistaken for one and people will be distracted by a line that's only slightly skewed. Better it be either straight or much more skewed than only slightly off, as that will drive people crazy with the sense of disequilibrium. A slight rotation counterclockwise and you're done and ready to output this image (I).

All in all, the processing on this image took me five minutes. Don't make your work more complex than it needs to be. Find your intent, pick your tools that best get you there, and then do it. In that order.

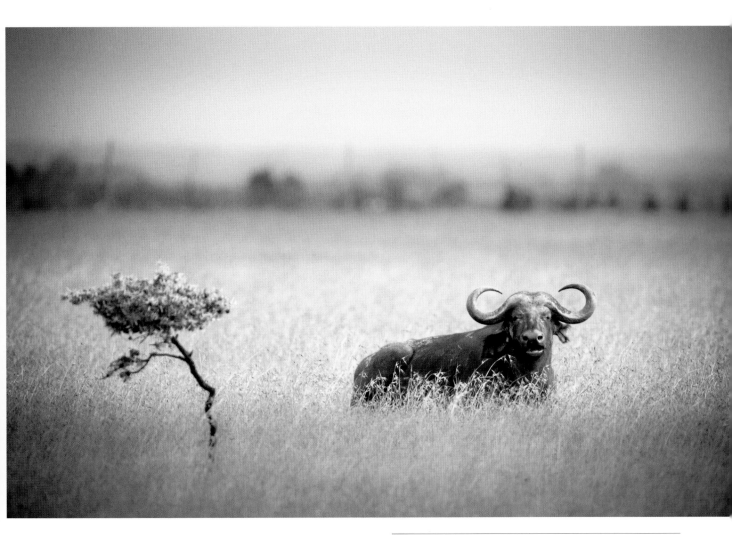

▲ Canon 1Ds Mark III, 600mm, 1/100 @ f/5.6, ISO 200

Kenya, 2009.

# Grandson

ON A WALK THROUGH THE SMALL VILLAGE of Dah Hanu in Ladakh, India, I met this little boy with his grandfather, and while my friend Matt Brandon and I talked with the grandfather, the interaction between grandfather and grandson mesmerized me. They had an intimacy and comfort with each other that particularly drew me, and while I shot a few images of the older man in his traditional hat, it was the relationship between the older and younger that I most wanted to capture—and finally did when the posing was over and the boy settled. To me, this image is about that intimacy, and about the contrast between the older and the younger, the large and the small. Because they wear their surroundings on them in the dust and grit, it is also an environmental portrait—despite the close crop and inability to see their full context.

Knowing what the image is about helps you make decisions about the direction of the postprocessing. Having identified the contrasts and the gritty feel of the surroundings, I'll work toward an image that feels warm and earthy, shows the texture and grit without emphasizing it, and pushes the eyes toward the contrasts—specifically the large weathered hands against the smaller innocent ones.

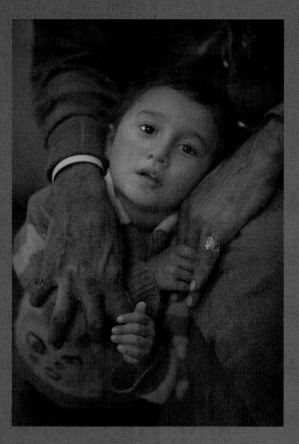

**Zeroed RAW file**

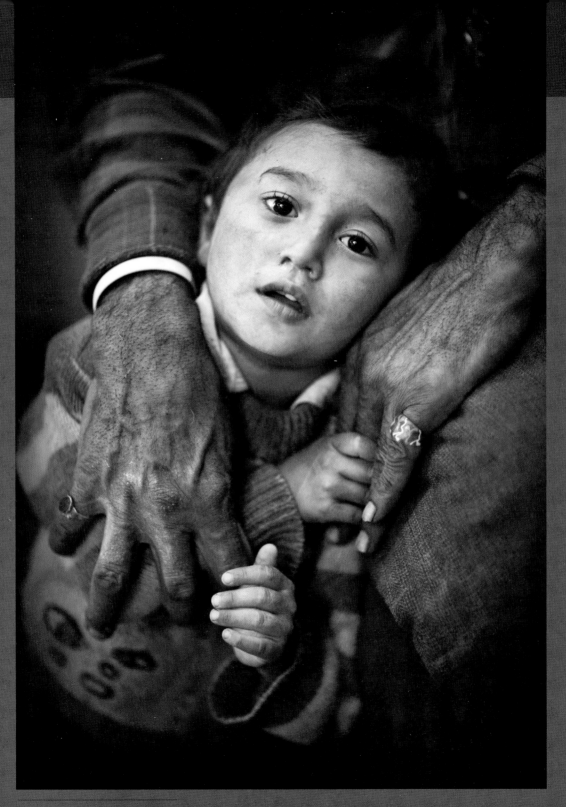

**Final image**

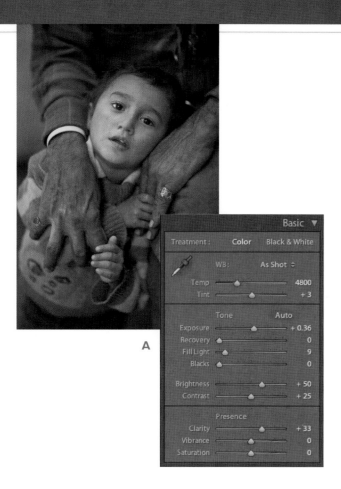

A

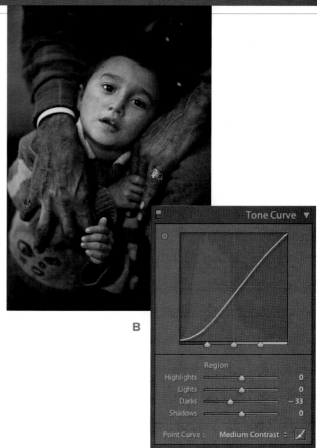

B

My first adjustments add brightness and contrast to the image through tweaks to the Exposure (+0.36), Fill Light (9), Brightness (+50), Contrast (+25), and Clarity (+33). These adjustments draw out the textures in the image (**A**).

I don't think that any of us do our work unaffected by the work of others, and in this case I recall an image by Steve McCurry of miners in Afghanistan, their faces sooty and the image feeling muted, dark, and gritty. I wanted a similar feeling here, and used the Tone Curve to darken things up and add the contrast that's important to showing grit. (Without

contrast, grit just fades into the background of whatever it's sitting on; adding contrast makes it immediately more evident.) I first added a Medium Contrast Point Curve, then pulled the Darks down to −33, just past the point where the blacks began to peak on the histogram (**B**).

The feeling of intimacy in this image comes not only through the intrinsic intimacy of the subjects; it can also be emphasized with a vignette, pulling the eyes in and making the image very much about the elements in the middle of the frame. Grandpa's hands already do that, but pulling in the Lens

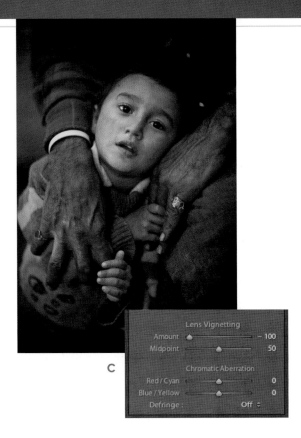

C

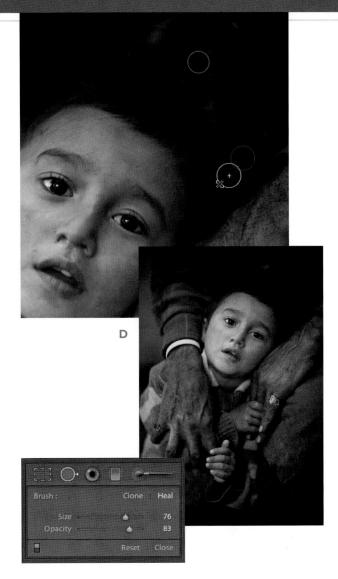

D

Vignetting (Amount: −100, Midpoint: 50) darkens up the corners, particularly the top–left corner, which, without the vignette, pulls the eye and unbalances the photograph (**C**). There are times when a feeling of imbalance or dynamic tension is appropriate to an image. This isn't one of them. If you want to communicate serenity and a feeling of safety or intimacy, symmetry and balance are more suited to the task.

In a moment, I'll finish what I started in the last step—pulling a gradient into the image to darken the left side of the frame further—but while working on this I noticed something that kept distracting me, so I'm going to get rid of it now. The buttons on the grandfather's shirt began to distract me, and once I noticed them I couldn't stop looking at them. Because I work better doing things as they come

up, I immediately got the Spot Removal tool, set it to Heal instead of Clone, and diminished their pull on my eye. Lowering the opacity of the healing, especially on the lower button, allowed me to reduce the pull of the button without removing it entirely as I did with the top button (**D**). I chose to use the Heal option instead of Clone because it blends things better than the Clone option on areas of texture.

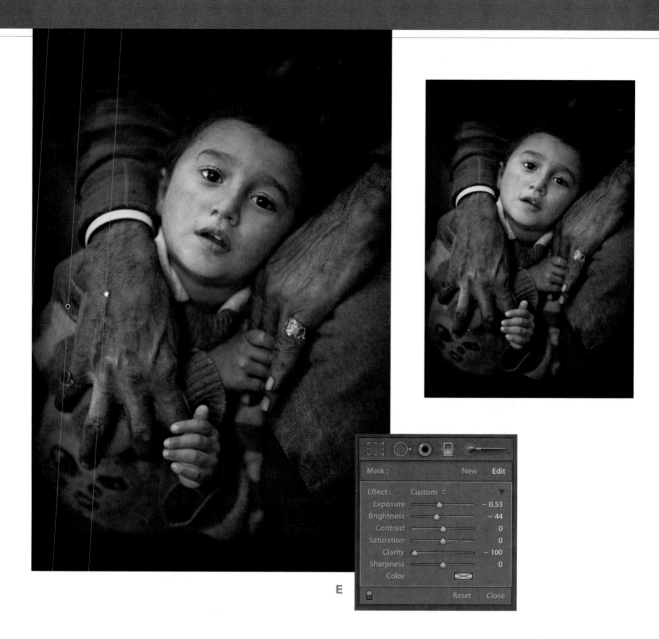

E

Returning to the task at hand—which was darkening the left side of the frame so the viewer's eye doesn't just fall right out of the photograph—I used the Graduated Filter (Exposure: −0.53, Brightness: −44, Clarity: −100) to darken and soften the left side of the image (E).

The last step is to dodge a few last details I want to draw a little more attention to. Using the same Adjustment Brush settings for Exposure and Brightness (Exposure: 1.08, Brightness: 59)—but with varying levels of Opacity on the brush—I painted the boy's hands, the folds of the man's sleeve, the hair

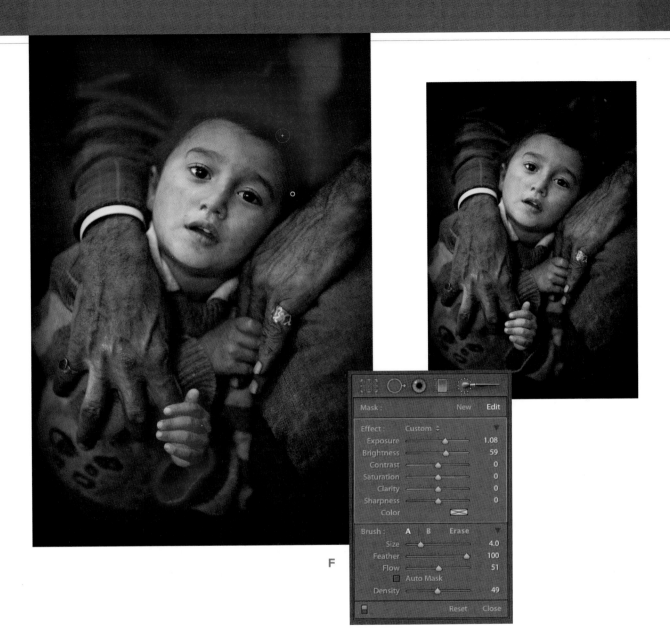

F

of the boy, and the man's chest. (Because I needed different Opacity settings for each element, I used brushes of at least four different Size, Opacity, and Flow settings, changing them as I went along to increase or diminish the effect instead of using four completely different sets of adjustments.) I wanted the hands to stand out a little more, and the boy's

hair was disappearing a little into the man's jacket (F). Finally, the key on the man's neck, though a small detail, was something I wanted to bring back in if only to be a subtle and hidden surprise for anyone who lingered long enough to see it.

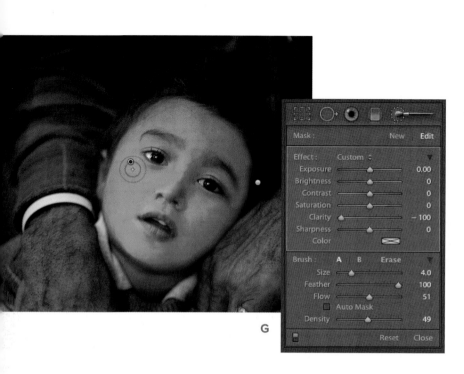

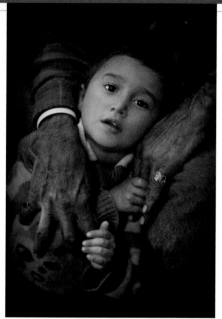

G

The last step is optional—and not one that ever occurred to me for this particular image. In fact, I don't think I'd ever use this kind of technique because of the work I do and the fact that I like lines and textures. But as my stated intention for this image was to draw notice to the contrast between the boy and his grandfather, I could have softened the boy's skin, further emphasizing his youth and increasing the contrast between his soft young skin and the man's older, weathered hands. It's not a choice I would generally make, but it is a good chance for me to show you the possibilities. Setting the Adjustment Brush to −100 Clarity, I've painted a mask on the boy's face (G). The negative value of the Clarity adjustment reduces the midtone contrasts that show the dirt and some of the texture on the skin, bringing back some of the innocence. Like I said, it's too sterile for me and betrays the reality

of the context they live in. But for images where you want this kind of effect, whether on skin or otherwise, it's a good technique.

The final image—without the skin-softening technique I just showed you—is now ready for output. As I often do, I've also created a final version in monochrome. I didn't do this wholly in Lightroom, but chose instead to edit in Nik Software's excellent Silver Efex Pro plug-in, which does a fantastic job of creating black and white (and toned) images much faster than I am able to do them in Lightroom. If you love black and white versions of your work, then I suggest you consider this plug-in. Lightroom is extremely capable, but its function and ease can be extended with a couple of well-chosen plug-ins like those available from Nik or onOne Software.

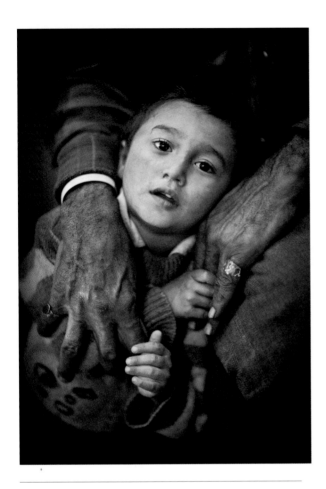

Canon 5D, 85mm, 1/160 @ f/1.2, ISO 400

Dah Hanu, Ladakh, India, 2009.

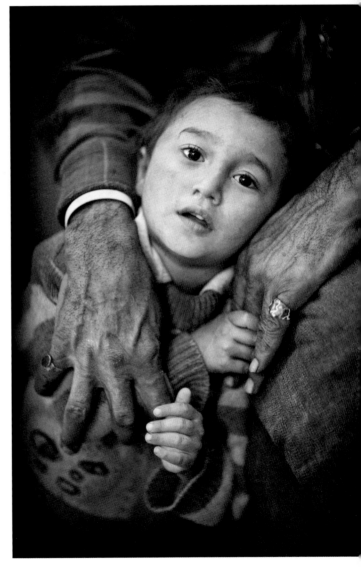

# Conclusion

TO BE HONEST, this was a hard book to write. Taking what is now an intuitive process and putting it into words and illustrations that make sense and give the illusion of a uniform process is difficult at best. At worst, it's just plain unrealistic. But, all the same, I hope it's helpful.

None of us sits down in the digital darkroom to follow a formula; we do it to polish the diamond we first saw when we raised the camera to our eye. The process—the workflow, vision-driven or otherwise—is just the way we get there, and very few of us learn this stuff for the love of software, sliders, and hours in a chair blinking at a studio display.

▶ Canon 5D Mark II, 16mm, 1/3 second
@ f/6.3, handheld at ISO 1600

Karen Blixen Camp, Kenya, 2010.

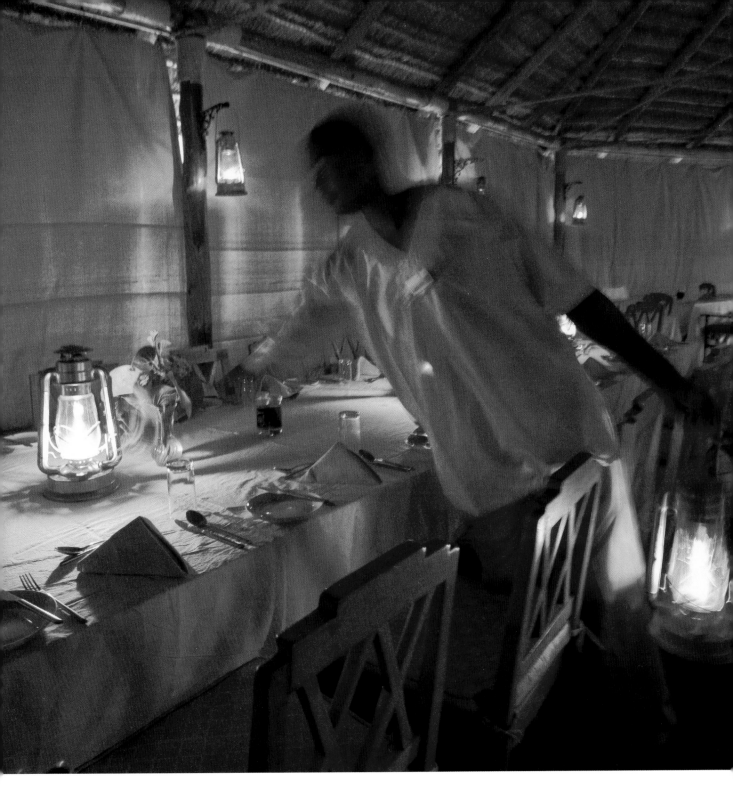

> "You can't paint by numbers when the canvases keep changing."

On top of that, it's a process that deals with images that are all different. Every one of them is unique, and you can't paint by numbers when the canvases keep changing.

What I've tried to impart here is a handful of principles with which you can form your own vision-driven workflow, a workflow that fits your individual and particular ways of working creatively. Some of us work better with order, some prefer complete chaos. What matters is that you recognize the way you work best and fit these principles in with that. As one of the visual arts, photography is a field in which we celebrate expression. We hold up the so-called masters and greats of this art for their unique vision and the ability to express that vision, not for painting within the lines. So the best I can offer you is my own technique, and to show you both my paradigm and the way I approach some of my own images.

If I had to give an elevator pitch on this stuff and cram it into an impossibly short minute or two, it would be this: Spend more time discovering and becoming comfortable with your intent for the image than sweating about which button to press. Then find the right tools to refine that vision by finessing the aesthetics of the image. Fix the weaknesses and minimize the distractions. Establish the mood. Subtly push and pull the eye of your viewer. And then output it and show the world that thing to which your eye, your heart, and mind were drawn. The process exists to serve the print, and the print to serve your vision.

Lightroom is, at its heart, a much simpler tool than Photoshop, and as such it's a better place for most people to learn the processes of the digital darkroom. But simple doesn't mean simplistic. Lightroom's a powerful program, and where it reaches its limits there are plug-ins that extend the possibilities beyond the edges of my own needs or imagination. The best among them, and the ones I use and love, are from onOne Software and Nik. OnOne's Plug In Suite and Genuine Fractals and Nik's Silver Efex Pro and Sharpener Pro are extremely useful, and highly recommended. And don't forget about the Develop module presets. They exist out there on the internet by the thousands; most of them free and they're easy to install. Presets can give you a window into the way other photographers realize their vision, and while I'm not a fan of simply adopting them for my own use, I love the idea of dissecting them and seeing how other minds have thought their way to a new aesthetic. Pull them apart, look at every setting, and ask yourself why the creator of the preset did things the way they did; you'll learn and be able to apply those same principles to your own work, adding

new tools to the toolbox, or—to go back to our metaphor—extending your vocal range and allowing you to sing new songs, or old songs in new ways. Finally, if you've not yet picked up on my subtle clues, I am a huge fan of the Wacom tablets and I strongly encourage you to get your hands on one. The control they give you over your work can't even be approximated with a mouse or trackpad, and once you get over the initial learning curve (during which you'll be tempted to throw it out the window; don't), you'll never want to work without it.

As for the really technical stuff—the nitty gritty of the craft—it matters a great deal, and there is much about the craft of postprocessing that I've not touched on because there are stronger voices than mine speaking to those issues right now, like Scott Kelby, Vincent Versace, John Paul Caponigro, and Katrin Eismann, among others. In fact, this book is really only minimally about craft. This book is about connecting your growing craft and your growing vision through the images you create. My hope is that you'll get a basic grasp of tools as you work through this book, and then move on to learning from teachers with a more specific grasp of the areas you feel are your weakest, and in those I'll be right by your side. I'm still figuring out color management, sharpening, and the world of fine-art printing, for which you normally need an education at Hogwarts to even scratch the surface. But those are peripheral issues. If you do not first learn to recognize and express your vision through the tools at your disposal, then there's no point perfectly sharpening or printing your work.

There are three images that go into a final photograph. The one you envision, the one you capture, and the one you finesse in the digital darkroom. The better you are at the latter two, the closer you'll come to the first. It doesn't matter how long it takes you to bring those three images into alignment, just as long as you enjoy the journey and get a little closer every day.

Peace.

David duChemin
Vancouver, 2010

"This book is about connecting your growing craft and your growing vision through the images you create."

# Index

WATCH
READ
CREATE

## Meet Creative Edge.

A new resource of unlimited books, videos and tutorials for creatives from the world's leading experts.

Creative Edge is your one stop for inspiration, answers to technical questions and ways to stay at the top of your game so you can focus on what you do best—being creative.

All for only $24.99 per month for access—any day any time you need it.

**creativeedge.com**